BEST OF WATERCOLOR

SPLASH 3

Ideas & Inspirations

DETAIL OF GERBER'S DAISIES
KASS MORIN FREEMAN

BEST OF WATERCOLOR

SPLASH 3

Ideas & Inspirations

NORTH LIGHT BOOKS
CINCINNATI OHIO

ABOUT THE EDITOR

RACHEL RUBIN WOLF studied painting and drawing at the Philadelphia College of Art (University of the Arts) and Kansas City Art Institute, and received her BFA from Temple University in Philadelphia. She is acquisitions editor for North Light Books and the editor of *Splash 2: Watercolor Breakthroughs* and *Basic Portrait Techniques*, as well as the co-editor of *Splash 1* and four books in North Light's Basic Techniques series. She resides in Cincinnati, Ohio, with her husband and three children, where she continues to paint in watercolor and oil.

SPLASH 3: BEST OF WATERCOLOR / IDEAS AND INSPIRATIONS. Copyright © 1994 by North Light Books. Printed and bound in China. All rights reserved. No part of this book may be reproduced in any form or by any electronic or mechanical means including information storage and retrieval systems without permission in writing from the publisher, except by a reviewer, who may quote brief passages in a review. Published by North Light Books, an imprint of F&W Publications, Inc., 1507 Dana Avenue, Cincinnati, Ohio 45207. (800) 289-0963. First paperback edition 1999.

03 02 01 00 99 5 4 3 2 1

Library of Congress Cataloging-in-Publication Data
Splash 3: Best of Watercolor: Ideas and Inspirations /
 edited by Rachel Wolf. — 1st ed.

 p. cm.
 Includes index.
 1. Watercolor painting, American. 2. Watercolor painting– 20th century–United States.
I. Wolf, Rachel II. Title: Splash three.
ND1808.S66 1990 759.13'09'048 90-7876

ISBN 0-89134-964-2 (pbk.:alk.paper)

The permissions on page 130-132 constitute an extension of this copyright page.

METRIC CONVERSION CHART		
TO CONVERT:	TO:	MULTIPLY BY:
INCHES	CENTIMETERS	2.54
CENTIMETERS	INCHES	0.4
FEET	CENTIMETERS	30.5
CENTIMETERS	FEET	0.03
YARDS	METERS	0.9
METERS	YARDS	1.1
SQ. INCHES	SQ. CENTIMETERS	6.45
SQ. CENTIMETERS	SQ. INCHES	0.16
SQ. FEET	SQ. METERS	0.09
SQ. METERS	SQ. FEET	10.8
SQ. YARDS	SQ. METERS	0.8
SQ. METERS	SQ. YARDS	1.2
POUNDS	KILOGRAMS	0.45
KILOGRAMS	POUNDS	2.2
OUNCES	GRAMS	28.4
GRAMS	OUNCES	0.04

ACKNOWLEDGMENTS

MY THANKS goes to Greg Albert for help in developing the "Ideas and Inspirations" theme and for help in selecting the art. To Kathy Kipp and Anne Hevener for help in selecting the art and in editing the text. To Julie Wilson for help in selecting the art and for helping organize the myriad details and massive mailings. To Donna Poehner for guiding this book through production. To Paul Neff for the beautiful design inside and out.

I would especially like to thank all of the devoted watercolor artists who so carefully responded to our call for entries, both those who are represented in this volume and those who are not. You are our inspiration and the source of our ideas for *Splash 3*.

Rachel R. Wolf

DEDICATED *to all of my remarkable friends in the watercolor world, too numerous to mention, whom I have had the privilege of working with in recent years.*

FAMILY HEIRLOOMS.
WILLIAM C. WRIGHT

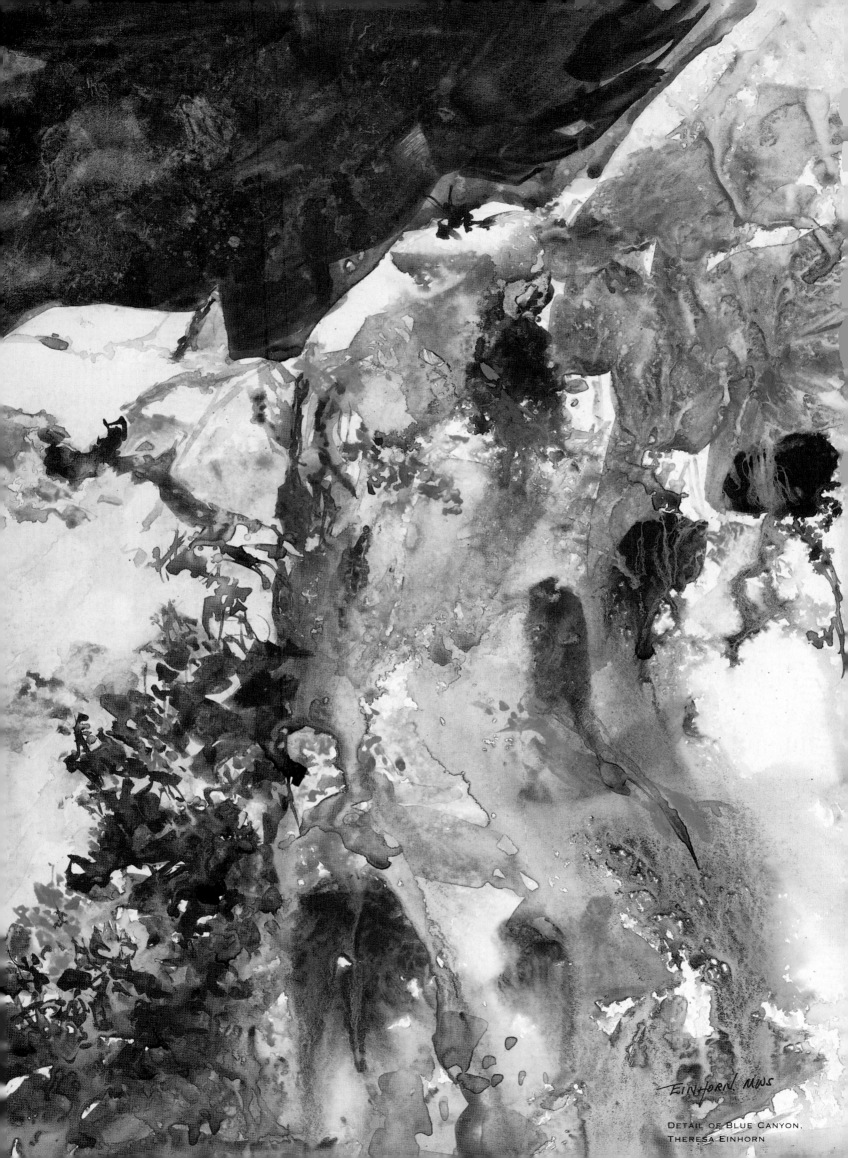

DETAIL OF BLUE CANYON.
THERESA EINHORN

ONLY THROUGH ART CAN WE GET OUTSIDE OF OURSELVES and know another's view of the universe which is not the same as ours and see landscapes which would otherwise have remained unknown to us. Thanks to art, instead of seeing a single world, our own, we see it multiply until we have before us as many worlds as there are original artists.

— *Marcel Proust*

ALLOW FOR THE JOY OF EXPLORATION

I intend for my paintings to reflect an enthusiastic response to the world around me—perhaps, more simply stated, a celebration of being. I attempt to communicate through the medium of paint a lively interpretation of my subject, endeavoring to capture its spirit.

 The foundation of my ideas is the result of being inspired by a particular shape, quality of light or arrangement of form. I am mindful to allow for the joy of exploration and discovery within the framework of each of my works. Paired with a love of painting is an incessant desire to express myself. My works represent the culmination of this combined love and internal stirring.

Tom Francesconi

IN BOTH **SECLUDED ENTRY** [BELOW] AND **NEW ENGLAND SUMMER** [LEFT], THE PERVADING INFLUENCE IS SUNLIGHT. IT WAS FULLY INTENDED THAT THESE COMPOSITIONS BE INFUSED WITH AN ABUNDANCE OF SHADOW TO ENSURE THAT THE LIGHT WOULD BE SPECIAL. AN ASSERTIVE HANDLING OF THE PIGMENT AND A BOLD USE OF COLOR COMBINE TO PRODUCE AN INTERPRETATION THAT IS LIVELY AND SPONTANEOUS.

SECLUDED ENTRY
TOM FRANCESCONI
19" x 26¾"

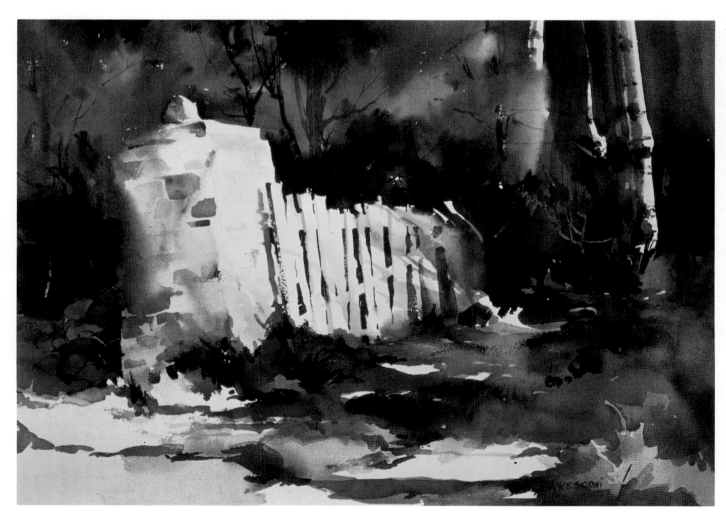

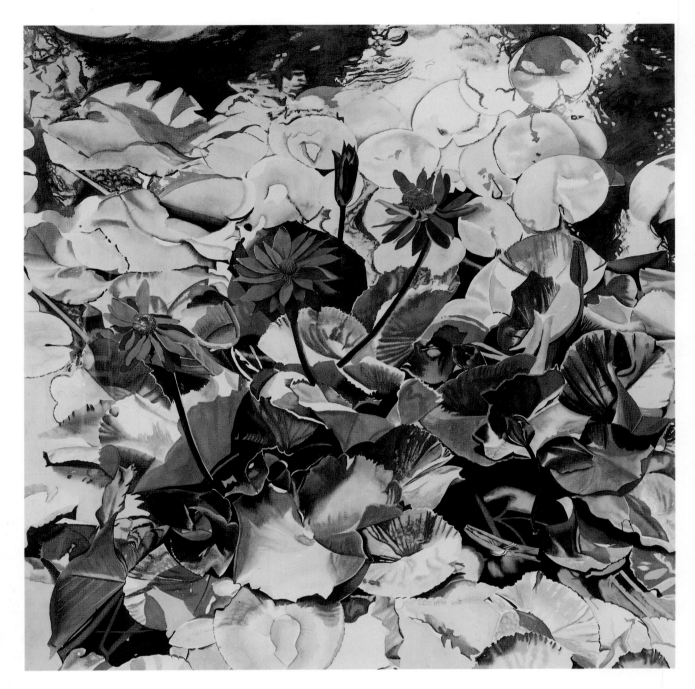

CAPTURE YOUR COLOR MEMORIES

I am inspired by experiences in nature that I term sensuous: the feeling of sheltering trees overhead, the translucence of leaves with sunlight coming through them, the awe of rock formations above and around me.

Color is the essence of my art. I begin a painting in the studio with my color memory and the desire to capture the radiant color I experienced. As I paint, color requirements dominate the process. I push my colors, trying to push the viewer to experience the nuances I discover. I have found that large paintings like *Waterlilies IV* need more "rest areas," since I use no mat on them. The light-colored lily pad shapes are the rest areas in this painting.

LeCrone Walston

WATERLILIES IV
DONA LeCRONE WALSTON
45" x 45"

WALSTON USES NO EARTH TONES; SHE FEELS THEY TEND TO MUDDY THE COLOR. EACH AREA OF THE PAINTING IS DONE TO NEAR COMPLETION BEFORE ANOTHER IS STARTED. SHE PAINTS ALLA PRIMA SO ALL HER COLORS GO ONTO WHITE PAPER FOR INTEGRITY AND SPARKLE. THE DARKS GO IN AS WALSTON COMES TO THEM; THEY HELP TO ESTABLISH THE VALUE SYSTEM. **WATERLILIES IV** TOOK ABOUT FIFTY HOURS PLUS DAYS OF CRITIQUE AS THE ARTIST OBSERVED THE PAINTING IN DIFFERENT LIGHTS AND IN THE MIRROR.

RECOGNIZE THE POSSIBILITIES

To be an artist is to recognize the possibilities found in everyday sights and scenes. I am especially attracted by certain conditions of lighting: reflections, sunbeams, shadows and refracted light. It is my intention to portray the mood as it was when I first encountered the subject, and that mood almost always depends on some quality of light. Many of my subjects are inspired by a paradox either real or imaginary: menace in the shadows on a bright, sunny day or turmoil on the other side of a door or window with an ordinary exterior.

Susan Morris McGee

QUIET RIOT
SUSAN MORRIS MCGEE
18" x 24"

SINCE MCGEE IS A TRANSPARENT WATERCOLORIST, SHE NEVER USES PIGMENT TO INDICATE WHITE OR LIGHT AREAS OF A PAINTING, PREFERRING TO LET THE WHITENESS OF THE PAPER SERVE THAT FUNCTION. HER INTENTION IN **QUIET RIOT** WAS TO USE A FORM OF POINTILLISM TO EXPRESS THE FEELING OF LIVING COLOR. BUT AS THE PAINTING PROGRESSED, A GRADUAL DELINEATION CREPT IN. TO ACHIEVE A SOFTENING EFFECT, SHE LIFTED (WITH A CLEAN, DAMP BRUSH) AND BLOTTED EVERY HARD EDGE THROUGHOUT. THE REMAINING SHARP CONTRASTS WERE A RESULT OF THE NUMEROUS AREAS LEFT UNPAINTED.

JUMP INTO THE RUSHING WATER

Watercolor and its application have become a moving force, directing and enriching my life. I have travelled all over the country taking in the beauty of our nation. Painting is an emotional response to nature and the scenes that inspire me. I use photo references only to spark my memory. I strive to create the essence of what I experience when a scene moves me. Painting ever-changing, rushing water is an exhilarating experience but an artistic challenge. I credit friend and teacher Irving Shapiro with helping me develop the tools and work up the courage to face that challenge.

Einhorn

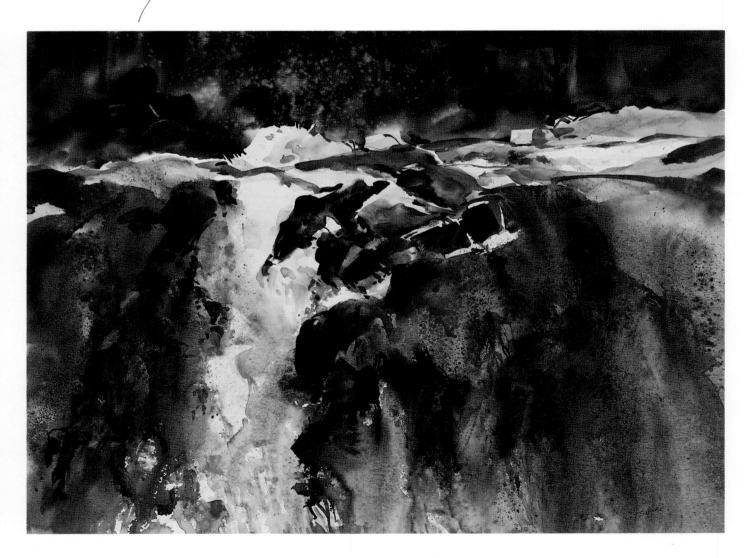

ROCK FALLS
THERESA R. EINHORN
14" x 18"

EINHORN BEGINS WITH A ROUGH VALUE SKETCH AND THEN PUTS ALL PHOTO REFERENCES ASIDE. SHE AIMS FOR A DYNAMIC PATTERN OF LIGHTS AND STRONG DARKS. THE WHITES ARE ESSENTIAL TO THE FINAL BRILLIANCE OF THE PAINTING. SHE USES EITHER PAPER OR BOARD, DEPENDING ON HER RESPONSE TO A PARTICULAR IMAGE. USING BOARD ENABLES HER TO PUT THE COLORS DOWN QUICKLY AND DIRECTLY.

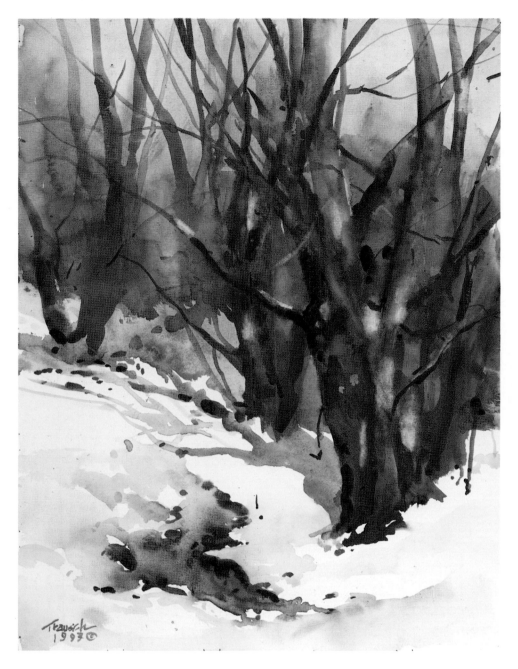

SHAGBARK
THOMAS J. TRAUSCH
22" x 15"

SHAGBARK IS A VERY DIRECT
PAINTING EMPHASIZING WARMS AND
COOLS. IT WAS PAINTED WET-INTO-
WET, WITH FORMS LATER CLARIFIED
ON DRY PAPER OR LIFTED OUT WITH A
BRUSH FOR MODELING.

IMPART A SPIRITUAL QUALITY WITH LIGHT

Sometime last year, my work took a positive change. With a combination of reading and study-ing plein air painting, I began to concentrate in a new way on light—what light and atmosphere do to objects, to the landscape—how it models form and the mood it creates. The pursuit of this became of paramount importance to me. Subject matter began to take a backseat to the effects of light.

Light, I believe, can impart a spiritual quality. Light represents energy and life. Light—how it alters form, edges and atmosphere—can be a subject one can pursue for a life-time. *Shagbark* is a scene that appealed to my daughter and me as we took a Sunday walk during the last snowfall of the season. There is a "dance" to the trees and creek that I like.

Thomas Trausch

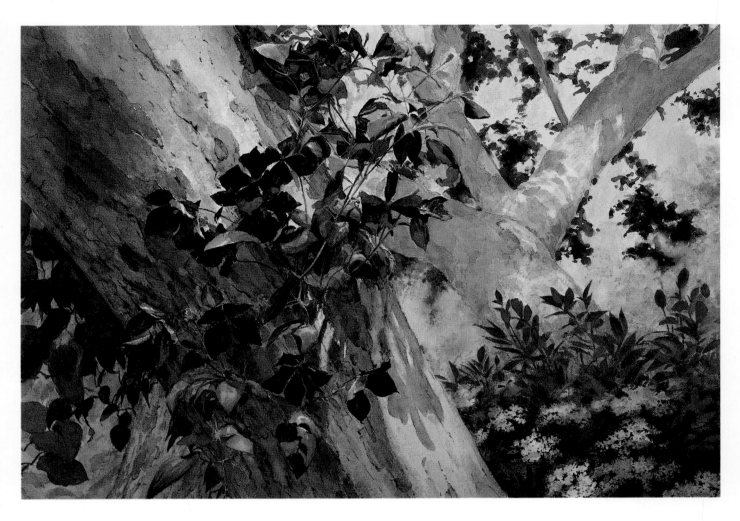

AN ENDLESS SUPPLY OF PATTERN AND TEXTURE

I am fascinated with what happens to light as it falls on my subject. I am constantly surprised and delighted by the changing combinations and patterns that the natural world presents to me. It is a boundless source of richness for my paintings. I start with objects, but they soon reveal the spirit that binds the whole assemblage into one image. I want to paint as though my technique were invisible. I want my effort to be in the form and texture created by light, not brushstrokes.

My current painting is largely based on travels in Arizona, where I find an abundant supply of color and form from which to choose. I came upon the subject for *Clematis* in a grove, in a desert. A sycamore was awash with a garland of purple flowers. Perfect watercolor serendipity.

CLEMATIS
BILL HARVEY
14½" x 20½"

BECAUSE OF THE REMOTENESS OF THE SITE AND THE DETAIL INVOLVED IN **CLEMATIS**, HARVEY CREATED THIS PAINTING IN THE STUDIO FROM HIS SLIDES OF THE SYCAMORE GROVE. HE ESTABLISHED THE VALUE RELATIONSHIPS WITH A LIGHT WASH OF THALO VIOLET AND WINSOR GREEN, THEN GRADUALLY LAYERED WASHES TO CREATE THE COLORS AND VALUES.

SUBJECTS CHOOSE ME

Deciding what to paint has never been a concern for me because I am surrounded by more than I will ever be able to use. I feel that my subjects choose me rather than my choosing them. Objects and places that I have taken for granted as part of my immediate environment or daily routine take on new meaning when I least expect it. When something captures my imagination, it's like a seed planted in my mind that develops gradually until the painting takes form. It could be anywhere from a few days to a few months before the actual painting is started. Because of this process my work is a composite of elements rather than an accurate rendering of a specific object or place.

BAND USES A COMBINATION OF TRANSPARENT AND OPAQUE WATER-COLOR TO DEVELOP COMPOSITIONS AND STRENGTHEN SUBJECT FORMS. HE ACHIEVES FINE DETAIL AND HIGH-LIGHTS BY LIFTING COLOR RATHER THAN USING A MASKING TECHNIQUE. ONCE THE COLOR HAS BEEN LIFTED, HE THEN OVERPAINTS WITH LIGHT OPAQUES FOR THE DESIRED CON-TRAST.

David M. Band

SUNSET, STRATTON
DAVID BAND
20" x 21"

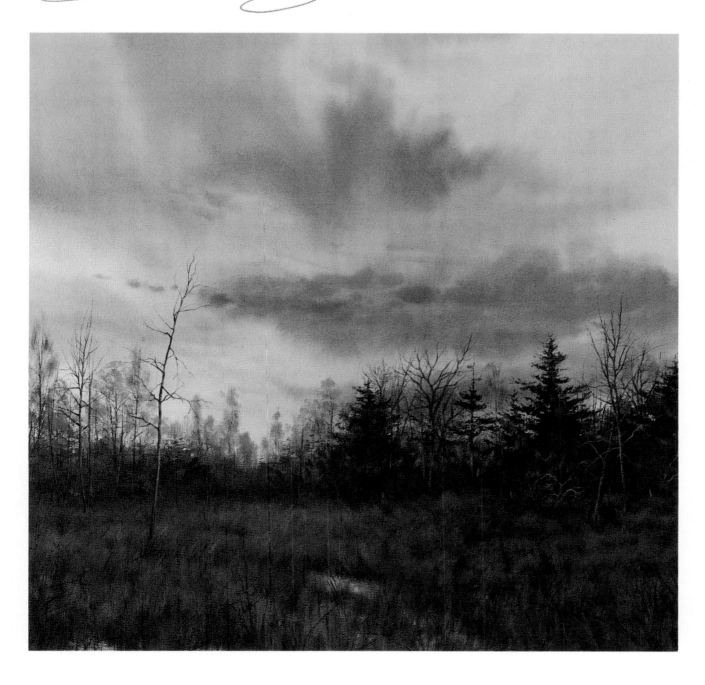

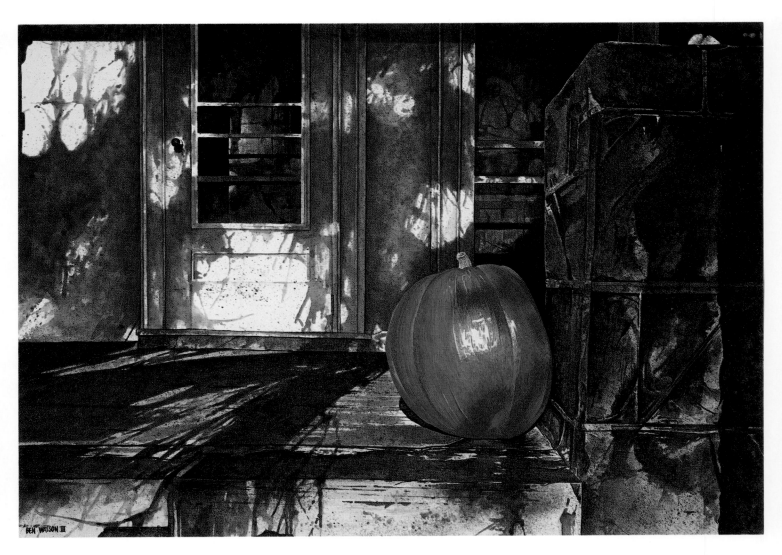

THE RIGHT PLACE AT THE RIGHT TIME

Life is a constant inspiration for me as an artist. The people, places and things I know best form a connection between my subject and myself. I never really plan a painting ahead of time; it's a case of being in the right place at the right time.

On October 1, 1992, as I approached the front of this house, I was taken by this image and knew I had to paint it. The warm afternoon sun and the shadows seemed to splash themselves onto the porch.

Being a realistic artist, I don't create the things that inspire me; I recreate them to appear as I experienced them in the first place.

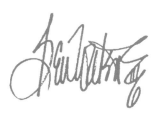

OCTOBER
BEN WATSON III
17½" x 21½"

TO RECAPTURE THE MOOD THAT INSPIRED THIS PAINTING, WATSON FIRST DID WARM WASHES OF RAW UMBER, BURNT UMBER AND ULTRAMARINE BLUE. TO GIVE THE ODD-SHAPED PUMPKIN A LOOK TO SET IT APART, HE USED SMALL DRY-BRUSH STROKES TO RENDER ITS SHAPE AND TEXTURES. THE COMBINATION OF THESE TWO TECHNIQUES HELPED GIVE THE PAINTING THE REALISTIC IMAGE THE ARTIST WANTED.

START ANEW EACH TIME YOU PAINT

I love color. A visit to the grocery store is a treat—all those beautiful fruits and vegetables! A field of flowers, the shape of a tree, a close-up view of a tangled mass of greenery, scenes on a misty morning, an ice storm, shadows and sunlight patterns, the colors in a piece of fabric, viewing an art exhibit—all these can inspire me.

I am not an outdoor painter. I take photographs of things that interest me, then paint in the studio. Most of the time I combine several photos to come up with a composition I like. I do not paint by a formula, except that I usually work from light to dark. Each painting is like starting anew.

Sunlight on My Tallow Tree is an effort to capture the beauty of my Chinese tallow tree in the fall. It has spectacular foliage along with big, white seeds and pods that remain on the tree for some time.

Joyce Ward

SUNLIGHT ON MY TALLOW
TREE
JOYCE WARD
21" x 29"

IN THIS PAINTING THE ARTIST KEPT
THE LEAF, SEED AND POD SHAPES AS
SIMPLE AS POSSIBLE AND CONCEN-
TRATED ON COLOR. WARD DOES A
LOT OF GLAZING TO ENHANCE AND
SUBTLY CHANGE HER COLORS.

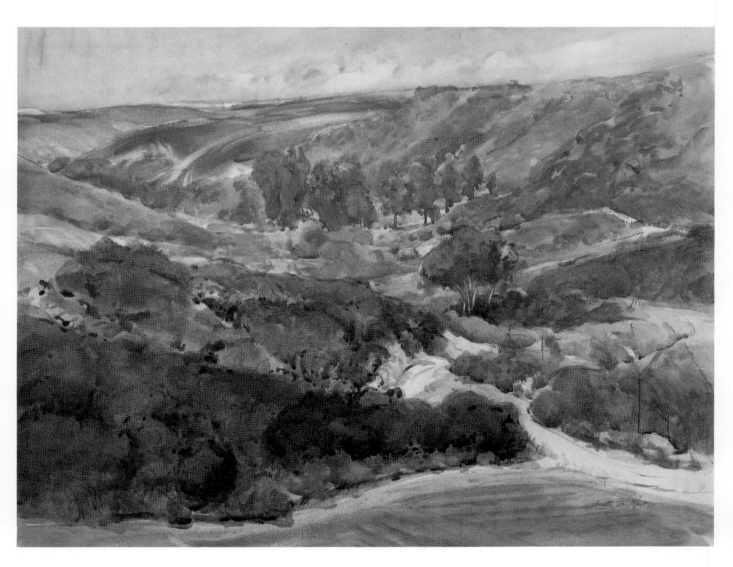

FIND POETRY IN THE LAND

I work mostly from nature on location—a source I find exciting and inspirational. Then, through selection and emphasis, I try to put down on paper the essence, a simplification, an idea of what I feel. It may be the way sunlight is falling, or certain colors that create a mood . . . perhaps the rhythms of nature . . . or the fascinating shapes of things in relation to one another.

Currently my work involves the land . . . the land about me as it is now, its character, its simple beauty and poetry, the ever-changing scene in light, time and seasons, humanity's impact on it, and especially the idea of the land's fragility.

In this painting, the exaggerated color expresses the idea of an exposed and vulnerable land, as in the orange shape of the land scraped bare of foliage, and in the reds of the stressed eucalyptus tree. The strong light and dark contrasts of the road and foreground bushes plus the strong diagonals create rhythm and movement in a land alive with new growth.

"CUT UPS" OR NOT MUCH LONGER
ANNETTE LOTUSO PAQUET
19½" X 27½"

PAQUET'S BRUSHWORK IS DIRECT, ALLA PRIMA, LOOSE YET DESCRIPTIVE OF THE FLOW AND CHARACTER OF A LAND IN TRANSITION. SOME COLOR WAS PREMIXED, AND SOME WAS MIXED ON THE PAPER. ONCE THE PAINTING WAS DRY, A FEW GLAZES WERE ADDED TO HEIGHTEN THE COLORS' IMPACT, AS IN THE SMALLER PIECE OF RED ON THE UNDERSIDE OF THE EUCALYPTUS TREE PLAYED AGAINST THE LARGER AREAS OF DULLER GREENS.

Annette Lotuso Paquet

THE JOY OF PLEIN AIR PAINTING

For many years I wasn't sure of my direction or what my "style" was or if I even had one. I experimented with ideas and what I thought would please others. Then I discovered my love of painting plein air, and now I paint for myself. My inspiration is what I see in real life. I enjoy all kinds of subject matter, but I always look for strong contrasts, color and texture. I first do a small compositional sketch, then work vertically on dry, unstretched paper. I seldom draw detail on the watercolor paper but let the color and area washes determine the need for detail. This keeps me looking at the subject.

I find that the limited time, lack of comfort, and changing light and shadows outdoors make me work faster and keep looser. The scene where I painted *Sacred Mountain* started out to be a sunny day but the skies soon turned threatening. I adapted the painting to the changing conditions.

De Loyht-Arendt

DE LOYHT-ARENDT WORKS VERTICAL-LY ON A FRENCH EASEL, USUALLY ON LOCATION. SHE WORKS ON DRY PAPER, NOT STRETCHING OR WETTING IT FIRST. HER INITIAL SKETCH IS MIN-IMAL BECAUSE SHE DOESN'T FEEL SHE HAS THE LUXURY OF TIME TO DO AN INTRICATE DRAWING AND BECAUSE SHE'S ALWAYS EAGER TO START PAINTING. HOWEVER, SHE DOES A COMPOSITIONAL SKETCH TO VISUAL-IZE THE FINISHED PAINTING.

SACRED MOUNTAIN
MARY DE LOYHT-ARENDT
22" x 30"

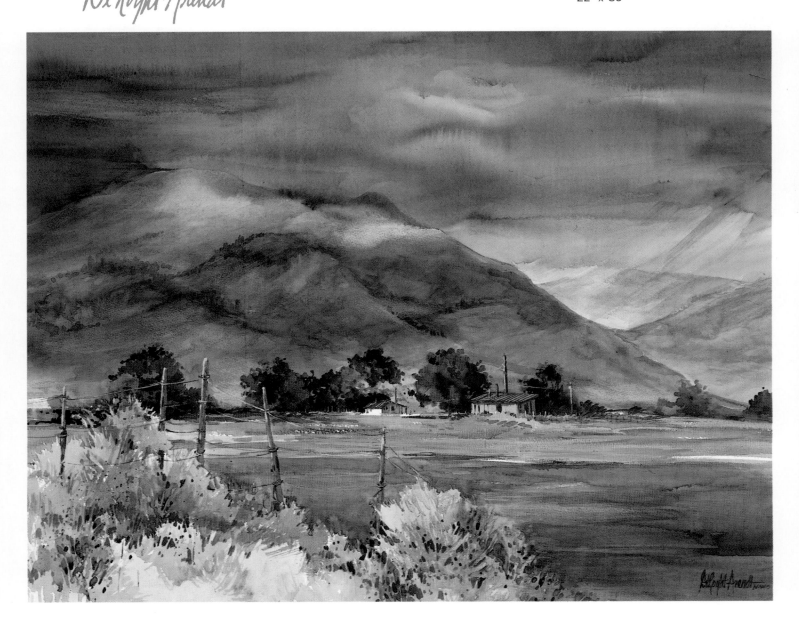

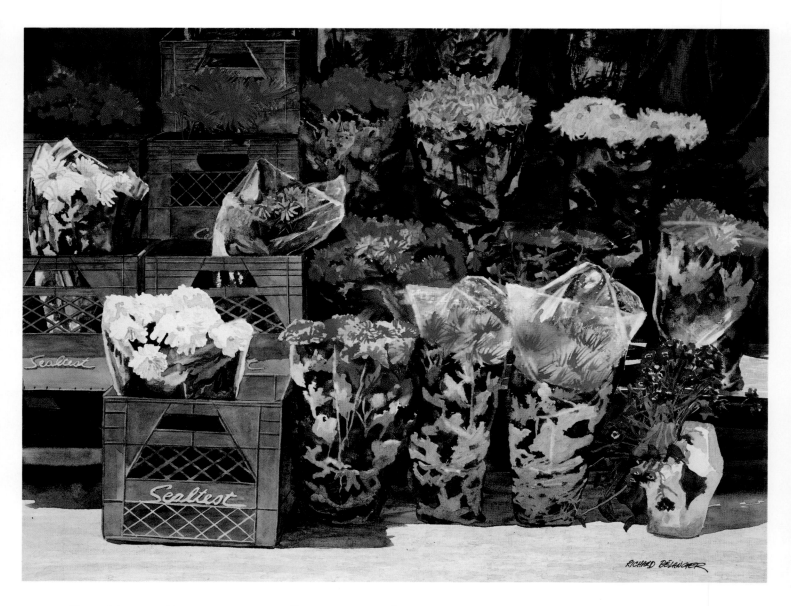

SEE YOUR SUBJECT IN A DIFFERENT LIGHT

The selection of subject matter to be translated into a watercolor painting may simply be triggered by an interesting pattern of light hitting a surface or by interesting shapes. I have always been fascinated by the way Renaissance painters made dynamic use of light and shadow.

Sometimes I stimulate the creative process by working on a theme. Sometimes I go to a location with a diverse display of subject matter to study it in depth, or to choose one object and try to work it into a balanced composition. In the case of *Depanneur, N.D.G.*, I was looking for a subject for a floral painting competition. Instead of setting up a classic still life with flowers in a vase, I decided to use this corner-store display.

DEPANNEUR N.D.G.
RICHARD BELANGER
15" x 20"

BELANGER STARTED BY MASKING THE FLOWERS WITH LIQUID FRISKET SO HE COULD RENDER THE BACKGROUND BY SCRUBBING PAINT AROUND, CREATING DIFFERENT TEXTURES. THERE WERE SEVERAL TECHNIQUES USED HERE, INCLUDING LIFTING, SPATTERING AND GLAZING. THE FIRST ROW OF FLOWERS WAS DONE IN BRILLIANT COLORS SO THEY'D COME FORWARD.

DESERT SHADOWS SPARK THE CREATIVE SPIRIT

All my paintings are direct responses to my environment. I can drive through the country-side or go for a walk and observe something that sparks the creative spirit. The image before me does not have to be dramatic; an intimate view of wildflowers gets the same attention as a spectacular sunset. I want to give the viewer the sense of having just left the scene I've depicted, or of experiencing the image for the first time.

This painting was inspired by many trips to Taos, New Mexico. I was especially drawn to the colorful desert shadows as well as the strong sense of movement and depth created by the composition.

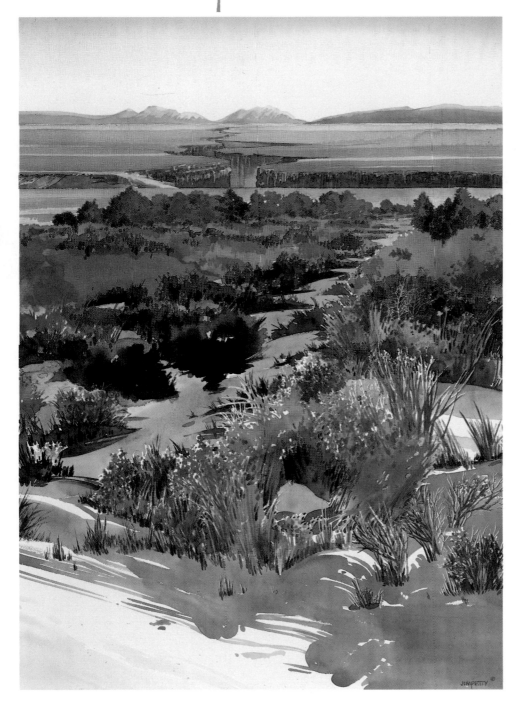

TAOS GORGE
JIM PETTY
27" x 20"

PETTY WORKS FROM A LIGHT,
DETAILED DRAWING THAT IS DIRECTLY
DRAWN ON THE PAPER. HE FIRST
LAYS DOWN THE LIGHTER COLORS,
YELLOW AND GREEN, THEN THE BLUE
SHADOWS, AND FINALLY THE DARKER
SHADOWS. AFTER ESTABLISHING
THESE COLORS AND SEEING THAT THE
COMPOSITION WORKS, HE ADDS THE
DETAILS.

CHAPTER 2

Enthralled With Paint, Water and Paper

WHEN WATER *sends that captivating color across the paper it inspires me, enlivens me.*

—*Carol P. Surface*

THE NATURE OF WATERCOLOR ITSELF is inspiring to many artists. Its unpredictability, its sensuousness, the textures it seems to make of its own accord, and its legendary luminosity are some of the qualities often lauded.

LIZARD RUN #8
SUE ARCHER
29" x 41"

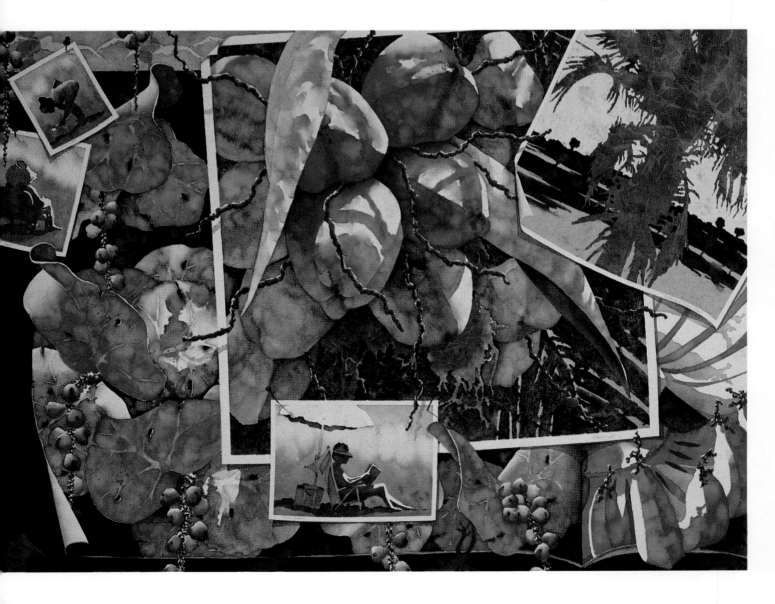

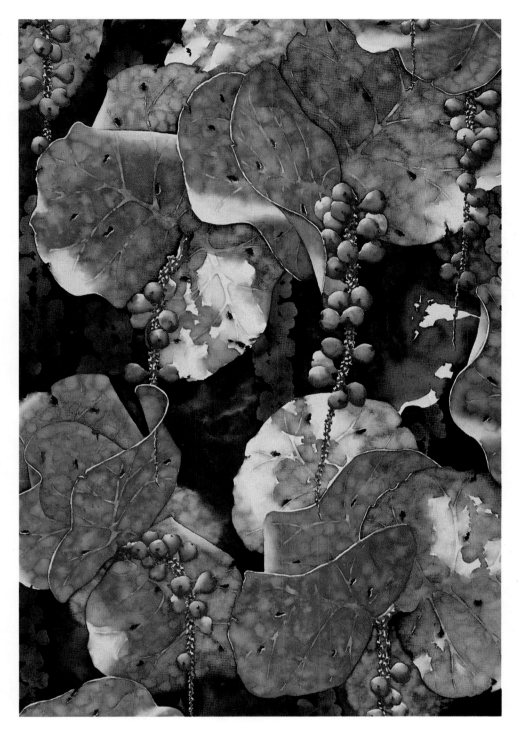

CHALLENGE YOURSELF WITH NEW PROBLEMS TO SOLVE

Ideas for my single image paintings come from working with close-up images. They are planned around intricate white shapes, which indicate strong light and shadow.

I recently began a series of multiple image paintings as a challenge to myself. Contrast was my objective. I presented myself with many problems to solve. These included contrasting past artists with contemporary images, flat/shallow areas with deep depth, different textural images, different viewpoints, rectangular versus organic shapes, painterly versus trompe l'oeil techniques. The subjects for the "multiples" came from the tropical imagery I was already using in my watercolors. Each image was first done as an individual painting, but putting several images together was the challenge.

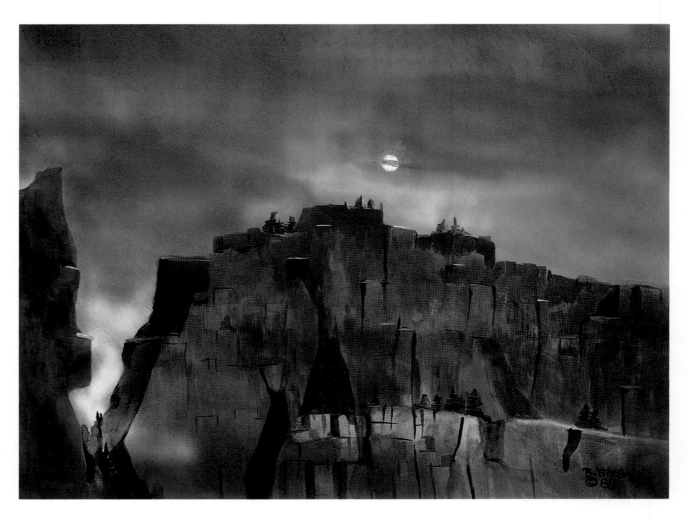

TRY PAINTING "OUTSIDE IN"

I mainly paint with two different approaches—one from "inside out" and the other from "outside in." The former is when a painting is planned from the outset; the latter is when I don't have a preconceived plan. Although more challenging and fun to do, this "outside in" mode is more difficult in that I don't even know what the subject matter will be. My paints are thrown or spattered on semiwet paper or board; the paper is moved about in various directions and water is sprayed to help move the paint.

This abstract manner eventually leads to a representational subject. Shapes and forms begin to appear and be identified as negative or positive shapes. I believe if you let your intuitive self take hold in the beginning of a work, a very beautiful "happening" might emerge. You can then use your intellectual self to refine where necessary.

A trip to the Grand Canyon must have unconsciously influenced *Canyon Fantasy*, but I began with no preconceived plan. I took my airbrush and just started spraying colors. Lo and behold—the Grand Canyon.

Barbara L. Siegal

CANYON FANTASY
BARBARA L. SIEGAL
22" x 30"

SIEGAL USED AN AIRBRUSH TO RANDOMLY SPRAY WATERCOLORS ON ILLUSTRATION BOARD, FILLING IT WITH BOLD HUES AND INTENSITIES. SHE TURNED THE PAINTING IN DIFFERENT DIRECTIONS UNTIL SHE "DISCOVERED" THE SUBJECT MATTER—A CANYON FORMATION. SHE THEN REFINED THE IMAGE WITH HER BRUSH, PUTTING IN CREVICES, ADDING A MOON, AND LIGHTENING AND DARKENING WHERE IT SEEMED APPROPRIATE.

USE UNPREDICTABLE MATERIALS

Dardanelle Blasted was composed from a photo of a bridge construction site with concrete slabs, rock walls and pooled water forming the basic shapes, which were executed with paper and plastic resists and manipulated inks.

I love the printmaking aspect of using resists and transferring shapes with things such as manipulated cloth and threads, leaves, plastics, mosses, etc. Many natural materials lend themselves well to producing images that may or may not resemble the original. This unpredictability leads to many new ideas that can then be further resolved with each new application of paint. Many of my paintings develop from the basics of color and composition, which are then manipulated with diverse materials along with watercolors, dyes and inks.

I have begun to use some mica overlays on some of my paintings, which give them more depth and variation of color as well as reflective value. This natural mineral has always intrigued me. As a child, I spent hours peeling the layers apart, fascinated with the shapes and transparency.

THE BASIC SHAPES WERE FORMED BY CUTTING PLASTIC WRAP, HEAVY GAUGE PLASTIC AND WAX PAPER PIECES, AND LAYING THEM ON WET WATERCOLOR PAPER. PRAHL THEN FLOWED INK UNDER THE SHAPES WITH MORE WATER TO DELINEATE THE FIRST EDGES. AFTER DRYING AND LIFTING THE PIECES, EACH SECTION WAS GIVEN ONE OR MORE LAYERS OF INKS UNDER A VARIETY OF WEIGHTS OF PLASTIC, AND THEN DRIED. PRAHL USED LUMA PEARLESCENT INK TO HIGHLIGHT SOME AREAS, AND HER LAST STEP WAS DRAWING IN A FEW LINEAR DARKS WITH A SMALL BRUSH.

Susan Prahl

DARDANELLE BLASTED
SUSAN PRAHL
12" x 18"

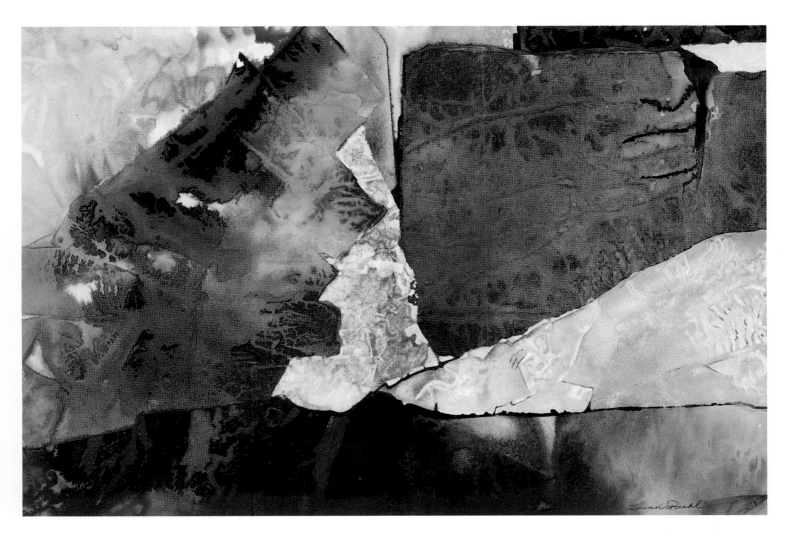

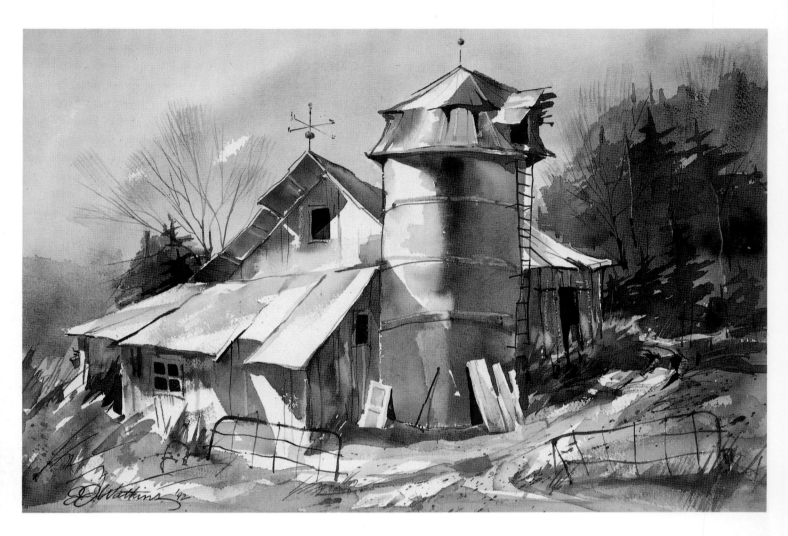

A GREAT MEDIUM FOR SPONTANEITY

The nature of watercolor itself is inspiring to me—the mixing of water and color, the way it can be controlled on the paper. The textures and techniques that have been developed by so many artists today have helped capture some of the fleeting inspirations that come our way. Watercolor is a great medium for interpreting an idea spontaneously.

Just as a thunderstorm or a passing rain may cause an intense response, a tranquil sun-lit setting may help me quietly formulate an idea—to work out something from an everyday experience. Light, shadow, and their effects on shapes and colors are often so eye-catching that I record them in a sketch that can spark interest later and see me through to a finished painting.

When I need to "loosen up" or gain a new perspective, I let things happen spontaneously on the paper. Watercolor offers us, as artists, an inspired approach to the age-old process of making paintings sing.

EVER GREEN
JEFFREY J. WATKINS
15" x 22"

FOR **EVER GREEN**, WATKINS USED A LIMITED PALETTE OF FOUR COLORS TO CREATE A DRAMATIC LIGHT SOURCE ON AN OLD BARN, AND TO HELP ISOLATE THE GREENS OF THE ROOF AND THE PINES IN BACK AGAINST THE NEUTRALS THAT DOMINATE.

HAVE FUN WITH WATERCOLOR'S VERSATILITY

I am inspired to paint by the versatility and spontaneity of watercolors. The subjects I use are wildlife, but the fun of painting is technique: loose opposite tight, texture versus wash, light against dark. I try to give viewers the ability to read into the painting what they want— to see texture or to focus on detail. Composition is critical to the success of my paintings. Avoiding the blatantly obvious, I use objects and texture to direct the eye to a focal point.

In essence, I would like to feel I am a portrait painter of nature, using washes, values and texture to depict a subject without rendering every detail.

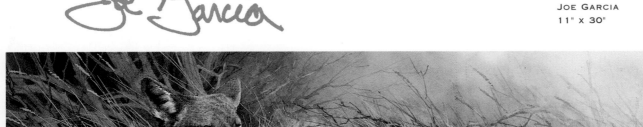

IN CREATING A PAINTING SUCH AS **COYOTE: BREAK TIME**, GARCIA COMPLETES THE MAIN SUBJECT FIRST, THEN PAINTS THE BACK-GROUND AROUND IT. HE DOES A VERY WET-INTO-WET BACKGROUND PAINT-ING UP TO THE EDGE OF THE SUB-JECT. WHERE THE BACKGROUND HAS BLED INTO THE SUBJECT, HE USES A LIFTING TECHNIQUE TO SOFTEN THE EDGES. HE DOES NOT USE A RESIST OR MASKING AGENT ON THE SUBJECT.

COYOTE: BREAK TIME
JOE GARCIA
11" x 30"

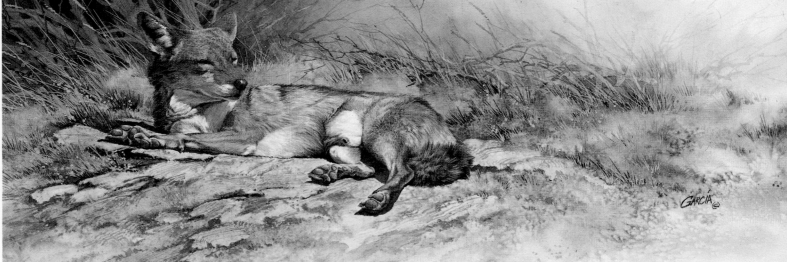

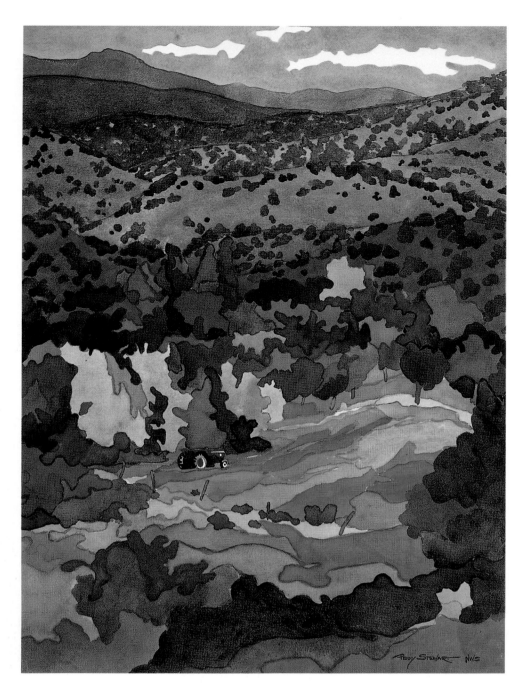

NEW MEXICO PUZZLE
PIECES: DIXON #1
PENNY STEWART
30" X 22"

STEWART PREPARES THE PAPER
USING EXTRA SIZING TO MORE EASILY
LIFT PIGMENT TO CHANGE SHAPES OR
COLORS DURING THE PAINTING
PROCESS. ON LOCATION, SHE MAKES
A QUICK PENCIL SKETCH TO WORK
OUT A COMPOSITION OF VARIED
SHAPES RELATED TO A PARTICULAR
THEME OR PATTERN OF MOVEMENT.
STARTING AT THE CENTER OF INTER-
EST AND WORKING OUTWARD SO
EVERYTHING RELATES, SHE KEEPS
THE LIGHTEST LIGHT, THE BRIGHTEST
BRIGHT, AND THE MOST INTERESTING
SHAPES NEAR THE FOCAL POINT.

FRUSTRATION GIVES BIRTH TO A NEW TECHNIQUE

The setting was a watercolor workshop in Taos, New Mexico. Our task was to complete on-site landscape paintings in two or three hours, and I was struggling with my traditional style. After three days, I was awash in failure and frustration. Wednesday afternoon our instructor took us to a new location: a beautiful vista of fields, fences and farm life, adobe dwellings and distant mountains. I was horrified. How could I possibly paint this scene in two hours?

Suddenly, I was inspired to paint a portion of what was before me using only flat shapes, attempting to capture the unique design and richness of color. During the evening critique, one friend whispered to another, "Penny's painting looks like pieces of a puzzle."

I liked that characterization of my new style. It was well received and it was fun. The idea of painting landscapes in this way electrified me.

Responding to my intuition, I try to reveal the essence of my experience using simple, flat forms. By painting translucent against opaque, bright against dull and light against dark, I create for my viewer the special light, color and texture of that place.

Penny Stewart

ENJOY EVERY ASPECT OF THE PAINTING PROCESS

Painting in transparent watercolor for me is striking a balance between manipulating and guiding the colors. While I'm fascinated by what watercolor paint does of its own accord, I also feel driven to record moments that attract my soul. But I want even these realistic compositions, on closer examination, to fall apart into abstract elements or illusionary passages of loosely held runs, drips and textures. I enjoy creating dimension and depth by using high-contrast value structures. The painting process itself inspires and motivates me.

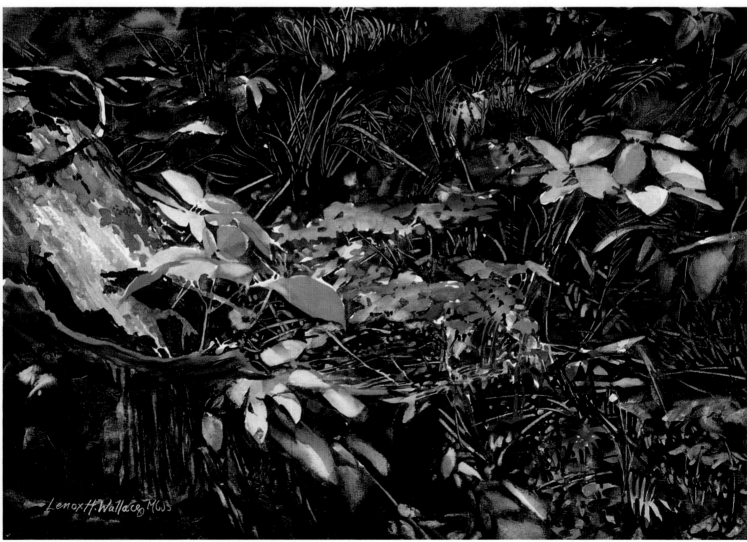

UNDERBRUSH
LENOX H. WALLACE
14½" x 19½"

WALLACE DID A LIGHT SKETCH FROM A PHOTOGRAPH, BUT MUCH COMPOSING OCCURRED DURING THE PAINTING PROCESS. AREAS OF LIGHT, PURE COLOR WERE PAINTED, IN PREPARATION FOR LATER OVERLAYS AND SCRAPING. ONLY THE SIGNATURE WAS MASKED. THE ARTIST USED A VARIETY OF COLOR COMBINATIONS IN THE DARKS, IN ANTICIPATION THAT THE STRONGEST STAINING COLOR IN EACH MIX WOULD LATER BE REVEALED, ALONG WITH THE PREVIOUS LIGHT WASHES, THROUGH SCRAPING. AS THE DARKS WERE DRYING, WELL-TIMED SCRAPES OF A BRUSH HANDLE DEFINED MANY OF THE LEAFY, PATTERNED AREAS. OTHER SECTIONS OF VEGETATION WERE NEGATIVELY PAINTED TO MIMIC THE CHARACTER OF SCRAPED LINES AND SHAPES.

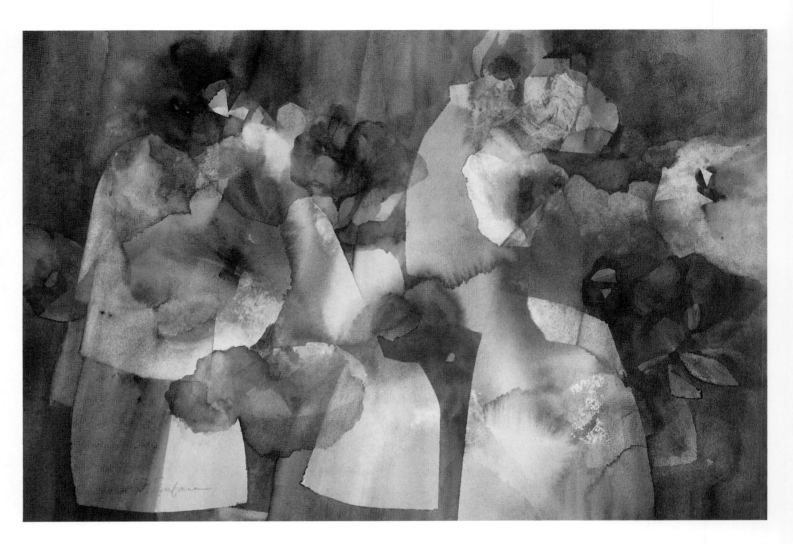

WATER MIRRORS THE FLOWING QUALITY OF LIFE

AFTERNOON DELIGHT
CAROL P. SURFACE
14" x 21"

Without water there would be no watercolor painting. Water's kinetic energy mirrors the flowing quality of life—indeed, without it there would be no life. When water sends that captivating color across the paper it inspires me, enlivens me. Water gives watercolor its life, but it is the artist's hand that fosters its growth.

Pouring watercolor on paper stimulates me to wrest from my subconscious the images that reflect my spirit. An impassioned painting session pursued in the name of adventure and spontaneity marks the first stage of my paintings. As I mist and tilt my paper, I let one stroke direct the next; my eyes and my brush search for appealing images. I react to the piece until it speaks to me, then I put it aside for another day.

Next, the soul-searching begins. I study the painting and ask, What am I trying to say? When I discern some concept, I then decide on its development. For me, watercolor is an enlightening journey filled with adventure and discovery.

AFTERNOON DELIGHT BEGAN WITH THE IDEA OF "POURING" FLOWERS. SURFACE WAS DELIGHTED WHEN ALL HER LIFTING AND MISTING REVEALED TRANSPARENT "VASES" THAT SEEMED TO MELD IN THE LIGHT. TO STRENGTHEN THE CONCEPT OF FLOWERS AND VASES, SURFACE CREATED SHIFTING PLANES AND PLAYED HARD EDGES AGAINST SOFT. SHE USED WAX PAPER SHAPES AS A RESIST TO ADD DEPTH.

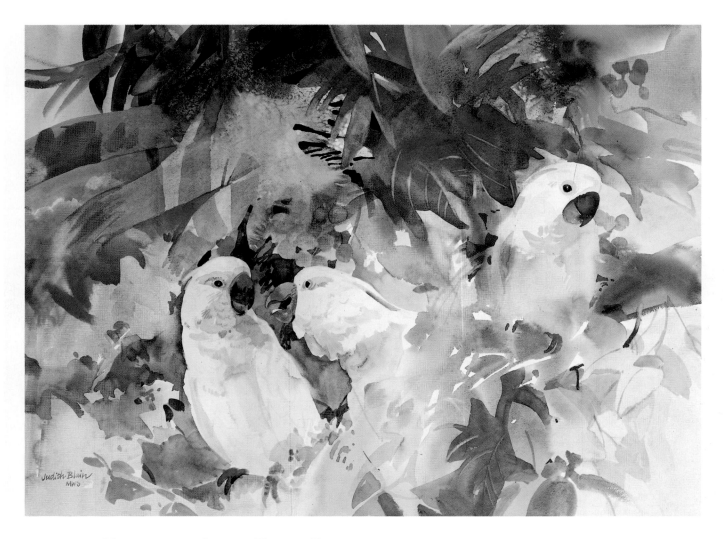

LURE YOURSELF AWAY FROM REALISM

Like many watercolorists, my inspiration comes primarily from the natural world with its lights and shadows, wonderful colors, and unusual viewpoints. For many years, as I practiced and learned, capturing the subject exactly was all-important.

Now I know that technical expertise isn't the end, but rather the beginning. Suddenly, subject matter is only a starting point. Sometimes I lure myself step by step away from realism. I change the color scheme, or the paper, or even the shape of the paper. At other times I plunge, almost giddy, into the watercolor, taking the chance that I can pull it off at the end.

This method of working gives me a great sense of freedom, but it's also much harder than simply painting what I see and sometimes isn't a very comfortable way to work. By putting concept first, however, I can concentrate on good design.

I had to smile when I read the definition of inspiration in this book: "the act or power of moving the spirit...." In my case, it's more like the carrot and the stick. There is a certain perversity or stubbornness that keeps poking me on beyond my comfort level. Fortunately, sometimes there is that wonderful carrot, an unexpectedly gorgeous painting!

HEADS, YOU ASK HER,
TAILS I DO
JUDITH BLAIN
22" x 30"

HEADS, YOU ASK HER,
TAILS I DO EVOLVED FROM AN
ABSTRACT UNDERPAINTING. BLAIN
CREATED THE THREE WHITE BIRDS BY
PAINTING DARK VALUES AROUND
THEM, WITH JUST ENOUGH DETAIL TO
EXPLAIN THE SUBJECT WITHOUT LOS-
ING THE ABSTRACT QUALITY.

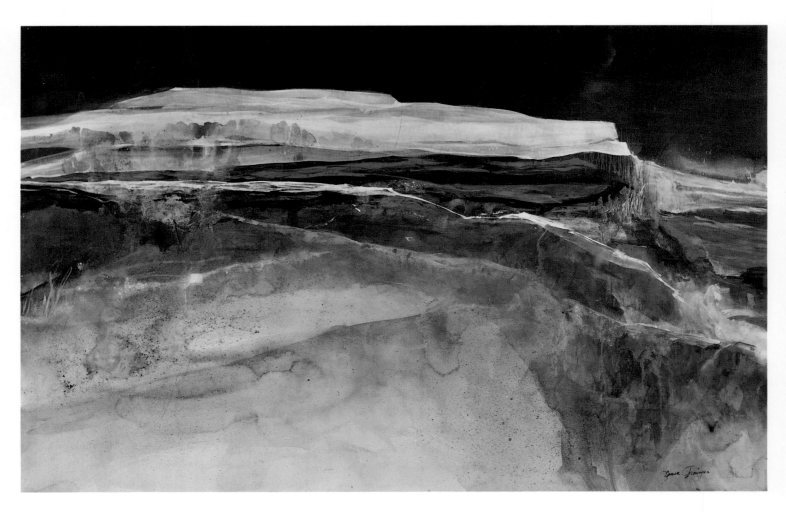

ABSTRACT IMAGES EXPRESS FEELINGS

Having enjoyed the benefits of a classical art education, my early paintings were traditional and representational watercolors. But after a number of years, the need for something new led me to abstract watercolors, to which I later added collage for texture and depth. The deeply moving landscapes of the Southwest have brought me to my current semi-abstract landscapes. I respond to the great openness and the rugged contrasts, which suggest their original unspoiled purity.

In these recent works I try to express that which I have seen and felt and that which I have always imagined.

Nessa Grainger

LANDLOCKED
NESSA GRAINGER
25" x 39"

TO SUGGEST THE RICHNESS OF THE LAND, GRAINGER COMBINED ON HOT-PRESS PAPER TRANSPARENT AND OPAQUE WATERCOLORS, ACRYLICS AND INKS—ALL IN STRONG, RICH, EARTH TONES. SHE FIRST APPLIED TRANSPARENT WATERCOLOR AS A BASE AND COVERED IT OVER WITH LAYERS OF OPAQUE WATERCOLOR AND ACRYLICS, WHICH SHE WIPED, SCRAPED AND BLOTTED TO REVEAL THE TRANSPARENT WATERCOLOR UNDERNEATH. SHE LEFT LARGE WHITE SPACES TO INTERPLAY WITH THE DARKENED SKY AND CREATED ADDITIONAL TEXTURES WITH PENCIL AND SPATTERING.

KEEPING A LIST FOR SUCCESS

New England is my inspiration. From that starting point I keep a list I call *The Whys and Hows List for Success*. The items on this list have been the prelude for my paintings, workshops and demonstrations.

My "whys" list includes the aroma of the area, the unusual coloring of the day, the memories or the anticipation of the subject, and the excitement of the moment. If I'm not excited, my painting will be uninspired, too. One of the listed ideas will become the title of the painting, which I place on the edge of the paper.

My "hows" list calms the panic of the white paper. A listing of four or five painting steps is all that is necessary to get me started. One . . . two . . . three . . . four . . . forward, march. The painting falls right in step with my brush. Over the years I noted which step was most enjoyable and successful, and it was not necessarily the same step each time. This led to the development of my technique.

Ruth Wynn

SUMMER HOME WAS PAINTED FROM A TRIAD OF COLORS: NAPLES YELLOW, CERULEAN BLUE AND CADMIUM SCARLET. THIS COMBINATION INCLUDES A FLOATING RED, A SINKING BLUE AND, FOR DEPTH, NAPLES. WYNN SPRAYED THE BACKGROUND AND DROPPED THE TRIAD WASH FROM A SQUEEZED BRUSH ONTO THE WATER, MAKING A TRANSPARENT BACKGROUND. SHE THICKENED THE WASH WITH MORE PIGMENT, DROPPED IT ON THE PLOW, AND TILTED. WHEN DRY, THE WHITES WERE LIFTED ON THE STRAWS AND OTHER AREAS. THE SHADOWS AND THE RUSTY DARK ACCENTS WERE ADDED NEXT.

SUMMER HOME
RUTH WYNN
15" x 20"

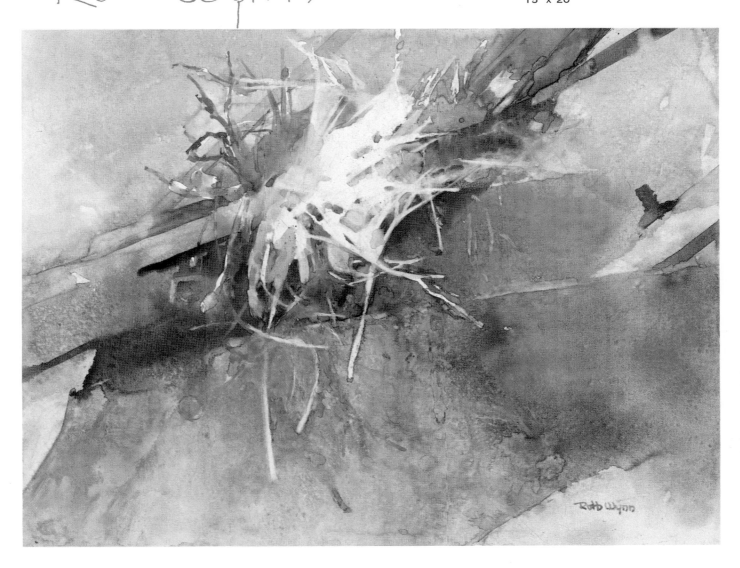

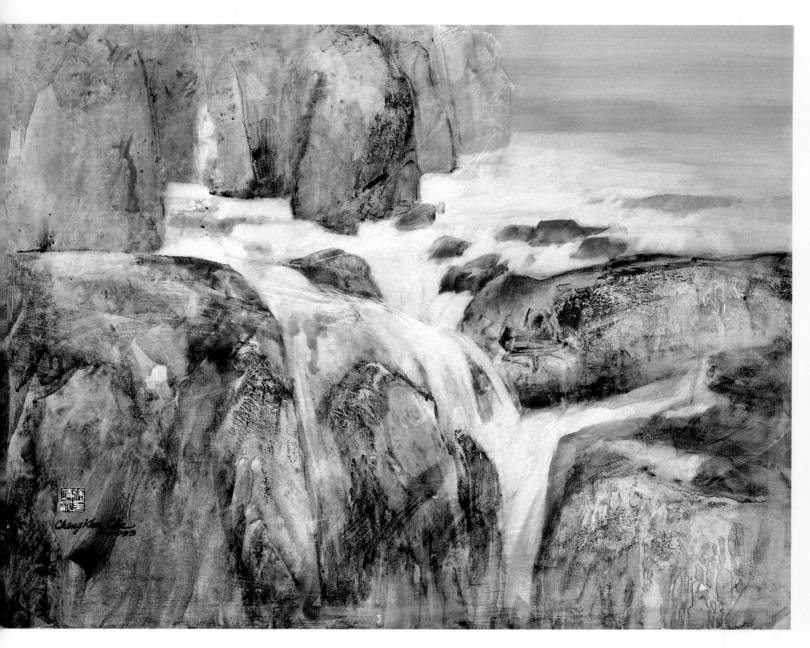

**LAKESHORE 93 NO. 2
CHENG-KHEE CHEE
30" x 40"**

FOR **LAKESHORE 93 NO. 2**
CHEE PREMIXED TUBE WATERCOLORS
IN DISHES SO THAT THEY COULD BE
APPLIED TO THE PAPER READILY.
WHEN THE GEL MEDIUM WAS DRY, HE
STARTED THE PAINTING WITH EMO-
TION, ENERGY AND SPEED. HE
WORKED AT WHITE HEAT FOR ABOUT
TWENTY MINUTES, TRYING TO COVER
THE ENTIRE SHEET OF PAPER.
GRADUALLY, THROUGH THE VERY ACT
OF PAINTING, HE DISCOVERED THE
SUBJECT MATTER. AT THIS POINT HE
EXERTED MORE CONSCIOUS CONTROL
AND GUIDED THE PAINTING TO ITS
FINISHED STAGE.

FIND A TECHNIQUE THAT EXPRESSES YOUR VISION

All my life I have been surrounded by rocks, water, surf and gulls. I have also experienced some of the most spectacular landscapes of China. These visions have become a part of my life and inspired many of my paintings. For many years I searched for a condition under which the medium itself would create the textures of rocks and mountains naturally and effortlessly.

My search ended in 1980, when I acquired my first John Pike palette. After using the palette for a few painting sessions I discovered exciting "paintings" of rocky shores and mountainscapes on the palette, just as I had envisioned. So I started searching for a surface that was smooth as plastic, yet able to retain paint so it would not be rubbed off. I finally found the Strathmore 500 series hot-press illustration board. I also discovered that applying

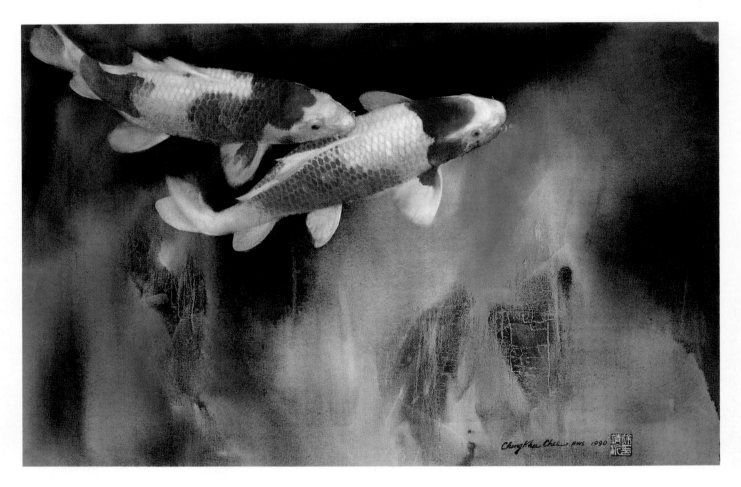

KOI 90 NO. 4
CHENG-KHEE CHEE
25" x 37"

diluted acrylic gel medium to the surface of the board enhanced the results. When sweeping a broad brush charged with color over the medium-coated surface, the paint is immediately repelled and creates exciting textures resembling rocks and mountains.

Goldfish and koi are another favorite subject. They are an important part of Asian people's pleasure and relaxation. I also am fond of them because of their beautiful colors, shapes and movement. The fish are generally lighter than the negative background, and they have soft edges. Saturated wet paper allows easy lifting, gives soft edges, and maintains a unified background. In painting fish I try to get the feeling that fish are in the water, and the two are inseparable. This can best be achieved in the saturated wet technique.

FOR **KOI 90 NO. 4** CHEE PAINTED THE NEGATIVE BACKGROUND FIRST, DARINGLY SPLASHING COLORS ON THE DAMP PAPER, TILTING THE BOARD TO LET THEM RUN AND MIX, GUIDING THEM IN THE DIRECTION HE WANTED THEM TO FLOW. THE GOAL WAS TO DO AN ABSTRACT UNDERPAINTING. WHEN HE WAS SATISFIED, HE EVALUATED THE COMPOSITION AND STARTED LIFTING SHAPES OF FISH OFF THE MOIST SURFACE. THE NEXT STEP WAS TO BUILD THE FORMS AND FURTHER DEVELOP THE PAINTING. THE FINAL STAGE WAS TO REFINE THE DETAILS. FOR FISH SCALES, HE CUT SCALES OF VARIOUS SIZES ON A SHEET OF PLASTIC, LIFTED OUT INDIVIDUAL SCALES WITH A MOIST SPONGE, AND TOUCHED UP WITH A BRUSH.

CHAPTER 3

Inspired by Artists and Other Special People

AN INTERESTING *face, an extraordinary hair color, a bright dress—and I'm drawing, sketching out my painting immediately.*

—*Nancy Tipton Steensen*

I N NUMEROUS WAYS THE ARTISTS in this chapter are inspired by people. Becoming immersed in the works of the old masters, befriending migrant farm workers, participating in a dynamic art community, or watching a granddaughter sleep are but a few of the ways we can be inspired by our fellow humans.

SMALL EDITION
BETTY DeMAREE
22" x 30"

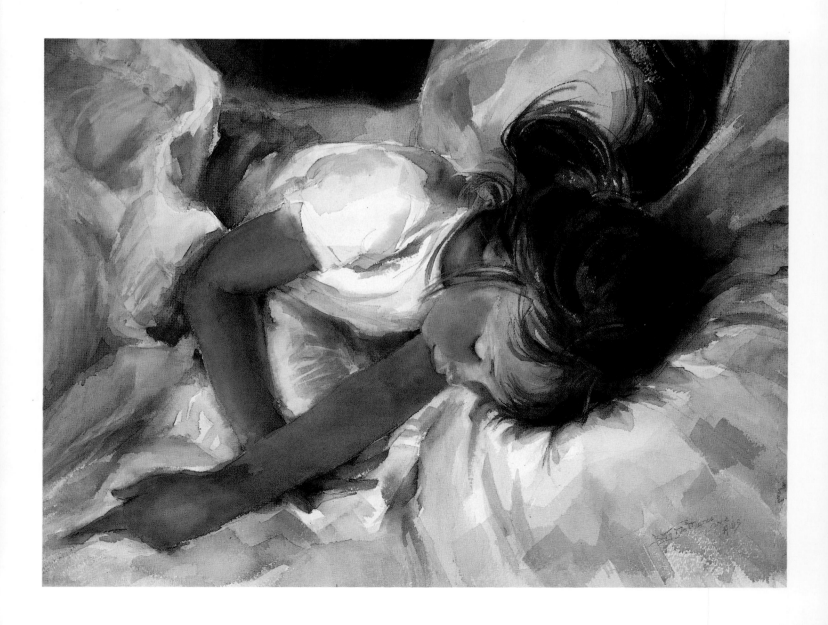

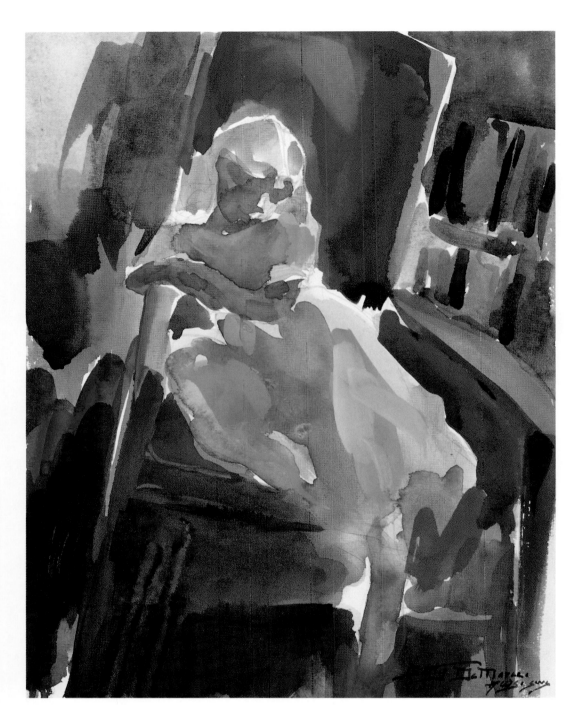

DeMaree approached **Leni, Small** [left] with complete abandon and love. Tilting the angle of the chair a bit provided the obliques needed in the design. The study is on 8" x 10" Crescent watercolor board.

DeMaree's little grand-daughter (far left) fell asleep unaware of the great design shapes and directional thrusts her arms and dark, strewn hair made against the bedclothes. In **Small Edition** the artist sought rich colors to depict white and, letting the hair transit the pillow, added warms into the cool blue shadows for unity.

LENI, SMALL
BETTY DeMAREE
10" x 8"

CAPTURE MAGIC FAMILY MOMENTS

To me, painting is life, a part of God, something sacred and uplifting. If I as a painter were denied my tools, my expression, I think I would become ill. Ed Whitney used to say, "Develop a skill or become neurotic."

I find joy in unexpected sources of inspiration—people, singly or in groups, become patterns of color and shapes. Landscapes, flowers—everywhere are ideas to explore, to challenge and excite. My granddaughter has provided me with great subject material. Asleep or awake, she is a delight. Her sleeping position that I caught for *Small Edition* was irresistible. *Leni, Small* was the color sketch for a larger painting of my god-daughter. I found it so appealing in its posture and spontaneity that I now value it above the rest.

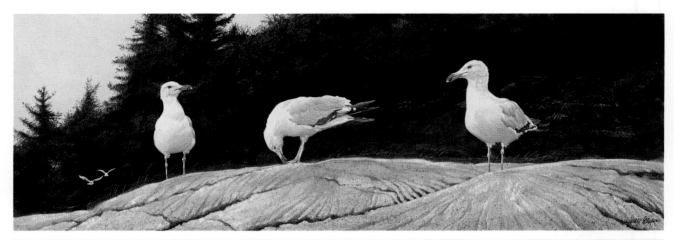

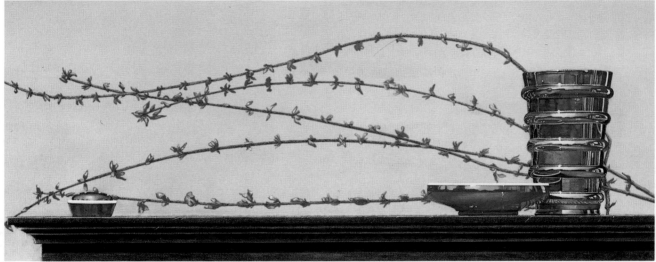

SPEND AN HOUR WITH REMBRANDT

At times there seem to be a million ideas worth painting. However, there are days when it's a challenge to have the drive, the strength, the inspiration to pull any idea together. On these days I go to my studio, leaf through an art history book, and tell myself that I am part of this great tradition. An hour or two of learning from the masters is usually enough to recharge my artistic batteries.

At other times I crave a trip to a museum. Standing in front of a Rembrandt at about the distance he stood while painting makes the hair on the nape of my neck stand on end. I walk through the museum with my sketchbook, making thumbnail drawings of the paintings I like. I fill my pages with notes of all kinds—both words and pictures—about color, brush technique, paper, feelings, my own observations. When I leave the museum I'm excited and inspired and thinking productively about my own art.

James Dean

ISLAND GULLS
JAMES DEAN
7" x 21½"

DEAN EMPHASIZED THE SOFTNESS AND SMOOTHNESS OF THE GULLS' FEATHERED BODIES TO CONTRAST WITH THE HARD, JAGGED EDGES AND SPATTERED PAINT USED TO CONVEY THE SOLIDITY AND PERMANENCE OF THE ROCKS AND THE EARTH ITSELF.

BLUE FORSYTHIA
JAMES DEAN
10½" x 29½"

BECAUSE OF THE RANGE OF TEXTURES IN **BLUE FORSYTHIA**— FROM HIGHLY REFLECTIVE GLASS TO WOOD GRAIN TO DELICATE FLOWERS—DEAN DECIDED TO USE GOUACHE TO MAINTAIN AS MUCH CONTROL AS POSSIBLE. THE VASE WAS PAINTED SLOWLY AND DELIBERATELY FROM SEVERAL VALUES OF BLUE, FOLLOWING CAREFUL OBSERVATION OF THE SUBJECT.

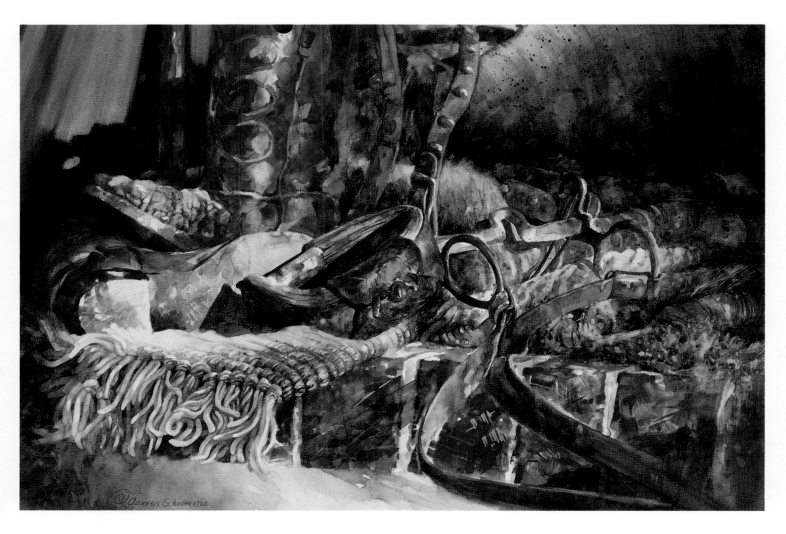

CONNECT THE PAST AND THE PRESENT

Before brush ever touches paper I contemplate the mood of a painting by asking, "What is the feeling? What moves me?" because I paint the things that touch who I am.

I am drawn toward connections between the past and the present and between generations. *Riding Still* shows the connection between my husband's grandfather, Carl, who gave me my first tubes of paint, and my daughter, who wears the boots. As a boy, Carl rode with this stirrup and these reins; and through his great granddaughter, Carl rides still.

An emotional response to the events in my life, my paintings often touch on those intangible but powerful moments when we feel the passing of time.

Garren Schrom

RIDING STILL
GARREN SCHROM
20" x 30"

SCHROM USED AN EMPTIED PAINT TUBE TO SCRAPE OVER STILL-DAMP WASHES TO CREATE THE TEXTURE OF THE BRICKS. THIN, OVERLAPPING LAYERS CONVEY THE WORN APPEARANCE OF THE BOOTS, ANOTHER CONNECTION TO THE IDEA OF AGING.

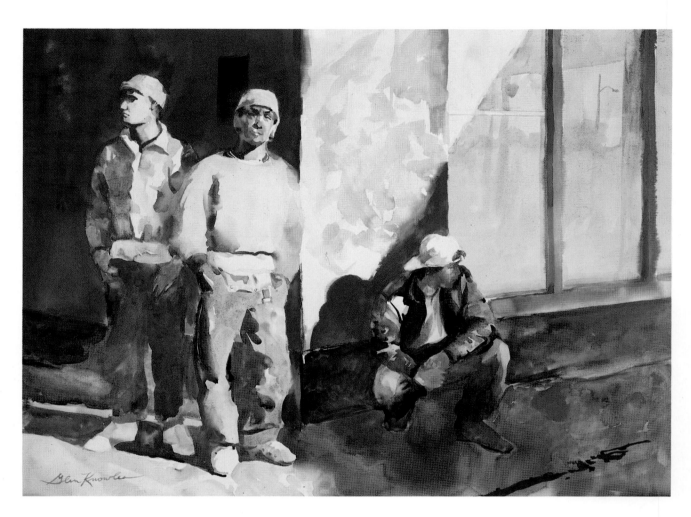

EXPLORE SOCIAL ISSUES

I had always kept separate my love of outdoor landscape painting and my love of human figure painting. Recently I decided to combine these ideas and create on-location watercolor paintings in which the figure would dominate the foreground and become the subject of the painting.

I have developed a desire to explore social issues with my art and to understand the social context of my work and myself, as an artist working in society. I chose to do a series of paintings of our local day laborers and migrant farm workers. One of the earliest discoveries I made was how many of my preconceived notions, formulated from watching TV and reading newspapers, were inaccurate. I have made friends and been deeply moved by the personal stories of these workers. The process of immersing myself in other cultures has become the most intensely emotional artistic experience of my life. I hope these images, and the paintings I will continue to do of these "invisible people," cause audiences to pause and consider the role these workers play in our society. If so, perhaps in the future these paintings will be of some benefit to the migratory workers themselves.

Glen Knowles

LOOKING FOR WORK
GLEN KNOWLES
22" x 30"

KNOWLES USES WATERCOLOR PENCILS FOR HIS PRELIMINARY DRAWING AND THEN PAINTS DIRECT IN TRANSPARENT WATERCOLOR. HE LIKES TO DRAW IN A COLOR RELATED TO, BUT NOT THE SAME AS, HIS FINAL COLOR. AS THE PENCIL DISSOLVES WITH SUBSEQUENT WASHES IT LEAVES A SPARKLE OF COLOR, ADDING SPONTANEOUS, SUBTLE ACCENTS.

NATURE INSPIRES IDEAS FROM THE MASTERS

"Inspiration" comes from nature itself. I am enamored of nature, and that admiration has only increased as I age. But I have no interest in cataloguing accurate detail. Rather I am impressed by the larger aspects that unify everything we see—nature's design, rhythm, light and atmosphere. This world itself is the greatest work of art, and it inspires me more than any masterpiece of painting.

However, I must acknowledge that my "ideas" do come from the masters. Vermeer's and Utrillo's streets, Van Gogh's fields and trees, Monet's skies, Cezanne's handling of space, Matisse's and Bonnard's color sensitivity, Turner's and Picasso's preoccupation with the turbulence and vitality of the world, have all been influential. The world is alive—I am alive—and I try to keep my paintings alive.

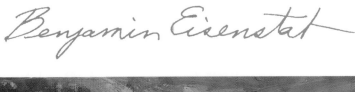

SAN FRANCISCO BAY WAS THE INSPIRATION FOR **INNER HARBOR #1**. EISENSTAT MADE USE OF WATERCOLOR'S LUMINOSITY ON THE SKY AND WATER, AND HE USED ACRYLIC TO GIVE SUBSTANCE ELSEWHERE. THE HORSE-SHAPED CRANES ADD A TOUCH OF SURREALISM. THE EXCITEMENT GENERATED BY SUCH VISTAS INSPIRED THE ARTIST TO PAINT "DANGEROUSLY" FROM THE VERY BEGINNING, USING INTENSE COLORS AND STRONG STROKES TO EMULATE NATURE'S VITALITY.

INNER HARBOR #1
BENJAMIN EISENSTAT
26" x 34"

SUGGEST A HUMAN PRESENCE

An idea that leads to a successful painting always contains a familiar subject about which I have strong feelings. Most often, these images refer to special human moments, real or imagined. The drama of light and shapes must work to pull you into the story. I want to move you into the painting by provoking questions. If I give you a chair with a crushed pillow casting shadows, will you wonder, "Who sat here? For how long? Why? What was his mood?" Figures are seldom shown in my work, but there must be evidence of their proximity. I want you to connect with the lingering human presence.

In *Clean Sheets* I was inspired by the cluttered, compartmentalized areas reflecting life within this complex structure. My goal is to get the viewer's mind to wonder about each inhabitant.

Andrew R Kusmin

CLEAN SHEETS
ANDREW KUSMIN
22" x 30"

TO ACCOMPLISH KUSMIN'S GOAL, ALL AREAS HAD TO BE OF ALMOST EQUAL INTEREST, SETTING UP A BALANCE OF SHAPE, LIGHT, COLOR AND TEXTURE THROUGHOUT. THIS BALANCE CREATES SEGMENTS THAT COULD STAND ALONE AS SMALL PAINTINGS, BUT IT ALSO TIES THEM TOGETHER. SIGNIFICANT REARRANGING OF COMPONENTS WAS NECESSARY TO BALANCE THE AREAS OF INTEREST.

THE IMPACT OF AN ART COMMUNITY

For sixteen years of my career, I experienced life while accompanying my husband as he moved throughout his career as a Navy pilot. This vagabond lifestyle assured me that virtually the entire world was available as subject matter for my "canvas." Unfortunately, this exposure was not accompanied by the other elements I deem crucial for artistic stimulation. It was not apparent until recently, but the right conditions for my greatest inspiration came together when we finally moved to California.

In addition to its unequaled natural beauty, California offers an abundance of active art associations, which creates a dynamic atmosphere that positively influences artists as well as the viewing community. Art exhibitions come alive in the form of street fairs, formal juried shows, or as organized "open studios." This bounty of skilled artists, notable art competitions, progressive community art festivals and sophisticated buyers is my genuine inspiration to better myself as a watercolor painter.

K H HONAKER

PIGEON POINT PROMONTORY
KAREN HONAKER
21" x 29"

AFTER DETERMINING WHERE THE ROCKS AND THE WATER WERE IN THE COMPOSITION, HONAKER APPLIED UP TO SEVEN LAYERS OF GESSO TO THE STRETCHED WATERCOLOR PAPER. USING THE SIDES OF OLD OIL BRUSHES, SHE RANDOMLY SLAPPED ON THE GESSO IN THE ROCKY AREAS, ALLOWING IT TO DRY BETWEEN LAYERS. THE WATER AREAS WERE LIGHTLY SANDED AFTER FOUR LAYERS OF GESSO. THE WATERCOLOR WAS PAINTED VERTICALLY, PERMITTING THE PAINT TO FLOW INTO THE CREVASSES MADE BY THE GESSO.

FIND FRESHNESS IN EVERYDAY MOMENTS

I live in a beautiful, hilly part of Virginia amidst old houses and interesting people. My first painting subjects were mostly charming street fronts with cast shadows, mountain vistas or buildings nestled together. More recently, I've been intrigued with putting figures in a land-scape setting. A small camera stays close at hand to capture interesting everyday moments—children waiting for the school bus, inveterate shoppers, and crowds at annual local events.

The more I paint, the more I appreciate that art reflects one's own life—that tech-nique is not nearly as important as awareness and meaning and feeling. The most difficult part of creation is keeping that freshness, that spontaneity that looks as if a painting "just happened."

Anne Adams Robertson Massie

BEDFORD COUNTY POINT
TO POINT II
ANNE ADAMS ROBERTSON
MASSIE
21" x 29"

AS GESTURE AND MOVEMENT ARE OF GREAT INTEREST TO MASSIE, SHE GIVES MUCH THOUGHT TO THE PLACE-MENT AND DIRECTION OF THE BRUSH-STROKES. THE PAINT IS APPLIED DIRECTLY AND MIXED ON THE PAPER. IN **BEDFORD COUNTY POINT TO POINT II** SHE MAKES AN EFFORT TO CREATE A FEELING OF SPONTANEITY, THE MOOD OF THE SUNNY, COLD DAY AND THE MOVE-MENT OF SPECTATORS WAITING FOR THE RACE TO BEGIN.

ASK YOUR "INSPIRATION" TO POSE

Ideas and inspiration work hand in hand with me. I see an interesting face, an extraordinary hair color, a bright dress . . . and I'm drawing . . . sketching out my painting immediately. Usually I'm lucky and have my camera along. If not, I improvise. Occasionally I get brave and ask my "inspiration" to pose a moment longer.

I also have hundreds of photographs I've taken that can often inspire me, and they may be photographs I've overlooked before. They can just look "different" this time, create a spark and a color mood that pushes me to my paints.

Most often, though, my daughter will be my most influential inspiration and idea. She can be lazing on the couch watching cartoons or doing homework or drawing her cat and I see that look of concentration in her face. She barely looks up anymore when I say, "Hold that pose."

Nancy Tipton Steensen

STEENSEN PUT IN LIGHT WASHES OF PAINT AT AN ALMOST VERTICAL ANGLE ON THE EASEL, LETTING THE DRIPS AND SPATTERS FALL WHERE THEY MAY, THEN ADDED SPATTERS IN STRATEGIC AREAS AROUND THE HAIR, CLOTHES, AND PLACES IN THE BACKGROUND THAT NEEDED COLOR. WHEN THE PAINTING WAS DRY, SHE USED A NO. 2 GRAPHITE PENCIL TO DEFINE THE FIGURE WITH RANDOM WANDERING LINES, ECHOING THE SPACES OR PUSHING AGAINST THEM.

CARTOON COMA
NANCY TIPTON STEENSEN
17" X 24"

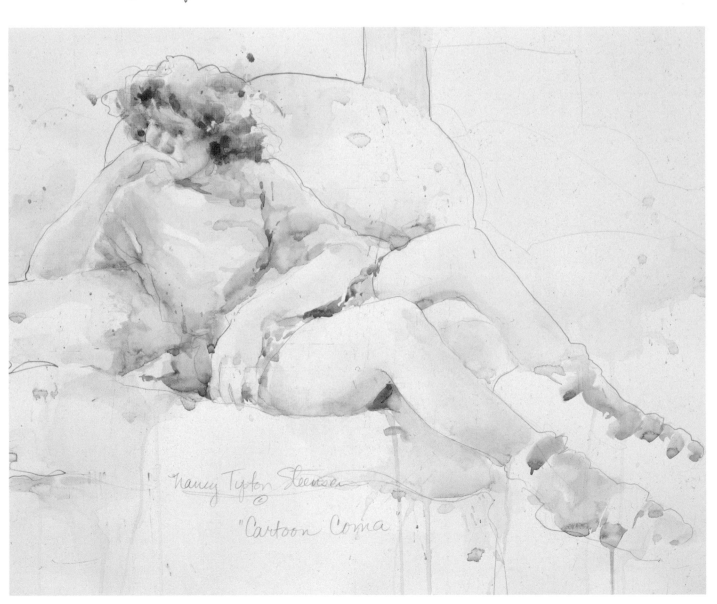

PAINT YOUR MOST IMPORTANT PEOPLE

I tend to paint subjects that are familiar to me, things or people that are part of my life. Currently, I am influenced by subjects relating to my parents. *Margaret's July* is inspired by my mother, who spent hours—years—in the garden. Insects weren't tolerated. This painting grew from the results of one of mother's rosebed beetle raids.

While compositional adjustments occur during the process of painting, I couldn't successfully resolve a work without beginning with a skeletal plan. But, unlike shape and value placement, I plan colors ahead of time only in a general sense. I have found that if I try to force the paint to do what I want, I miss valuable input from the watercolor process. As a result, the colors grow and change as the painting grows and changes. Everything remains open to modification for as long as possible.

SCHRADER RARELY USES MASKING FLUID, BUT **MARGARET'S JULY** IS ONE OF THOSE RARE OCCASIONS. BEFORE FLOATING MULTIPLE LAYERS OF COLOR ON THE LARGE RECTANGULAR AREA, SHE MASKED MOST OF THE SHAPES CONTAINED WITHIN THAT AREA.

MARGARET'S JULY
CAROL ANN SCHRADER
22" x 29"

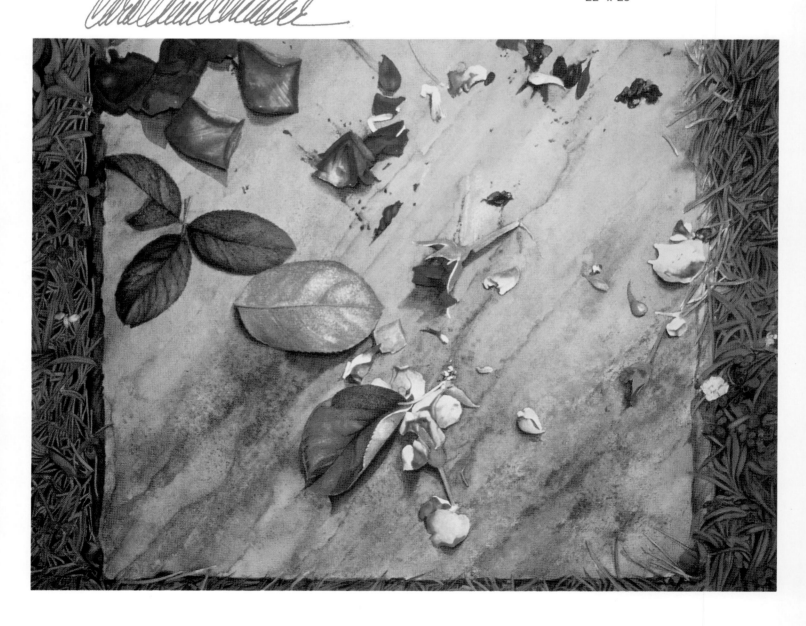

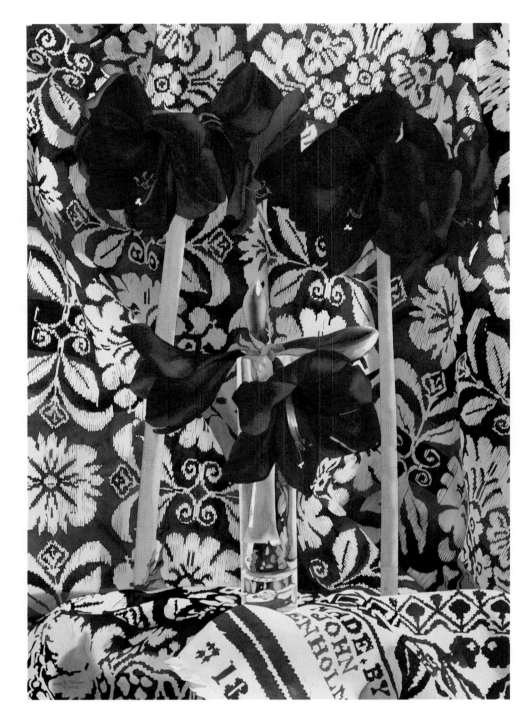

GRANDMOTHER'S
TREASURES
JUDY D. TREMAN
38" x 27"

AFTER DRAWING EVERY DETAIL ON
300-LB. ARCHES ROUGH PAPER,
TREMAN APPLIED FRISKET TO SMALL
AREAS OF THE WHITE PAPER. SHE
FIRST PAINTED ALL THE SHADOWS
AND CONTOURS. AS SHE WORKS, SHE
ALWAYS HAS A BRUSH LOADED WITH
CLEAR WATER AS WELL AS A PIG-
MENT-LOADED BRUSH. THIS ENABLES
HER TO CREATE BEAUTIFUL WASHES
AND TO MAKE SOFT WET-INTO-WET
EDGES WHILE WORKING ON BASICALLY
DRY PAPER. SHE ADDED THE WINSOR
RED LAST, AS IT TENDS TO BLEED
ALONG THE EDGES IF YOU TOUCH A
WET BRUSH TO IT.

TWO GIFTS FROM A SPECIAL PERSON

My desire to create paintings of *joy* coupled with my love of vivid colors has led me to paint a series of very large watercolors of flowers with multicolored quilt and fabric backgrounds. My grandmother, with my use in mind, bought this 1846 coverlet at a garage sale. Because of the powerful design of the woven fabric, I knew an equally strong yet simple-shaped flower was needed for the foreground. It wasn't until three red amaryllises bloomed at the same time that the inspiration for the painting—made even more meaningful because grandmother first introduced me to growing these dramatic blossoms—was born. The shapes of the flowers seem almost to repeat the patterns of the coverlet. I worked with composition for hours and nothing seemed to work until I accidentally broke the stem of one of the blooms. That was a happy accident! Only then, by putting the shortened stemmed flower in a vase, did the composition finally come together to make *Grandmother's Treasures*.

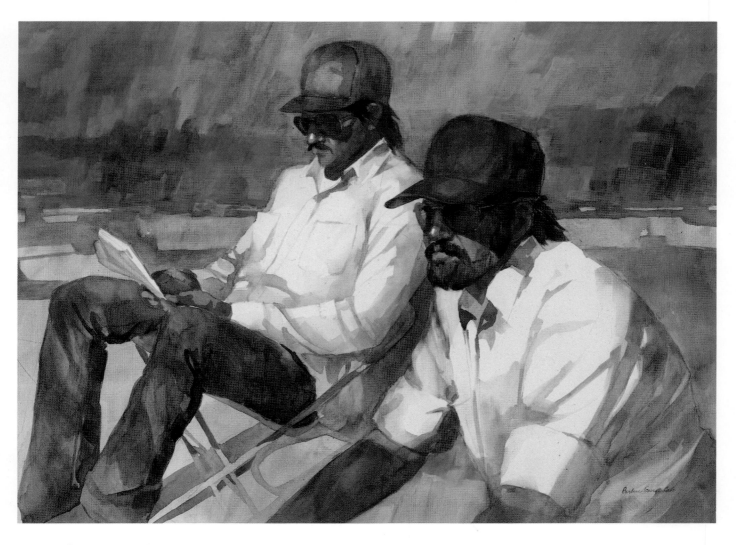

SEARCH FAIRS AND FESTIVALS FOR CASUAL POSES

A lifetime of interest in the human face and figure is the inspiration behind most of my painting. In searching for ideas I look for casual and relaxed poses, for unusual views, and for interesting relationships between figures. Using two figures usually makes for a more interesting composition.

I am inspired by people caught in repose or engrossed in an activity. Local events such as art festivals, livestock shows, Renaissance fairs and peach festivals provide plenty of material. I look for unusual light patterns on faces and figures. Many times the people in my paintings wear glasses or hats that shadow their faces. I am not trying to present a traditional portrait, but a dynamic composition using figures as subject matter. In *Slow Morning* I decided to leave the shirts of the parking lot attendants white to emphasize the glare of the sun.

Barbara George Cain

SLOW MORNING
BARBARA GEORGE CAIN
24" x 34"

CAIN WORKED LIGHT TO DARK, ADDING THE DETAILS LAST. SHE CHANGED THE COLOR OF THE LARGER FIGURE'S CAP FROM WHITE TO RED TO DRAW ATTENTION TO HIM. TO GET THE EFFECT SHE WANTED IN THE BACKGROUND SHE USED WATERCOLOR OVER GESSO OR WATERCOLOR MIXED WITH GESSO.

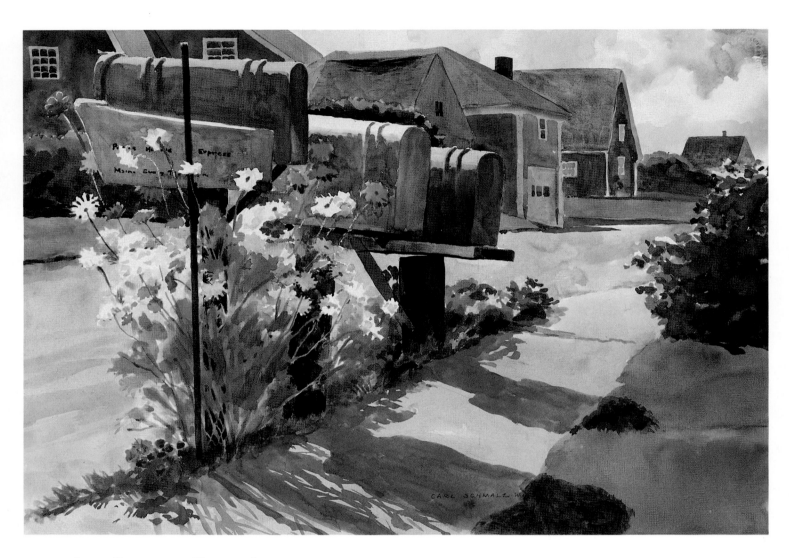

ART SPRINGS FROM ART

For any artist, I think, inspiration is ever present. Awe and wonder must underlie the urgency felt by all artists—musicians, poets, dancers, painters—to sing forth the deep joy of existence.

Since art springs from art, it is not just the miracle of being that inspires me. I am also moved by the example of artists who have preceded me: Botticelli, the somber honesty of Rembrandt, Ruben's panache, Watteau's sad fetes, joyous Fragonard. Corot's perfect modalities have moved me, as have Manet's austere tones. More recently, my interest in still life has redirected me to Zurbaran, Chardin, Raphael and others.

Mailboxes & Cosmos is an outdoor still life, a favorite subject for many years. A close-up of things seldom seen—in this case, my Kennebunkport neighbor's boxes. I think my ideas come from what I see in the world but are often subconsciously sparked by something that brings a recollection of a previously admired work of art.

CARL SCHMALZ

MAILBOXES & COSMOS
CARL SCHMALZ
15" x 22"

SCHMALZ USES A FAIRLY SPARSE PALETTE OF SOME FIFTEEN PIGMENTS, TO WHICH HE ADDS OTHER COLORS AS NEEDED. HERE, HE WORKED FROM THE LIGHTER TONES THROUGH THE MIDDLE VALUES, DOING THE DARKEST LAST. **MAILBOXES AND COSMOS** TOOK ABOUT AN HOUR AND A HALF.

CHAPTER 4

Moved by a Unique Event

GATHER *your inspirations as you live— and then recapture them as needed in the studio.*

—Nita Engle

AT TIMES, SPECIFIC EVENTS, WHETHER personal or of worldwide significance, can kindle such strong emotions that art and life seem to merge. Nature, as always, performs her well-staged dramas, but war, personal trials and the comics also give these artists painting ideas.

ONE NATION UNDER GOD
PATRICK R. WHITE
16" x 24"

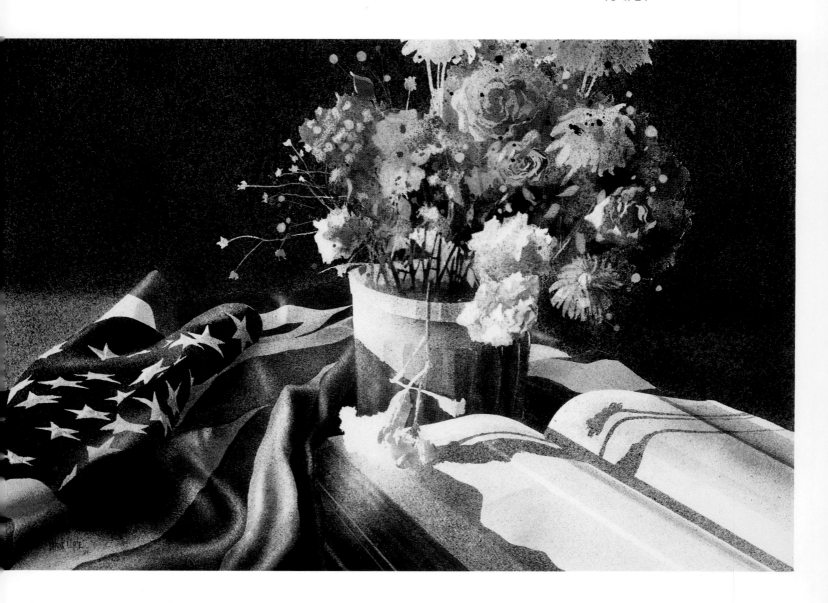

IDEAS FROM GREAT AND SMALL EVENTS

I am inspired and moved by things from the past as well as the uniqueness of everyday objects. A cast shadow, a reflection, an unusual aspect of an ordinary subject gives me the urge to re-create it. My art must have heart—an emotional content and something to say. Even when I'm not painting, I get ideas everywhere and they race through my head with abandoned imagination! Often my friends can inspire me. More than once a painting has come about by a single idea, event, or expression of insight from another person.

One Nation Under God was done at the time of Operation Desert Storm and reflects a patriotic theme. The Bible has always been the cornerstone of our nation, and I hope it will continue to be.

The arrangement for *Paper and Rose* came about by accident. I buy paper in rolls, and I had a piece of paper standing on a work table with a bottle in front of it. The light from the window created an interesting shadow form I couldn't resist.

Patrick R White

JUST WEAR A HAT, NO ONE
WILL KNOW
COLLEEN NEWPORT
STEVENS
30" X 20"

THIS PAINTING WAS DONE ON A SLICK
WATERCOLOR SURFACE, UNDERCOAT-
ED WITH TRANSPARENT WATERCOLOR.
STEVENS USED OPAQUE GOUACHE
FOR THE HAT AND BACKGROUND AND
FOLLOWED WITH A TOUCH OF INK
AND PASTEL.

GROWING THROUGH ADVERSITY

My art was influenced immensely by a turn of events in my personal life. At that period of time I was undergoing chemotherapy. Coming face to face with mortality gave me a real jolt; my eyes opened more than ever to color and contrast. I always wanted to go beyond paint-ing another "pretty picture" but lacked the guts to jump in with both feet. I put aside dead-lines, commissions, etc., and let this be a growing period of self-discovery.

I was painting emotions, expressing my soul and spirit, and I found I was no longer content with transparent watercolor, which I had used in the purest form for years. So gouache, acrylics, pastels and inks were added to my palette. This painting was done one day when my son locked me out of my bedroom where my wig was. All I could think of was what a friend had told me: "Just wear a hat, no one will know." I looked in the mirror and started sketching myself. I was going for the feeling of inner turmoil and yet the other feel-ing of, "Hey, this is my chance. A hat—yeah, a big orange hat." I think there can be real heal-ing through the arts. I'm glad I went through my experience (although I don't recommend it to everyone!). It got me out of a rut and sent me in a whole new direction.

Colleen Newport Stevens

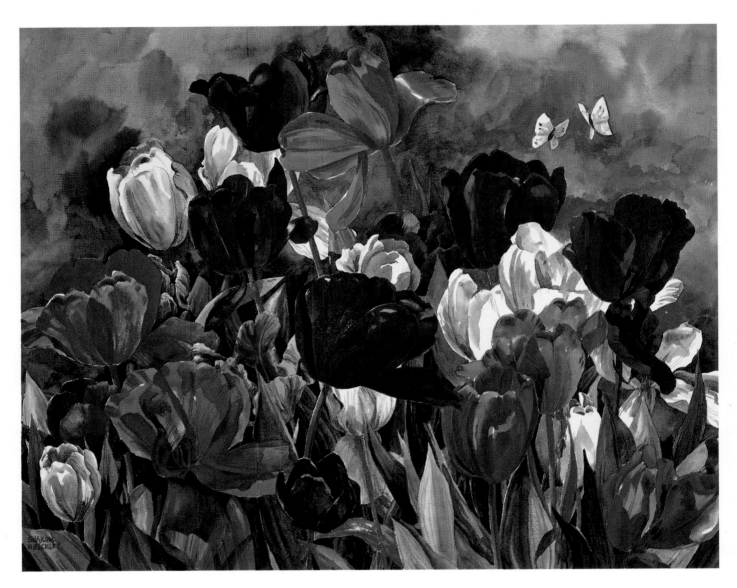

EVOKE THE JOY OF GOD'S DESIGNS

My main love is painting the effects of light: sunlight and shadow reflecting on the walls of a white building; light sparkling across the ocean surface; sunlight glowing on the delicate petals of a flower. My greatest pleasure is in finding a scene that I just "have to" paint. The Tulip series was the result of riding my bicycle home and coming across an exquisite small garden filled with hundreds of tulips of different varieties, all growing happily together.

Some artists talk about trying to make a painting "more interesting than the subject." However, I feel that God is such a wonderful designer—in this case, along with Ethel and Nick, the gardeners—that I simply hope to capture in my work some of the joy that the subject evokes in me.

DANCING TULIPS
SHARON HINCKLEY
21" x 29"

MOST OF HINCKLEY'S WORK IS THE RESULT OF CONSTANT OBSERVATION AND INTERACTION WITH THE SUBJECT. SHE FEELS HER JOB IS SIMPLY TO HOLD THE BRUSH AND ALLOW THE ENERGY TO FLOW WHERE IT WILL. WHEN SHE DOES THIS, THE "PAINTING" ALWAYS TAKES CARE OF ITSELF.

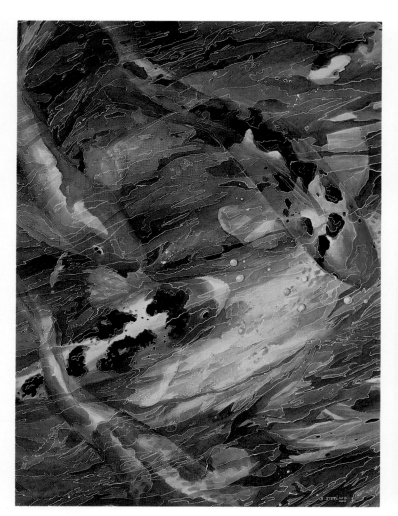

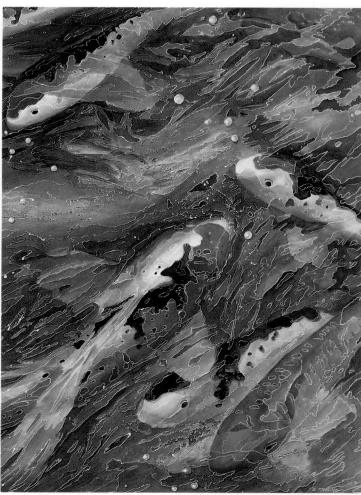

GATHER ENOUGH MATERIAL FOR A SERIES

My students of more than twenty years have been a major motivating force for me. To encourage creative ideas in my more advanced students, I seek challenging problems for them that, in turn, challenge me.

Ideas come to me from almost everything I see. A couple of years ago, while visiting Oahu, the sunlit Koi fish pond at Ala Moana Shopping Center attracted me like a magnet. I spent hours and used rolls of film at the edge of the pool, capturing the movement and light of those beautiful fish. That experience spawned a series of Koi paintings, including this 4´x 7´ diptych for the permanent collection of a San Antonio hotel. Working in a "series" can inspire dozens of paintings.

SHIRLEY STERLING

FISH FANTASY, DIPTYCH
SHIRLEY STERLING
48" x 42"

FISH FANTASY WAS PAINTED WET-INTO-WET ON HOT-PRESS PAPER, FLOWING BRILLIANT BLUES, GREENS, YELLOWS AND LAVENDERS ONTO THE COMPOSITION IN AN ABSTRACT PATTERN, EXPRESSING THE MOVEMENT OF THE WATER. AFTER STERLING ADDED THE FISH, SHE ALLOWED THE PAPER TO DRY. THEN, USING A DIP PEN AND WHITE INK, THE ABSTRACT WATER SHAPES WERE "FOUND," INDEPENDENT OF THE FISH, EXPLORING THE FEELING OF THE MOVING, SPARKLING WATER. A FEW DARKER AREAS WERE ADDED TO COMPLETE THE PAINTING.

COMBINE YOUR INTERESTS

The Death of Raven Sherman is an effort to combine two of my loves: painting and cartooning. It is my homage to my boyhood hero, Milton Caniff, newspaper cartoonist of *Terry and the Pirates*. October 5, 1941, is the date of one of the most unique happenings in the history of newspaper comics. Raven Sherman was a major character in the *Terry* comic strip, and Caniff killed her off on that date. Followers of the strip demonstrated nationwide, and there were mock funerals on many college campuses. The cartoonist received tens of thousands of sympathy cards as well as letters of protest for eliminating such a popular fictional character. My painting will have special meaning to all Milton Caniff fans, but the general public is probably unaware of the historical significance of October 5, 1941.

The Death of Raven Sherman is the largest painting I've done to date.

ELTON DORVAL

THE DEATH OF RAVEN
SHERMAN
ELTON DORVAL
29" x 40"

THE DEATH OF RAVEN SHERMAN IS ONE IN A SERIES OF PAINTINGS USING A SUNDAY COMIC SECTION AS A COLORFUL ELEMENT, REFLECTED IN HIGHLY POLISHED SURFACES. AFTER MAKING A ROUGH SKETCH OF A POSSIBLE COMPOSITION, DORVAL PHOTOGRAPHS THE ELEMENTS IN POSITION. THIS HELPS HIM PAINT THE COMIC SECTION AND HOW IT LOOKS REVERSED IN THE SHINY OBJECTS. THEN HE SETS UP THE OBJECTS ON A TABLE IN FRONT OF HIS DRAWING BOARD TO PAINT THE FINE DETAILS. EXCEPT FOR USING INDIA INK ON THE COMIC STRIP, THE REST OF THE PAINTING IS DONE IN TRANSPARENT WATERCOLOR.

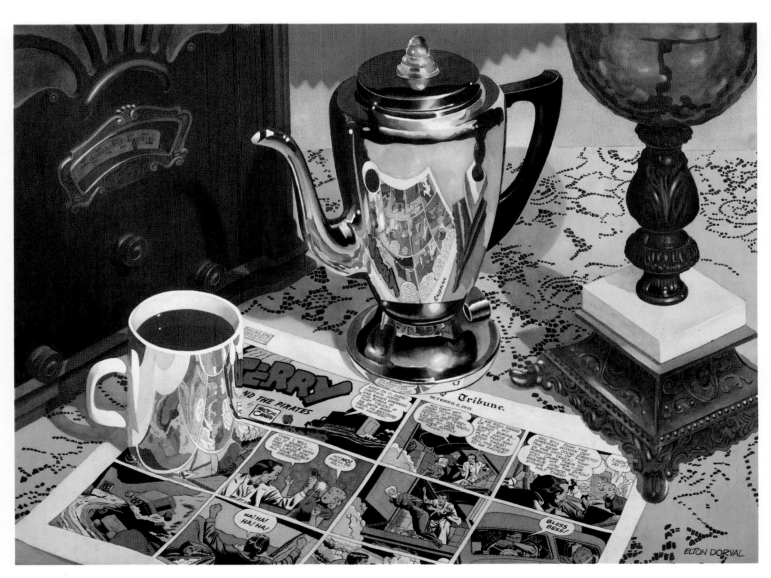

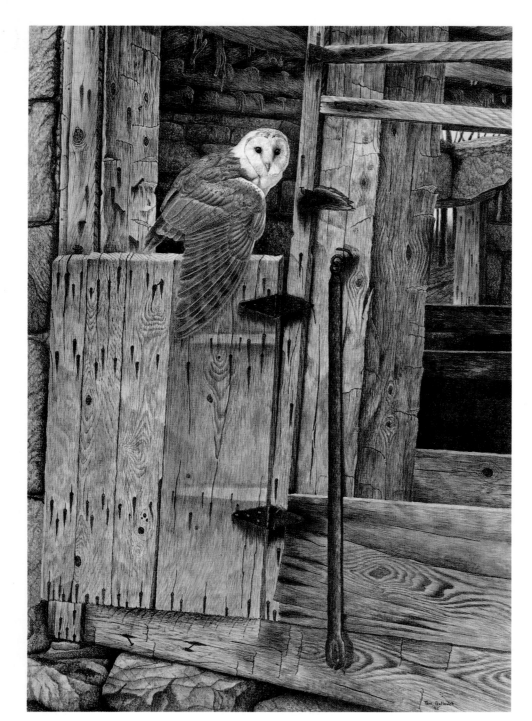

THE DOOR MAN
TOM GALLOVICH
31" x 21½"

GALLOVICH PAINTS IN A PLANNED
SERIES OF CONTROLLED WASHES FOL-
LOWED BY A GREAT DEAL OF DRY-
BRUSH SCRIPT WORK. THE BRUSH-
WORK DEFINES TEXTURES AND GIVES
THE PAINTING A LIFELIKE LOOK.

SPEND TIME IN THE FIELD

My inspiration comes from experience. I spend a great deal of time in the fields and swamps, photographing wildlife. The orange glow of an early morning sun, the heart-stopping stare of a predator, or the mood that fog creates on an uncertain background—these combined with some basic rules of composition can be the "thought-stirring start" of a new painting.

I got the idea for *The Door Man* while photographing songbirds in a blind at a feeder. During the rough times of winter the high concentration of songbirds and small game birds often brings out the local predators. While setting up one morning, I watched the silhouette of a barn owl fly over the cornfield into a tree line. Later that day, I walked its flight path and found this particular barn. With the silent flight of the owl still fresh in my mind, I took a slow walk around the barn, which led me to this watercolor painting.

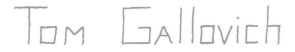

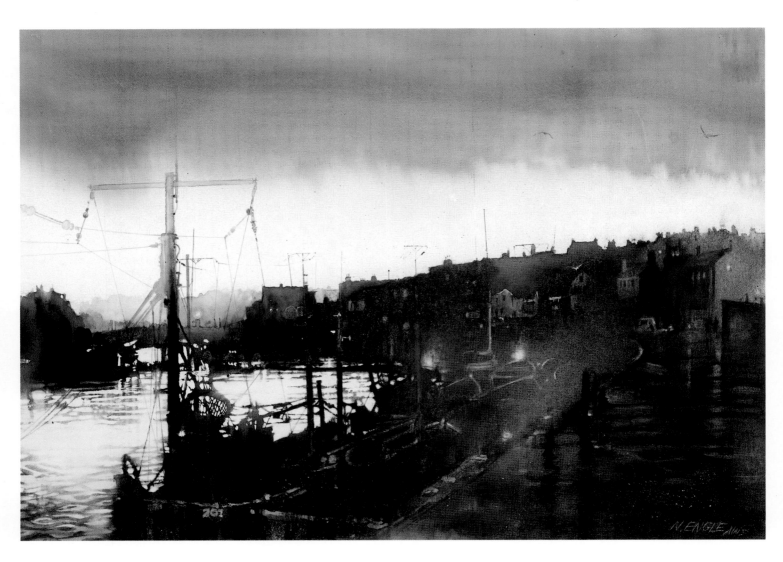

GATHER AND HOARD YOUR INSPIRATIONS

In a way I equate inspiration with desire—the desire that moves us to be artists in the first place. To attempt to make a painting without this motivation is a waste of time.

Of all media, watercolor is the most immediate and the most volatile. Because a direct eye-hand connection shows every faltering brushstroke, it demands an approach of exuberance, confidence, élan. Because the paint actually *moves* on the paper, it is the most active of all mediums, almost a performance art. If the desire or inspiration is lacking on a particular piece, the joy is lacking—the very heart and soul of the work.

Of course, anyone who tries to make a living as a painter knows you can't lounge about waiting for inspiration to hit; nothing motivates like keeping a roof over your head. So I feel the answer, speaking as a landscape artist, is to travel—to go to nature, to cities, to reality—to live life. Gather and hoard your inspirations as you live, then recapture them as needed in the studio. *After the Rain, Whitby* is one case in which a familiar scene was brought to life by an unusual weather event.

N. ENGLE

AFTER THE RAIN, WHITBY
NITA ENGLE
18" x 27"

ENGLE EXPERIENCED THIS SCENE. SHE GOT CAUGHT IN A HEAVY DOWNPOUR, HUDDLED AGAINST A SHELTER WITH OTHERS TRYING TO KEEP DRY, AND WATCHED INTENTLY FOR ANY SIGN OF THE STORM'S PASSING. FINALLY, SHE SAW A BRIGHTNESS ON THE SKYLINE, AND THEN THE CLOUDS LIFTED LIKE A VEIL—A WATERCOLOR VEIL. SHE SAYS, "THE WHOLE SCENE WAS A WATERCOLOR, THAT UNIQUE BRIGHTNESS THAT HAPPENS AFTER A SUMMER RAIN, THE THUNDER STILL RUMBLING IN THE DISTANCE, THE HIGH CONTRAST IN VALUES, THE STRONG SHAPES, THE OLD WET, WOODEN WHARF, AND THE FEEBLE ARTIFICIAL LIGHTS AGAINST THE TREMENDOUS LIGHT OF THE WHOLE UNIVERSE."

CHAPTER 5

Challenging the Senses With Travel

TO PAINT, TO *travel…
to combine the two is to celebrate
life.*

—*Jack R. Brouwer*

MANY ARTISTS FIND IDEAS AND INSPIRATION by actively seeking new environments through travel. Somehow even the light and the water, not to mention land forms and man-made structures, look wonderfully strange in different parts of the world.

MEVAGISSEY HARBOR—
CORNWALL
GERALD J. FRITZLER
18" x 29"

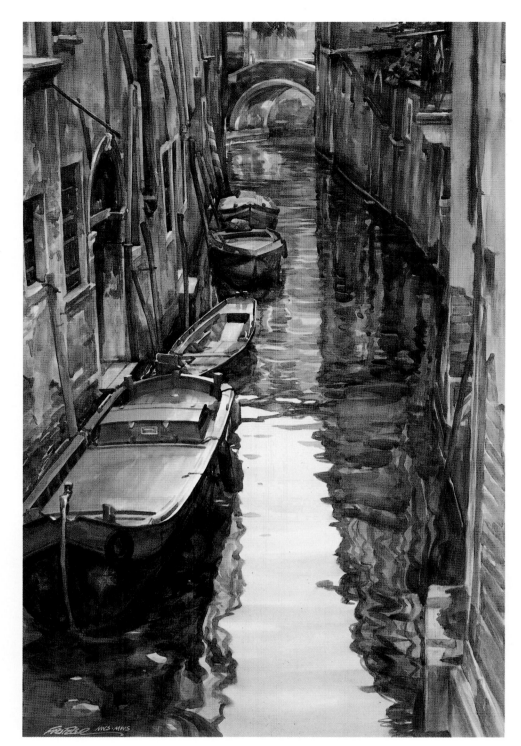

RIO DI SANTA MARIA
ZOBENIGO
GERALD J. FRITZLER
27" x 18"

RESEARCH YOUR PAINTING LOCATIONS

The inspiration for my work comes from the many painting trips I make each year. Painting on location all around this great world of ours is my greatest pleasure. I research areas in depth prior to planning a trip so I have a good idea of the many paintable locations in or near the area where I will stay. In this way, I can leisurely look for the essential quality and personal feeling for a specific location.

By being at a location and capturing a certain light, mood or feeling, my interpretation comes alive with spontaneity and color. It becomes a very personal experience. In both of these paintings I was inspired, in diverse locations, by the magical light of the afternoon sun.

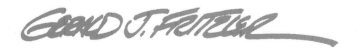

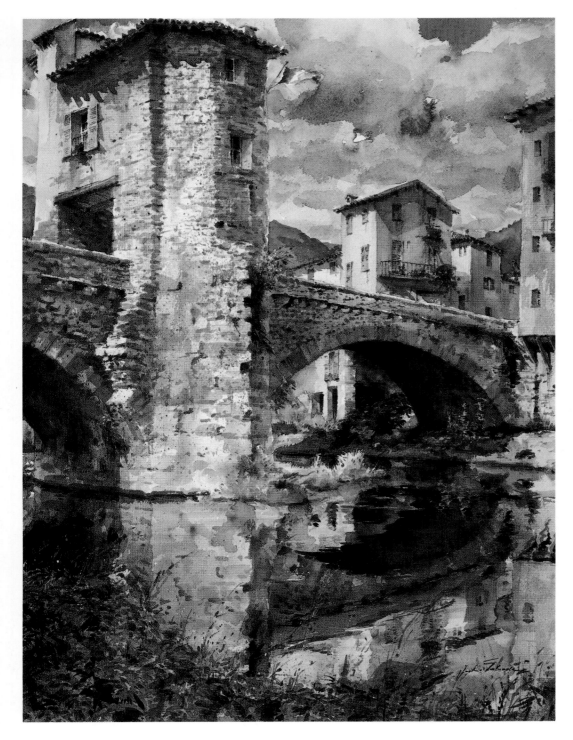

SOSPEL
JACK LESTRADE
25½" x 19"

SOSPEL WAS PAINTED ON ENGLISH HANDMADE COLD-PRESS PAPER. THE MEDIUM IS TRANSPARENT WATERCOLOR. NO WHITE OR OPAQUE COLORS HAVE BEEN USED. SOME EFFECTS OF OPACITIES WERE PRODUCED BY USING NAPLES YELLOW WITH OTHER PIGMENTS.

CAPTURE THE SERENITY OF THE PAST

I love to travel. Most of my voyages take me to villages where there are still old buildings on meandering, crooked streets and a slow pace of life. These recall my upbringing in the southwest countryside of France. Our world is changing rapidly, and I want to preserve some of these serene scenes through my art in hope that perhaps someone will be emotionally touched like I was.

The village of Sospel is in Haute Provence, France.

FIND A NEW POINT OF VIEW

I have always been moved to paint the landscape. From time to time, I have painted more intimate views of nature, but I am always drawn back to the larger view. The patterns and rhythms of the terrain are the magnets that hold my attention. I remember as a boy peering out the windows of my dad's '55 Plymouth, watching the West go by. I am still travelling, seeking that unseen vista.

I look for subjects that create contradictions. The hard-edged geometry of engineered bridges, dams and roads act as a counterpoint to organic forms. Large natural structures like boulders, mountains or large monoliths contrast with the softer aspects of nature.

In my most recent work I have taken the eagle's-eye view of the subject. The most recent of these aerial views are from the vantage point of a helicopter; others are from canyon overlooks and other high points. Taking away the familiarity of the eye-level view and replacing it with the aerial viewpoint helps me see the relationship of natural land forms to each other and to man-made objects. It opens up new possibilities for design. From these heights I can easily engage the imagination in my interaction with the landscape.

BIG SUR BRIDGE
DALE LAITINEN
22" x 30"

IN **BIG SUR BRIDGE**, SEMI-TRANSPARENT GLAZES OF GESSO ARE LAYERED OVER TRANSPARENT WATER-COLOR, CUTTING AWAY THE SHAPE OF THE SKY AND OCEAN. THE LAND MASS HAS MANY LAYERS OF TRANSPARENT WATERCOLOR. THE DARK PASSAGES HAVE LAYERS OF WATERCOLOR, GOUACHE, ACRYLIC AND COLORED PENCIL.

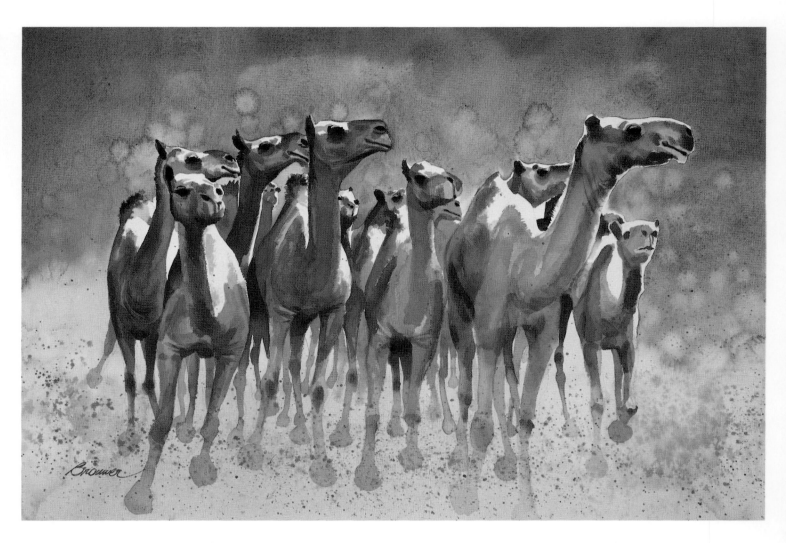

CELEBRATE LIFE—AROUND THE WORLD

To paint . . . to travel . . . to combine the two . . . is to celebrate life. Add to this ancient history, mystery and intrigue. Egypt, a country bathed in dazzling sunlight that creates exciting contrasts and textures, became my inspiration for a series of paintings of its markets, camel auctions, and towering statues of pharaohs. The emotional impact of the sounds, smells, moods and sights was almost more than could be digested. All of my preplanning was soon forgotten; I was overwhelmed by the inspiration and urgency to paint.

Transparent watercolor (my favorite medium) seemed to offer the best way to capture the spontaneity, the luminous color and chromatic freshness that I experienced. Observing the camel market—those smelly, spitting, arrogant animals under a relentless sun, dust swirling below—was my inspiration for *Camel Market.*

CAMEL MARKET
JACK R. BROUWER
14" x 21"

WORKING WET-INTO-WET TO CAPTURE THE ARID HEAT AND CHOKING DUST SEEMED TO BE A PARADOX. SPATTERING WATER IN THE DARKER AREAS AND DARKER TONES IN THE LIGHTER AREAS CREATED THE IMPRESSION OF PUFFS OF DUST IN THE ATMOSPHERE. THESE SAME SHAPES ARE REPEATED IN THE PARTIALLY OBSCURED FEET OF THE CAMELS, CREATING A UNIFYING DESIGN ELEMENT SURROUNDING THE SUBJECT. TO OBTAIN THE ILLUSION OF A HIGH, NOONDAY SUN, THE CAMELS ARE STRONGLY LIGHTED FROM ABOVE.

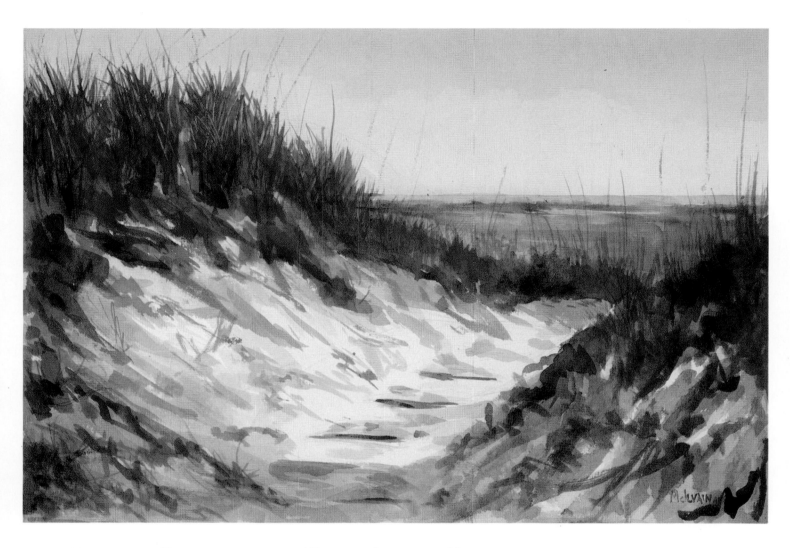

FEEL THE ENERGY OF THE WORLD AROUND YOU

As a landscapist, inspiration comes to me from the outdoors, especially when I'm able to envelop myself in the energy of the world around me. Whether it's Florida or Maine, each place has a pattern, design and color unique to itself. Ideas abound if I can get out of my everyday environment and travel to a new one. First come the abstract patterns of the region, followed by its colors and vegetation. After devoting two to four weeks to nothing but painting, I get to really know a region.

Painting outdoors each day has become my way of life; it gives me natural energy that can't be experienced indoors.

PASSAGE TO THE SEA
FRANCES H. MCILVAIN
15" X 22"

MCILVAIN USED PENCIL GUIDELINES TO BLOCK IN THE MAJOR AREAS OF **PASSAGE TO THE SEA**. WITH THE PAPER TILTED, THE ENTIRE AREA WAS SPRITZED WITH WATER. MIDTONE WASHES WERE LAID IN, KEEPING THE WHITES UNPAINTED. THE SEQUENCE OF LIGHT TO DARK WAS FOLLOWED, PAINTING WET-INTO-WET. GLAZING AT THE END GAVE DEPTH AND CONTRAST, AND CALLIGRAPHY WITH A RIGGER BRUSH DEFINED CONTOURS AND TIED AREAS TOGETHER.

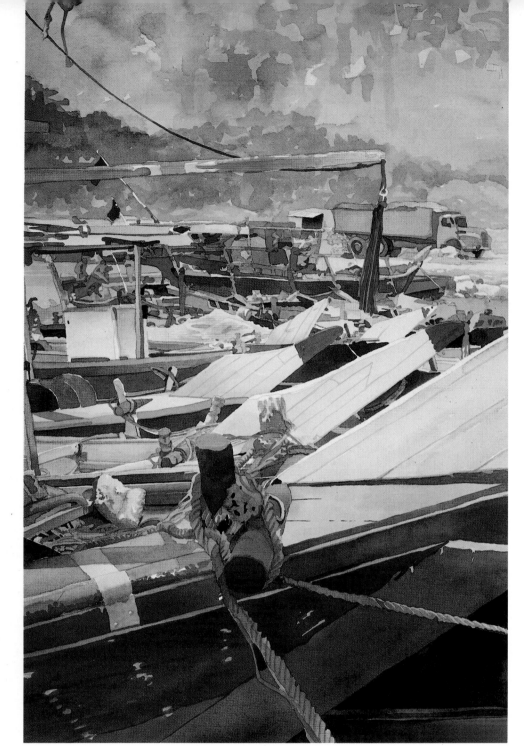

YOU CAN'T DRIVE THERE
MARC CASTELLI
22" x 15"

BECAUSE CLEAN COLOR IS SO IMPOR-
TANT TO CASTELLI, HE STARTED WITH
A COMPLETE DRAWING, PLANNING
SOME AREAS TO BE LOOSE AND
PAINTERLY TO CONTRAST WITH THE
DETAILS. AFTER A PALE WASH OF
NEW GAMBOGE DRIED, HE PROCEEDED
TO BUILD THE COLOR CLASSICALLY
FROM LIGHT TO DARK.

EXOTIC PLACES CHALLENGE YOUR SENSES

Water. Many of my paintings deal with water and boats, water and the shore, water as ice or snow, and even water implied by the total lack of it, such as a desert. While in Oman, I was struck by the contrast of spectacular coastline and harsh desert interior. The mountains in the Musandam are so incredible in their steep rises, dramatic drops and radical slopes that roads are few. It is on this peninsula jutting into the Straits of Hormuz, where indigenous dhows put into ports to be loaded with gravel, that I painted *You Can't Drive There.*

There they were, row after row, with their prows sticking up and their stems repeating each other right along the dock. The numerous repetitions screamed to become a painting. The light filtered through the gravel dust and made shapes come and go in the background. How could I not want to paint them?

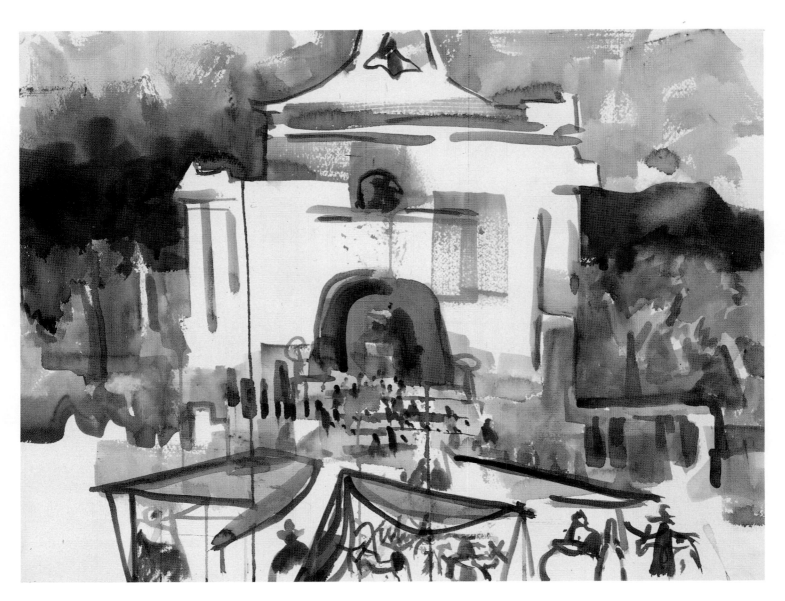

DON'T WORRY ABOUT TECHNIQUE

A number of years ago I visited Chichicostenango. I was so impressed with the white facade of the church, it has never left me. Inside I viewed the worshippers and climbed to the top of the church, guided by a persistent native boy full of persuasive charm. What a view from above!

I was so inspired when it came time to paint, I did this from memory after a few preliminary value sketches. I was happy doing the subject; I felt vigor . . . freshness . . . freedom of attack. The brush was loaded with water and pigment, and I was without inhibition, like a child. I think it is important not to worry about technique, but to concern yourself more with painterly quality. I feel I have captured the spirit and feeling of Chichicostenango.

CHICHICOSTENANGO
HENRY FUKUHARA
18" x 24"

FUKUHARA PAINTED
CHICHICOSTENANGO FROM
MEMORY. HE LIKES TO "LET WHAT
HAPPENS, HAPPEN," IN ORDER TO
PRESERVE THE FRESH BRUSH MARKS.
HE ALLOWS THE PAINT TO MIX ON
THE PAPER.

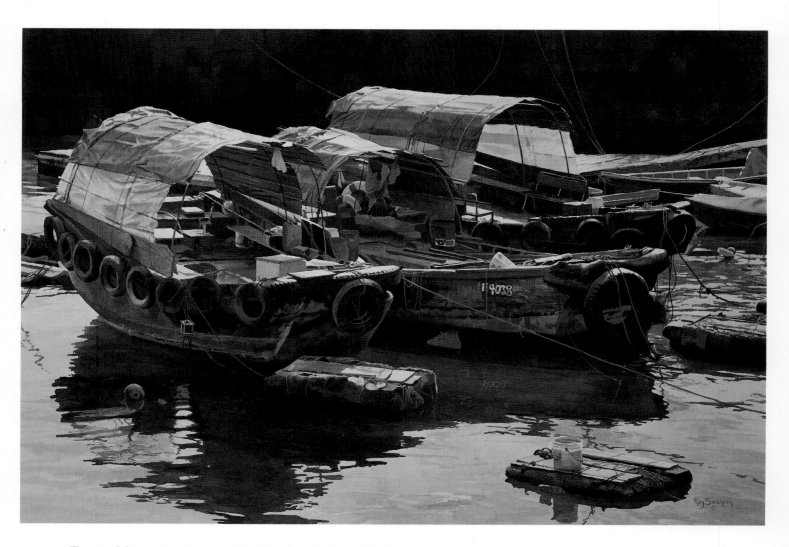

FIND MEANING IN DIVERSE CULTURES

My earlier watercolors focused on nostalgic themes from my childhood on a Midwestern farm. These works captured a passing era of rural life. Lately my inspiration has been places and nationalities of the world. As a genre painter, I depict various cultures and the struggle for survival of farmers, shepherds and artisans. I empathize with them because in my farm family, each member was taught to be industrious. In many countries where I have travelled, the people won my admiration because of their willingness to toil to make a living from the earth. I portray them as having contentment, color and spirit.

I have also found a challenge in the moods, colors and reflections of water. The Hong Kong harbor of Aberdeen fascinated me because of the strikingly divergent cultures sharing the same water. The traditional sampans reflected in the water, contrast with the bustling commercial ships.

Ray Swanson

IN ABERDEEN HARBOR
RAY SWANSON
22" x 30"

SWANSON FIRST LAID IN THE DARK
WASHES OF THE BACK WALL, ALONG
WITH THE PRELIMINARY WASHES OF
THE WATER AREA. THEN THE SAM-
PANS WERE LAID IN AND BROUGHT TO
COMPLETION. AFTER THAT, THE VAL-
UES AND COLORS OF THE WATER
AREA WERE REWORKED AGAINST THE
SAMPANS' COLORS AND VALUES.

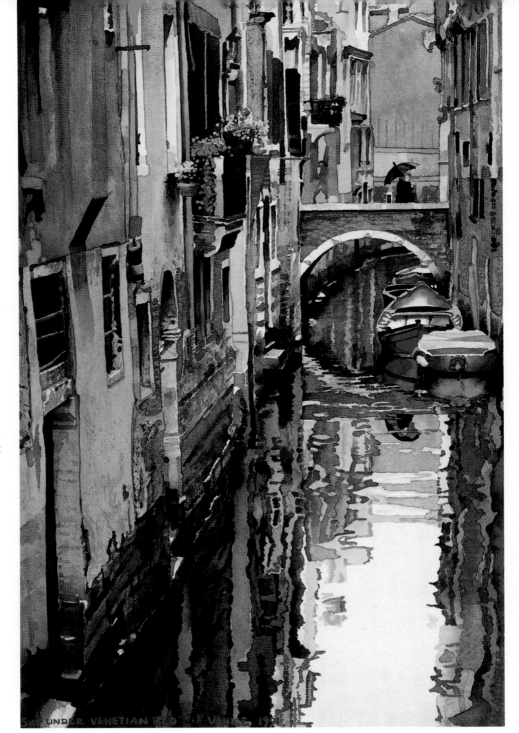

SKY UNDER VENETIAN RED
WILLIAM McALLISTER
22" x 15"

IN MOST OF HIS PAINTINGS,
McALLISTER WORKS DIRECTLY IN
SMALL BUT VERY WET WASHES, USING
ONLY A NO. 12 KOLINSKY SABLE
BRUSH. IN **SKY UNDER
VENETIAN RED**, HE SAVED THE
WATER FOR LAST. AS HE WORKED
TOWARD THE BOTTOM OF THE BUILD-
INGS, HE LAYERED GLAZES OF PAINT
TO BUILD UP DEPTH. THEN HE CARE-
FULLY DREW THE PATTERNS IN THE
SURFACE OF THE WATERWAY AND
PAINTED IN DIRECT SINGLE WASHES.
THE RESULT IS A SLICK, REFLECTIVE
WATER SURFACE THAT THE EYE HITS
AND THEN SLIDES RIGHT BACK TO THE
FOCAL POINT OF THE PAINTING.

DISCOVER THE MOOD IN AN ENVIRONMENT

While working as a motion picture production designer for twenty-nine years, I found my personal artistic expression through painting large, abstract oils. The switch to realistic water-colors marked the starting point for a period of great artistic growth, one that drew together my film work and my painting. I've spent well over half of my life designing environments based on the emotional requirements of a script. The way I designed sets and modified loca-tions was the "palette" I chose for each production, and it was geared to arouse specific emo-tional responses in an audience. This led me, in my own time, to seek environments that people have created for themselves. I learn an enormous amount in what I perceive as the inspiration of others in shaping their own surroundings.

In Venice I discovered these sources of inspiration around the marketplace, in unnamed interiors and in narrow streets and canals. I can only begin to grasp the audacity of the Venetians—their going out into the middle of a lagoon to sink pilings into the seabed, and then building one of the world's most beautiful cities on those wooden stilts—by paint-ing the results of their special madness.

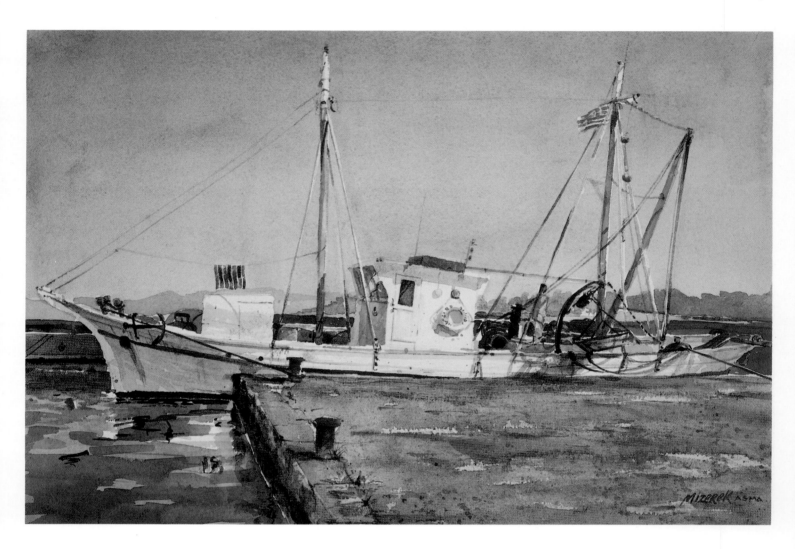

PAINTING THE WATERS OF THE WORLD

My primary interest is maritime subjects. For years, I've travelled around the world, brush in hand, always drawn to the water. I'm intrigued that one can recognize different parts of the world solely by the particular color of the water. I look for a special visual relationship between boat and water. Time of day, shadows, shapes and intensity of light are all critical to me, as I paint most of my work on location.

While on the island of Corfu, Greece, I spotted this working boat at the dock. The intense midday sun heightened the shape of the boat and defined shadows and reflections that I just couldn't resist. The sun-drenched hull appeared pure white against the sky and sparkling blue water of the Aegean.

Painting directly with bold brushstrokes, I kept my colors intense. The basic colors and shortened drying time due to the sun and dry breeze keep this painting crisp and fresh.

CORFU
LEONARD MIZEREK
11" x 14"

BASIC COLORS AND SHORTENED DRY-
ING TIME GIVE THIS PAINTING ITS
FRESHNESS. THE SUN HITTING THE
PAPER AND THE WIND DRYING THE
PAINT FORCED MIZEREK TO THINK
FAST. WITH NO UNDERDRAWING, HE
ALLOWED THE LINES TO BE LOOSE
AND PLAYED WITH THE MEDIUM.

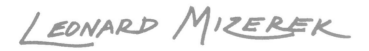

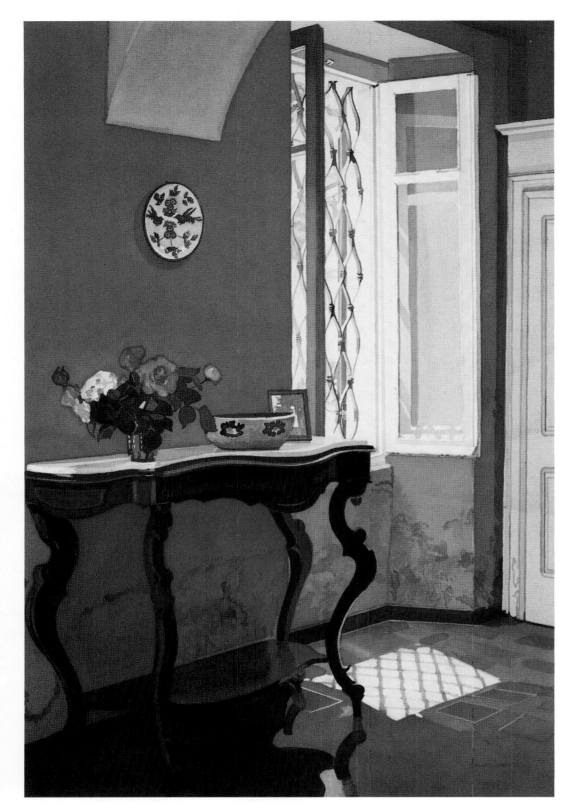

PIEMONTE INTERIOR
LINDA KOOLURIS DOBBS
30" x 22"

PIEMONTE INTERIOR SHOWS
THE WARM ITALIAN LIGHT ENTERING A
ROOM. (DOBBS LOVES THE WAY
EUROPEANS ARE NOT BOTHERED BY
PEELING PAINT.) TO ADD EXTRA
"BOUNCE" TO THE WALL, THE ARTIST
ADDED A FEW WASHES OF YELLOW-
OCHER ACRYLIC TO THE WALL TO FIN-
ISH IT.

HEIGHTEN YOUR SENSES BY TRAVELLING

I have always been a realist, and it is through realism that I try to call forth universal feelings.

My senses are heightened and my eye sees with clarity when I travel. I look for subjects bathed in and sculpted by light. When I am in a place long enough, I do watercolors on the spot, but mostly I use the camera for a sketchpad. I shoot each image as if it were to be the next painting, tightly composed in evocative light.

If I can make viewers wonder what is behind a door or believe they know that place though they were never there, the work is a success.

Linda Kooluris Dobbs

CHAPTER 6

Finding Meaning in Special Objects

FINDING THAT *special object that sparks the idea for a new painting is a thrill.*

—Judy Koenig

WHETHER AS UNIVERSAL AND NATURAL as water or flowers, as massive and strange as roller coasters or heavy construction equipment, or as simple and personal as pottery and collectibles, certain *things* delight and inspire these artists.

**MORNING LIGHT
SHARON CROSBIE
22" x 30"**

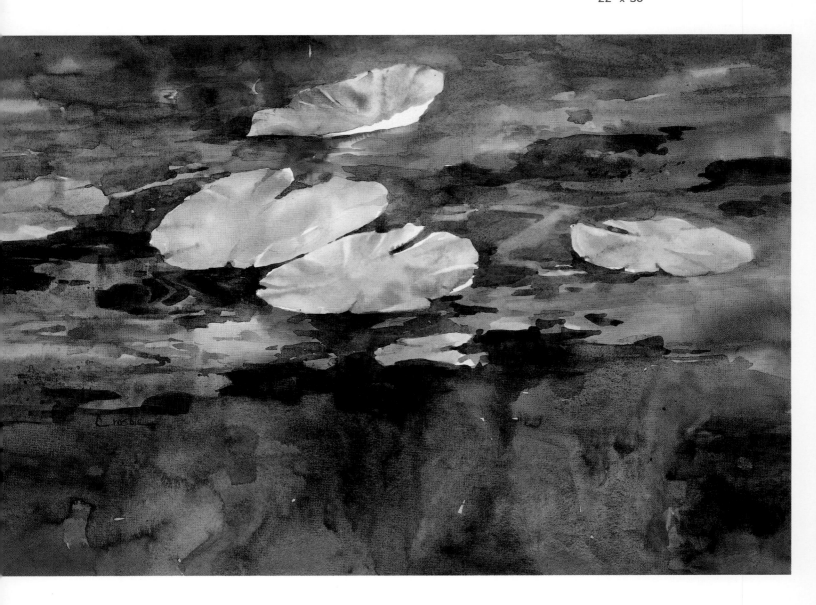

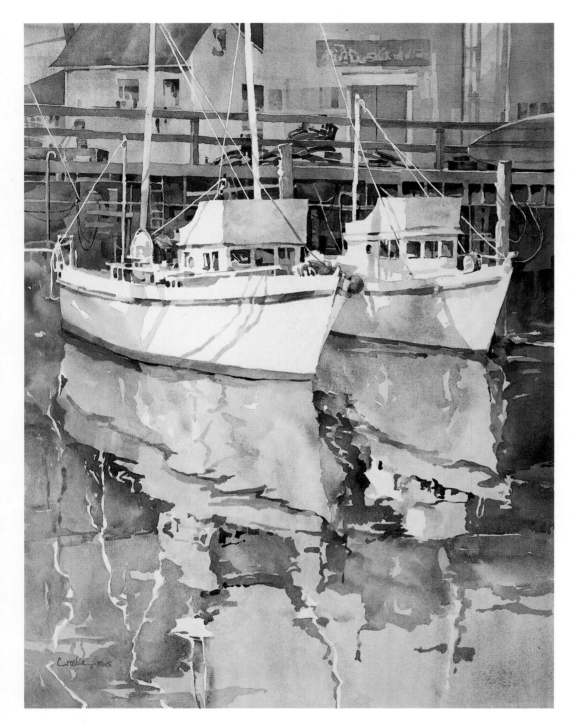

THE FIRST WASH IN **MORNING LIGHT** [FAR LEFT] WAS AN ABSTRACT LAYERING OF COLOR IN LIGHT TO MEDIUM VALUES OVER THE UNDERDRAWING OF THE WATER LILIES. ONCE THIS WASH OF COLOR WAS DRY, CROSBIE PAINTED THE JUICY TRANSPARENT DARKS. SHE WORKED AROUND THE LILY PADS, VARYING THE EDGES FROM HARD TO SOFT AND BACK AGAIN. SHE WAS ABLE TO KEEP THE DARKS BOTH LIQUID AND TRANSPARENT BY LETTING THE COLORS MIX ON THE PAPER AND TILTING THE BOARD NOW AND AGAIN.

JUST THE TWO OF US [LEFT] MAKES USE OF THE WHITE OF THE PAPER. THE LARGE WHITE AREAS WERE PAINTED AROUND, WHILE SOME OF THE NARROW RIGGINGS WERE MASKED TO ALLOW FOR A CONTINUOUS BACKGROUND WASH. THE PAINTING IS BASICALLY DONE IN THREE WASHES, GOING FROM LIGHT, TO MIDDLE, TO THE DARKEST VALUES LAST, LETTING EACH DRY BEFORE STARTING THE NEXT.

JUST THE TWO OF US
SHARON CROSBIE
30" x 22"

WATER—THE STUFF OF LIFE

Water never ceases to amaze me with its endlessly varied responses to its surroundings. Besides motivating me to paint its patterns, abstract shapes and colors, I see it as a great equalizer. It supports all our endeavors, from the simple task of making my paint flow, to sustaining life. It is the common denominator that all humanity shares. However the stage is set, the real star of my paintings—and my inspiration—is water in all its varied forms and all the effects it creates. I find the interaction between water and its environment most exciting.

Sharon Crosbie

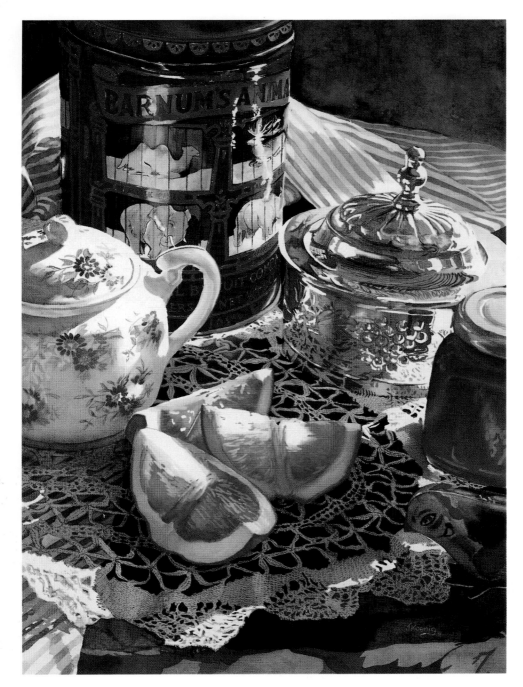

PAINT A STILL-LIFE TREASURY

There are so many worlds we don't know about. When a different world is opened to us it can be utterly inspiring. A friend from the eastern United States grew up in a family whose hobby it was to collect antique art pottery. This is a whole world I had no idea existed. To my amazement, there are thousands of people who are collectors. My friend and I went to some antique shows together and before long I was hooked on this incredible pastime, a natural for a still-life painter.

The collecting extended to other antique objects, fabrics, books and tins. Combining this hobby with the fruits and vegetables I already loved to paint led to a show-winning combination and years and years of subject matter and enjoyment.

Finding that special object that sparks the idea for a new painting is a thrill. Most of my paintings are highly personal and sentimental. I try to combine my own precious objects, like letters from friends and family treasures, with the great "junk" I love to collect.

MINE A MUSEUM DISPLAY FOR IDEAS

My ideas and inspirations for painting come from my memories—childhood through adult experiences—that move or excite me. American Indians have fascinated me since childhood with their garments, weapons, implements and decorations. I have my own collection, and visits to national and local museums to see artifacts further my study of Native American ways and stimulate my desire to paint them.

I like doing night scenes like *Kindred Spirits I.* Here, I tried to challenge the viewer with two points of view. Are these shields displayed in a U.S. cavalry camp, or is the American flag in an Indian camp?

Joseph Melançon

MELANCON WILL GO TO ANY LENGTH TO ACHIEVE TEXTURE. HIS PROCE-DURE IS UNSTRUCTURED AS HE CUTS OUT SHAPES WITH A TWO-INCH BRUSH. HE GLAZES AND THEN REMOVES BITS AND PIECES OF COLOR.

HE SPATTERS, DRAGS AND SCRAPES, TORTURING HIS BRUSHES AND USING HIS FINGERS TO DO EVERYTHING POSSIBLE TO ACHIEVE VARIETY, INCLUDING RUBBING THE SURFACE WITH A DRY TOWEL.

KINDRED SPIRITS I
JOSEPH MELANCON
22" x 25½"

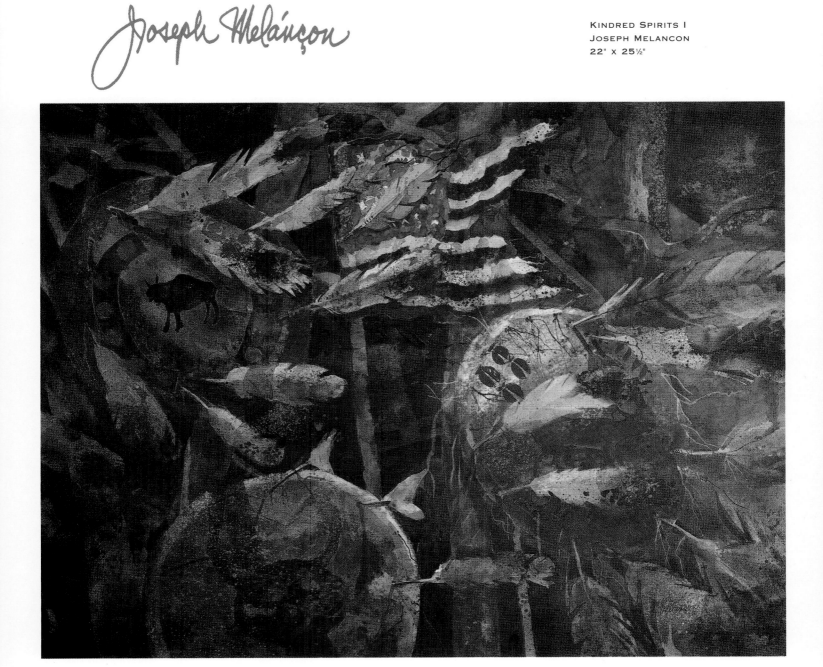

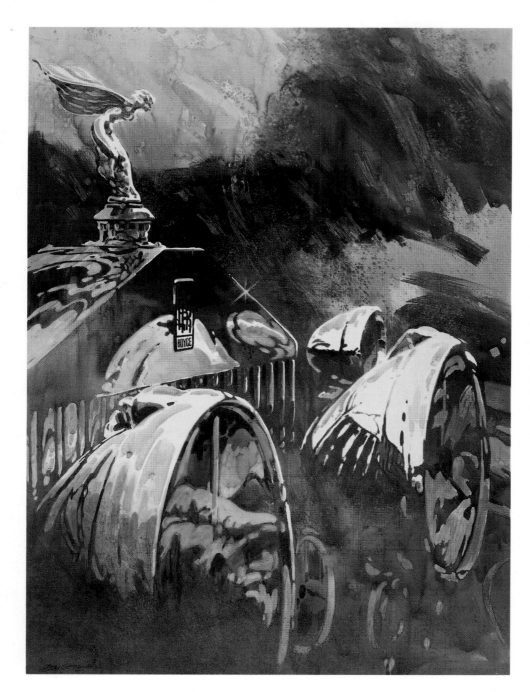

SILVER LADY, NO. 3 IN
AUTOMOTIVE IMAGES SERIES
DONALD JAMES GETZ
40" x 30"

GETZ DESIGNS THE PAINTING WITH A
NUMBER OF SMALL PENCIL SKETCHES.
HE MAKES HIS FAVORITE INTO A
35MM SLIDE AND PROJECTS IT ONTO
THE PAPER OR CANVAS. THIS
PROCESS OF ENLARGEMENT ALLOWS
HIM TO MAINTAIN THE FINE DETAILS
AND PROPORTIONS OF THE ORIGINAL
DRAWING, WHILE CROPPING CRE-
ATIVELY. HE BLOCKS OUT THE WHITE
HIGHLIGHTS WITH PEBEO LIQUID
MASK, THEN PAINTS IN THE BACK-
GROUND AREA WITH ABSTRACT PAT-
TERNS USING A LIMITED PALETTE OF
A SPECIFIC BLUE, RED AND YELLOW.

NEW LOOK FOR AN OLD SUBJECT

Throughout my life, I've been fascinated by automobiles: antique cars, classics, rods, customs and racing cars. I built two hot rods by the time I graduated from high school. I raced drag cars and sports cars in the fifties and sixties. After marriage and starting a family, I settled for the excitement of attending road races and photographing cars in action.

Meanwhile, my career progressed from commercial illustrator to fine artist, painting the usual landscapes and seascapes, but I still had an urge to get back to my automotive interests. Recently, I decided to create a series of automotive images that I hoped were different from the works of other artists dealing with this subject. Inasmuch as my landscape and seascape works were reasonably traditional, I wanted this automotive series to have a totally different impact.

The challenge to me is to take this traditional subject and use what is there to create an even more fascinating image—my personal statement. It's a whole new world for me and, as a result, I also enjoy my landscape and seascape painting more than ever.

Don Getz

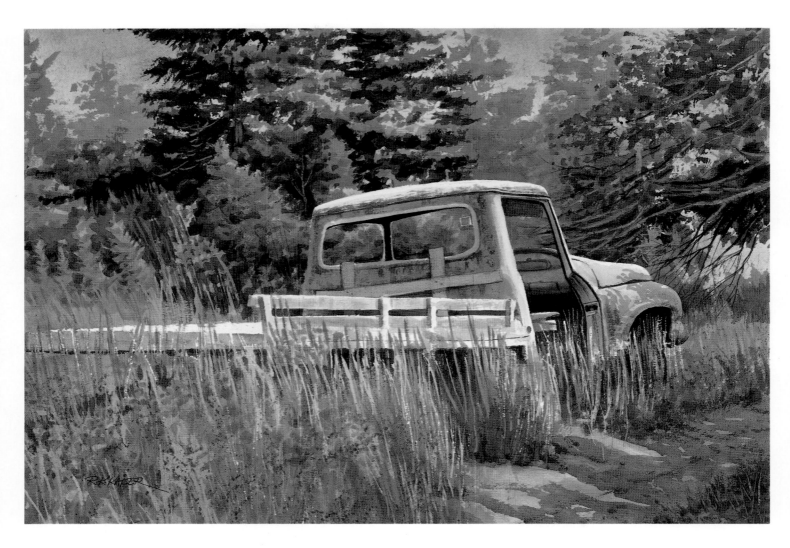

DETERMINE WHAT IS SPECIAL ABOUT EACH SUBJECT

When I arrive at a scene or subject and decide that this is what I want to paint, I ask several questions: Does the subject or scene affect me? Shall I paint the subject or scene as I see it or should I rearrange it? Will I finish it in one sitting or finish it later (with the help of notes, sketches, photos, etc.) in my studio? Concentrate on your motivation (inspiration, if you will) and the thought of what about the scene made you stop to look.

On a research and painting tour of Monhegan Island I was walking down one of the few roads and came across this poor old truck. The old workhorse didn't work anymore, but it still worked for me. What a great subject to paint. Note all the cast shadows and the textures in the painting, which help make it a "special" subject.

DERELICT NO. 2—
MONHEGAN ISLAND
RICHARD K. KAISER
22" x 30"

AFTER PAINTING THE SKY WET-ON-WET KAISER MASKED MOST OF THE TRUCK WITH TAPE. HE CUT THE OUTLINE OF THE CAB AND CUT OUT THE WINDOWS, THEN USED MASKOID TO INDICATE WHERE THE GRASSES AND MAJOR WEEDS WERE TO STAND OUT AGAINST DARK WEEDS. HE PAINTED THE BACKGROUND TREES AND THE FOREGROUND DARK TO MAKE THE TRUCK CAB STAND OUT. SOME SPATTER WAS ADDED OVER THE FOREGROUND WEEDS TO INDICATE COLORFUL BLOSSOMS.

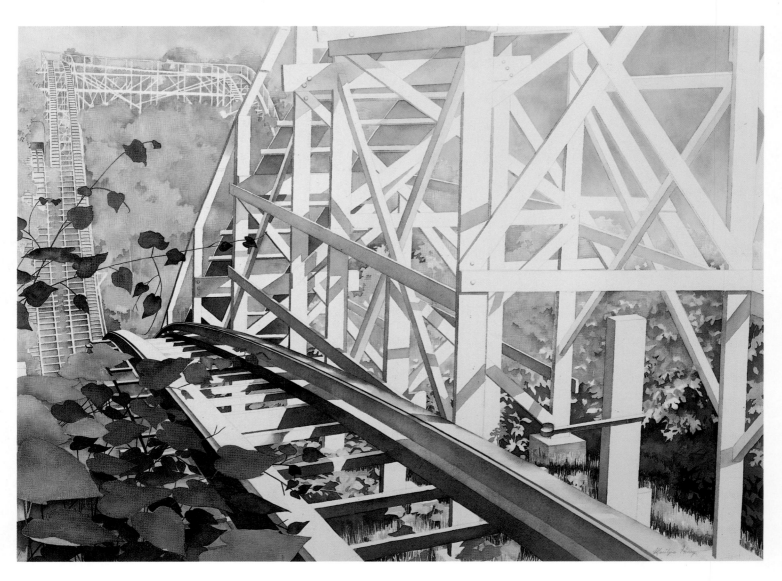

CONJURE UP SENSATIONS FROM CHILDHOOD

Climbing the rollercoaster tracks on summer mornings before the park opens conjures up sensations from my childhood: the warm summer breezes, cresting the big dip and antici-pating the thrill ahead, being hurled around the curves; remembering the sounds: the click-ity-clack of the tracks, the laughter, the screams, the carousel music in the background. Even the smells motivate me: damp woods in the hollows, newly cut grass, cotton candy, French fries. Without a doubt, my most inspired and most personal paintings have been Pennsylvania amusement park scenes.

It is important that the painted images are large enough for me to feel that I can walk into the scene and relive it. No figures are included in these scenes to break this mood or date the paintings. My goal is to capture the mood of anticipation and create a feeling of timelessness. In this scene, I was attracted to the large geometric white structure contrasting with the lacy tracks in the distance. I moved the post that blocked the crest of the hill to cre-ate a dramatic center of interest.

Marilyn Henry

THE THUNDERBOLT,
AFTERNOON
MARILYN HENRY
30" x 41"

THE THUNDERBOLT,
AFTERNOON IS PAINTED ON
ARCHES 555-LB. COLD- PRESS PAPER.
AFTER THE DRAWING WAS COMPLET-
ED, HENRY BEGAN PAINTING LIGHT
WASHES IN THE SHADOWED AREAS,
BUILDING UP A CONNECTING PATTERN
THROUGHOUT THE PAINTING. SHE
DREW IN THE SMALL DETAILS AS SHE
PAINTED, SLOWLY BUILDING UP THE
VALUES AND COLORS, CONTINUALLY
BALANCING THE COMPOSITION WITH
EMPHASIS ON THE CENTER OF INTER-
EST UNTIL THE PAINTING WAS COM-
PLETE.

COMBINING NATURAL AND HOUSEHOLD TREASURES

My inspiration is molded by my childhood dream world of small boundaries—the perennial border of fairy tales and domesticity, summers that stretched long and unplanned at an unhurried, quiet pace. Growing up in the northern United States, I had the experience of being deprived of flowers for six months of the year. The first spring blooms were so long awaited they had near-spiritual significance. Flowers still inspire me with their organic splendor heightened by the drama that light creates. I like to combine their natural beauty with the small treasures of domestic life to conceive a personal rendering.

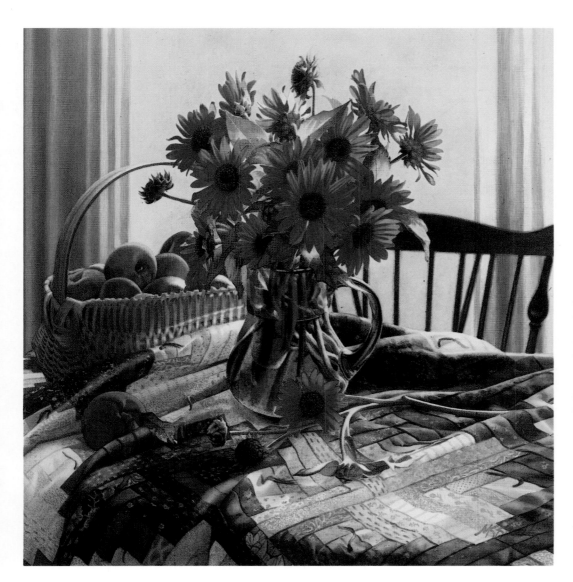

PRAIRIE GOLD
MARY KAY KRELL
22" x 22"

UNLIKE SOME ARTISTS, KRELL BEGINS WITH DETAIL FIRST. SHE STARTED **PRAIRIE GOLD** WITH A CAREFUL DRAWING, PAYING PARTICULAR ATTENTION TO THE FLOWER, QUILT PATTERN AND BASKET WEAVE. SHE THEN ADDED COLOR TO THE DETAILS WITH SMALL BRUSHES BEFORE SHE BUILT FORM WITH GLAZES OF COLOR. SHE ACHIEVED SHADOWS WITH NEUTRAL GLAZES.

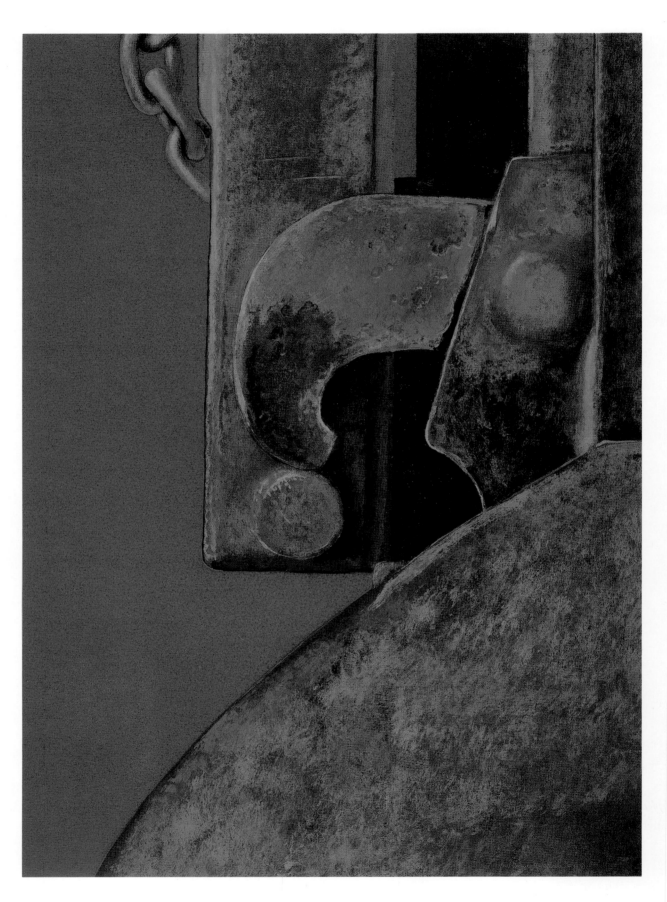

SEEDEATER
EARL GRENVILLE KILLEEN
14¼" x 10¼"

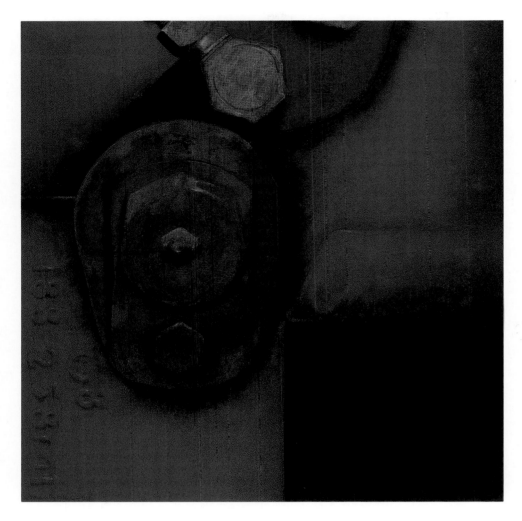

CHRYSALIS
EARL GRENVILLE KILLEEN
14" x 14"

KILLEEN CREATES HIS UNIQUE TEX-
TURES WITH MANY LAYERS OF VIS-
COUS WATERCOLOR, WHICH HE PUSH-
ES INTO HIS PAPER WITH A STIFF
BRISTLE BRUSH. HE THEN LIGHTLY
APPLIES A POWER SANDER, ALTER-
NATELY BUILDING UP PAINT AND
SANDING IT AWAY.

THE SEARCH, FOCUS AND APPLICATION

The creative process for me unfolds in three stages that I call the search, focus and applica-
tion. First is the search for subject matter, which I will have to translate from a three-dimen-
sional world to a two-dimensional painting surface. For this, I put on my "2-D vision glass-
es" so I can search my surroundings for flat planes of strong values and fluid lines vibrant
with energy and opposition.

Next, my focus is drawn to a subject by its properties of size, shape, color and value,
and its impact on my mind and emotions. Recently, I've been drawn to heavy construction
equipment, intrigued by its massive presence and latent power, and by the contrast between
its impassive docility at rest and its impressive potency when activated. I'm amused at often
finding a portion of one of these metal behemoths animated by a resemblance to a flesh-and-
blood creature, which has inspired titles such as *Pelican, Triceratops, Unicorn* and *Trojan
Elephant. Seedeater* was the first subject that resembled something animated—in this case,
something parrotlike.

Finally, I undertake the most difficult phase of the process in my studio, armed only
with a dozen or so snapshots showing different angles of the chosen object, and with a feel-
ing not so much of inspiration as of awe (if not terror) at the task facing me. The photos are
aids to my understanding of the three-dimensional structural reality that I will wrestle (or
waltz, if I'm lucky) into a convincing and compelling form on paper.

Earl Grenville Killeen —

LOOK FOR A HUMOROUS TOUCH

As an artist living near the picturesque city of Charleston, South Carolina, it has always been my goal to paint this city in a unique and personal way. I have also been interested in the use of humor in paintings.

In 1988, at Charleston's annual Southeastern Wildlife Festival, I noticed the absence of humor in the works displayed. That's when the idea occurred to me to paint wild animals in humorous and unlikely situations with recognizable Charleston scenes.

The inspiration for each painting comes to me either by looking through my photographs of Charleston and visualizing the animal best suited for that image, or by finding a photo of an animal whose pose suggests to me a specific Charleston scene. The interesting fact behind *Tale of Colonial Lake* is that the lake is only three feet deep.

Steven Jordan

TALE OF COLONIAL LAKE IS
ON HOT-PRESS PAPER USING TRANS-
PARENT WATERCOLORS. MUCH OF THE
COLOR IS APPLIED BY PREWETTING
THE PAPER AND FLOATING THE COLOR
INTO IT.

TALE OF COLONIAL LAKE
STEVEN JORDAN
14" X 19"

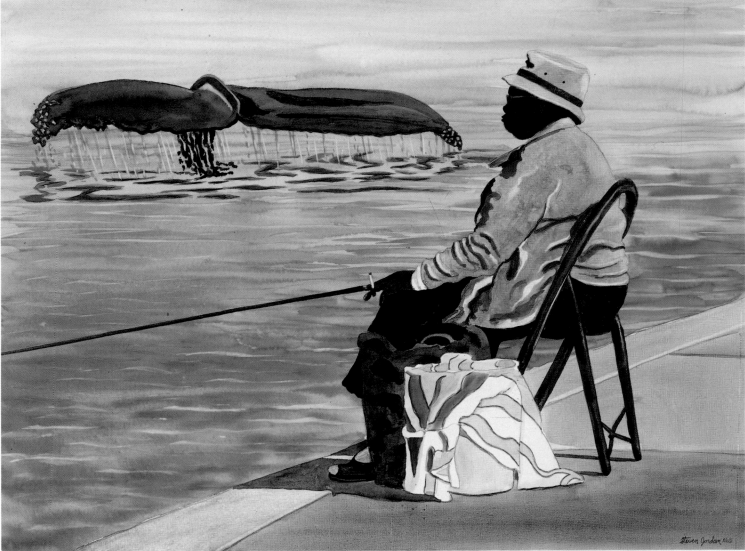

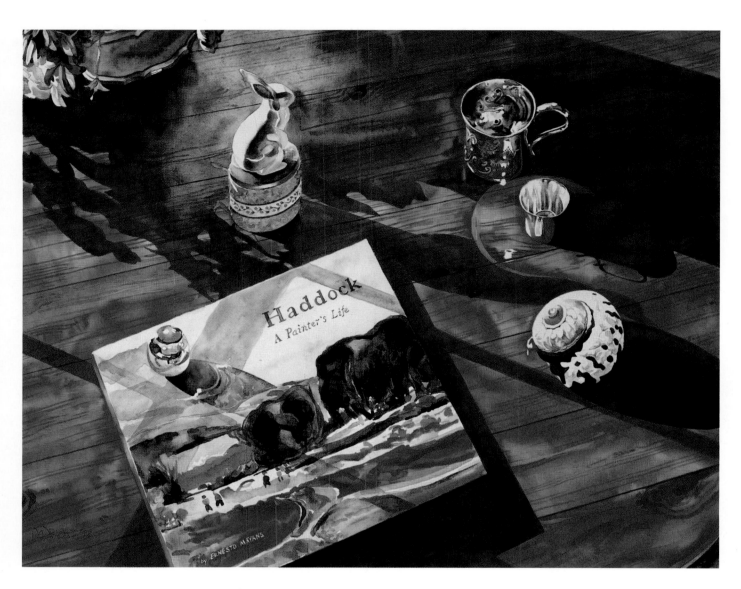

DRAMATIZE FAMILIAR OBJECTS

Inspiration comes from many areas and has a lot to do with our individual personalities and family upbringing. I have always been interested in objects, mostly man-made. When I got around to still-life painting many years ago, I knew I had found myself as an artist. I focused on the objects in my home, items I live with and know best.

Even so, my still-life painting has more to do with light and shadow than with the objects themselves. I always choose strong, direct backlighting that creates patterns of intricate abstract shadows. These shadows become strong design elements that lie across and touch other objects in the setup.

When I choose objects for a setup, I look for pieces of various sizes, shapes, textures and colors. I move the pieces around the table, exploring the spatial relationships, the reflective light, the cast shadow patterns. I also photograph the setup as the light changes. Even though I am a realist, I try to let the medium show and allow it a certain degree of freedom.

HADDOCK WITH SHELL
WILLIAM C. WRIGHT
14" x 18"

IN **HADDOCK WITH SHELL**, WRIGHT USED PERSONAL OBJECTS IN A WARM COLOR SCHEME. HE WORKED IN A TRADITIONAL METHOD, PAINTING AROUND THE WHITE AREAS AND LAYERING LIGHT WASHES, SAVING THE DARK, STRONG COLORS FOR LAST.

CHAPTER 7

A Place That Touches the Soul

WHEN I REACH *down within myself to find inspiration, I am searching for ways to visually convey my feelings about a place that has special meaning for me.*

—*Robert Reynolds*

FROM COASTAL MAINE to the Sierra Nevadas, from northern Michigan to the Florida peninsula, from the Rocky Mountains to Staten Island, there is a special "place in the heart" that inexorably draws these artists back again and again.

WINTER LIGHT
ROBERT REYNOLDS
27" x 38"

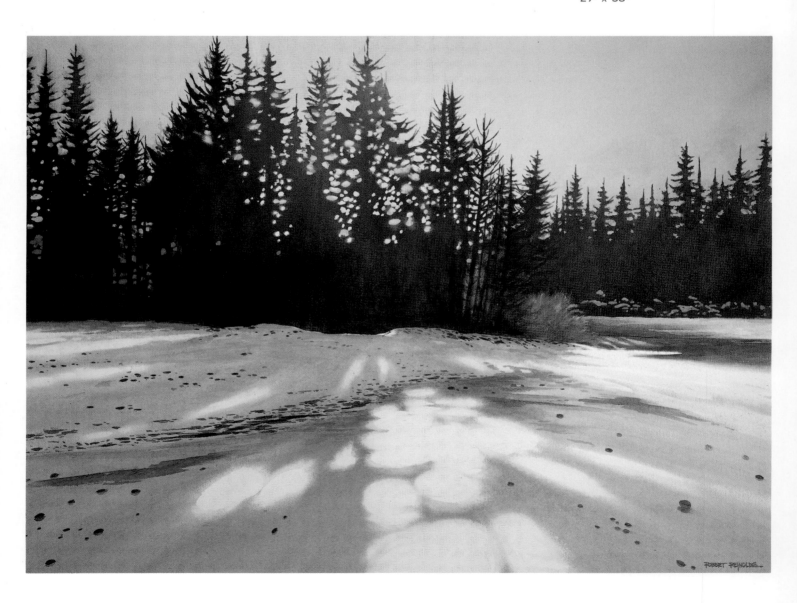

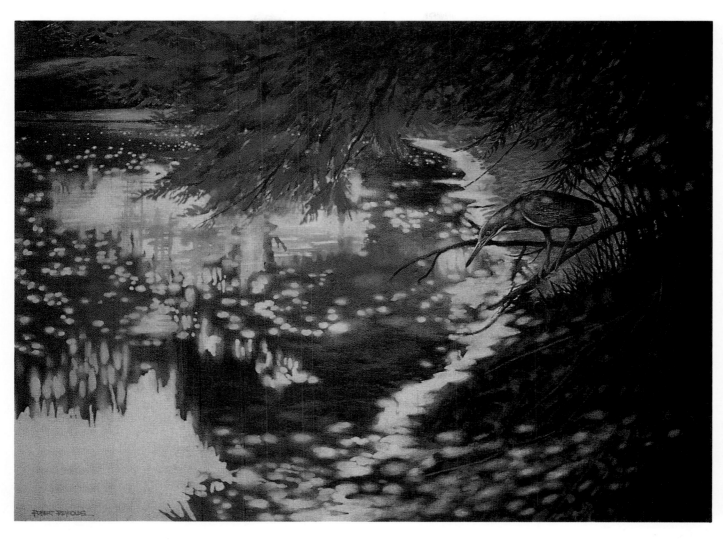

REACH DOWN WITHIN YOURSELF

Much like a patchwork quilt, inspiration that stirs and motivates me is made of many things. It might be discovering an interesting arrangement of nature's objects, colors, or textures and patterns. Or inspiration might occur because I am in a particular place when atmospheric conditions provide a surprising display of sunlight dramatically striking various forms.

It can be magical if all of these conditions occur concurrently at a particular location, but they rarely do. It is up to the artist to provide some of these conditions from experience and memory. When I reach down within myself to find inspiration, I am searching for ways to visually convey my feelings about a place that has special meaning for me. Generally, I paint in two areas that I intimately know and love: the central Sierra Nevada mountains and the central California coast. Although I modify location elements to best suit the mood I want to convey, the painting essentially remains faithful to the "place," but hopefully in a subtle, spiritual way.

Through my work, I have always strived to convey uplifting human values. No small task, but this alliance with nature provides unlimited opportunities for this personal conviction to take place.

AUTUMN LIGHT
ROBERT REYNOLDS
27" x 38"

IN **AUTUMN LIGHT**, REYNOLDS LEADS THE VIEWER THROUGH THE COOL FOREGROUND SHADOWS INTO THE PLAY OF ABSTRACT LIGHT PATTERNS CREATED BY THE SUN STRIKING THE WATER. A GOOD DEAL OF MASKING FLUID WAS USED TO SAVE THE VARIOUS WHITES, BUT LATER, AFTER THE MASKING FLUID WAS REMOVED, HE SOFTENED THE LIGHT SHAPES WITH WET TISSUES.

WHAT ATTRACTED REYNOLDS ON THE PARTICULAR DAY AND TIME HE PAINTED **WINTER LIGHT** (LEFT) WERE THE INTERESTING LIGHT PATTERNS THAT THE SUN CREATED ON THE FROZEN LAGOON AS IT PEEKED THROUGH THE VARIOUS TREES. HE TOOK A SMALL BACKLIT SCENE AND EXPANDED THE EFFECT INTO A DRAMATIC ARRANGEMENT OF SHAPES.

A PAINTING BEGETS A PAINTING

Creating is a natural response to stimuli, both internal and external. I am inspired by the light of the Florida sun and how it affects the objects it shines on and through. This is my "external trigger." Once a completed painting has explored this subject, it becomes the "internal stimulus" for another. Working in series—using the old "a painting begets a painting" theory—works well for me.

I have no interest in the dark and gloomy. To me, the delight of watercolor is in capturing the light within the white paper by surrounding it with successive washes of transparent color. I further push the luminosity by pouring and blending the washes on wet paper while preserving the white space with masking. The brush is used only for finishing details.

Jean Grastorf

WHILE MASKING AND THEN POURING TRANSPARENT WASHES WAS THE METHOD USED FOR **BEACH**, A PAPER GRASTORF USED FOR THE FIRST TIME—WATERFORD'S 300-LB. ROUGH—PRODUCED A SPECIAL SPARKLE. THE PIGMENTS USED WERE TRANSPARENT STAINING COLORS, WHICH WERE ALLOWED TO BLEND AND FLOW ON THE PAPER, CAPTURING THE LUMINOSITY OF THE SCENE AT FORT DESOTO PARK, NEAR ST. PETERSBURG.

BEACH
JEAN GRASTORF
20" x 28"

PAINT THE CHARACTER OF A PLACE

My subject matter is generally some aspect of the landscape, either natural or human-built, but they're not mere depictions. Simply put, I try to capture the essence of a place and deal with its character. I like my paintings to feel like a place rather than look like it. I have become aware of the temperature of light and can finally recognize subtle differences in textures and colors, all of which I try to depict. I even want to express the quality of sounds and to portray qualities like energy, dynamism, calmness, solitude, and similar attributes of the landscape elements. *Coastal Path* was begun on location with the intention of creating a work that captured the sensual nature of the central California coast, including its sight, smell, sound and feel. The quality of the cool light fixes the atmosphere and establishes the mood.

The environment becomes inspiration. My response to it becomes idea. And idea becomes purpose and action through interpretation and painting.

Gerald F. Brommer

COASTAL PATH
GERALD F. BROMMER
22" x 30"

COASTAL PATH WAS FIRST DEVELOPED WITH LIGHT VALUES, AND SUCCEEDING GLAZES GRADUALLY BUILT UP THE FINAL SET OF VALUE CONTRASTS. BROMMER RAN THE FOGGY SKY AS A WET-INTO-WET WASH ON AN ALMOST VERTICAL SURFACE; HE POSITIONED THE FOG-SHROUDED TREES AS THE SKY STARTED TO DRY. THE VEGETATION AT THE BOTTOM WAS ADDED, AND THEN ROCKS, TREES AND FOLIAGE IN ASCENDING SHAPES TO BUILD RECEDING FORMS THAT PULL THE EYE INTO THE FOGGY DISTANCE.

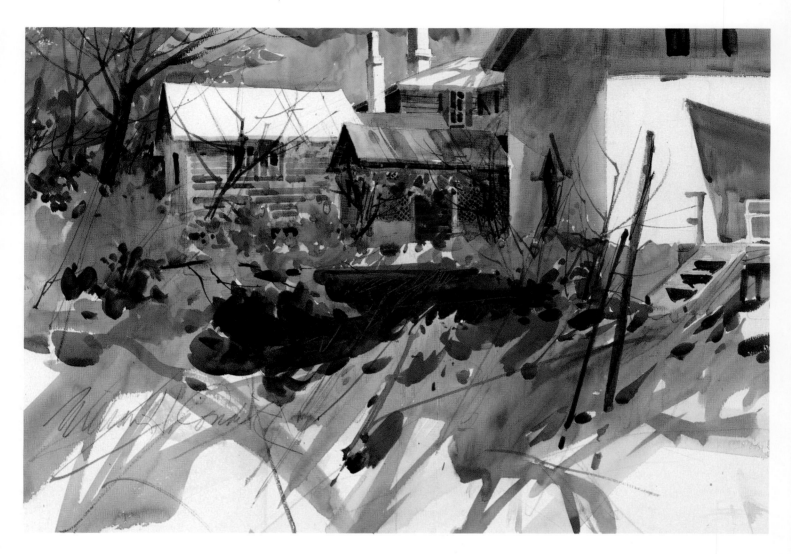

CIVIL WAR HIDEOUT
WILLIAM H. CONDIT
14" x 21 ½"

IN **CIVIL WAR HIDEOUT** CONDIT
MAKES HIS FIRST STATEMENT WITH A
LARGE, TWO-INCH BRUSH. HE TRIES
TO COMPLETE AT LEAST 60 PERCENT
OF THE WORK WITH THIS TOOL, MUCH
LIKE USING THE "DRIVER" IN A GAME
OF GOLF. AFTER HIS FIRST STATE-
MENT, HE DROPS DOWN TO A "FIVE-
IRON" BRUSH, THEN ON TO THE
"GREEN," WHERE HE FINISHES OUT
WITH SMALLER "PUTTER" BRUSHES.
IN THE FOREGROUND YOU CAN SEE
HOW HE USED THE RIGGER BRUSH
FOR INDIVIDUAL BLADES OF GRASS.

TELL THE STORY BEHIND THE SCENE

My commitment to watercolor began many years ago, and I am still obsessed with it. Aside from my family, it has become my first priority in life. I cannot "sort of" be a watercolorist; I'm forever trying to be the best I can be.

I am inspired by both the sensations of nature and the stories behind the scene. I could not resist painting the unusual rock formation in *Sounds of Nature's Music*. In that place, the wind and rapids together make a sound I could listen to all day.

The "story behind the scene" came to life for me in *Civil War Hideout*. This group of buildings in Gainesville, Georgia, escaped the fighting in the Civil War and became a hide-out for one large family. It is in almost the same condition today as it was then, furnishings and all.

When painting these emotion-packed scenes, I attempt to combine the abstract with realism. I avoid copying the subject as a camera would. As I sketch a loose pencil drawing,

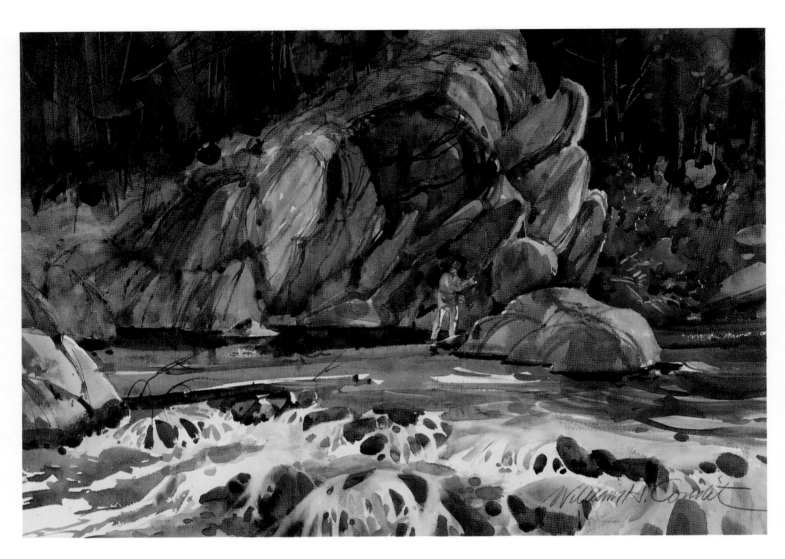

my "plan of attack" for the watercolor medium begins to emerge in my mind. I try to think ahead through at least one-third of the work. If this first statement is successful, the rest seems to subconsciously pull me into the piece to, hopefully, a grand finish. The never-ending challenge of transparent watercolor keeps me on a constant "high." My motto has always been, "Do something better today than I did yesterday."

William H. Condit

SOUNDS OF NATURE'S
MUSIC
WILLIAM H. CONDIT
14" x 21½"

SOUNDS OF NATURE'S
MUSIC WAS PAINTED NEAR
KITTREDGE, COLORADO, ON BEAR
CREEK. CONDIT AND HIS CLASS
CRAWLED THROUGH BUSHES TO AN
OPEN SPOT ON THE OPPOSITE BANK.
CONDIT ALWAYS TAKES A LONG LOOK
AT HIS SUBJECTS TO ARRIVE AT A
GAME PLAN BEFORE STARTING TO
WORK. HE PUT IN THE FISHERMAN TO
SHOW SCALE, THOUGH THERE WAS NO
FISHERMAN THERE AS HE WORKED.

LISTENING TO THE BOATS TELL THEIR STORY

"The docks" was an area I took for granted in my youth. Now that I have lived away for many years I feel inexorably drawn back to the boats whenever I visit my hometown. Here I find solace and inspiration. Through my painting I strive to describe and preserve this endangered species—endangered not so much by the elements and time, which they have weathered for centuries, but by people who seek to "develop" this way of life out of existence. A fisherman once told me my own grandfather helped build some of these boats. But now that I want to know more, there is no one left to ask. So I listen to the boats. I let their scars and scents, lobster traps, coiled ropes and barrels tell me their story. I explore the mysteries beneath the surface and in the undulating alter-ego reflections.

Bottoms Up II is a memorial to my hometown and its special way of life. The symbols and character of generations of fishermen are reflected in the rhythmic water—vulnerable to the whims of wind, current and humanity. *C.A. Harrington* is a grand old man of the sea. Its sides are burnished with rust that's almost iridescent, testimony to a lifetime of sea service.

Lois Salmon Toole

C.A. HARRINGTON
LOIS SALMON TOOLE
21" x 28"

TOOLE USES TRANSPARENT WATERCOL-
OR ON 300-LB. COLD-PRESS PAPER,
THOUGH ALL OF HER LARGER WORKS
BEGIN WITH MINIATURE PAINTINGS.
SHE USES NO TRICKY TECHNIQUES BUT
EXPLOITS THE PROPERTIES OF THE
PAINT: STAINERS THAT FEATHER AND
BLEED, AND SO-CALLED "OPAQUE"
EARTH TONES THAT SIT ON TOP OF THE
PAPER. AFTER SAVING THE WHITES
WITH MASKING FLUID, SHE LAYS IN
BROAD UNDERLYING PATTERNS ON
WHICH TO BUILD THE IMAGES, PAINT-
ING SKY AND BACKGROUND FIRST,
REFLECTIONS LAST. SHE REWETS THE
PAPER FOR PASSAGES WITH SMOOTH
TRANSITIONS AND SOFT EDGES. FOR
SHADOWS UNDER THE HULLS, SHE
REWETS THE PAPER AND LETS UNDI-
LUTED COLOR MIX AND BLEND ON THE
PAPER.

BOTTOMS UP II
LOIS SALMON TOOLE
28" x 20½"

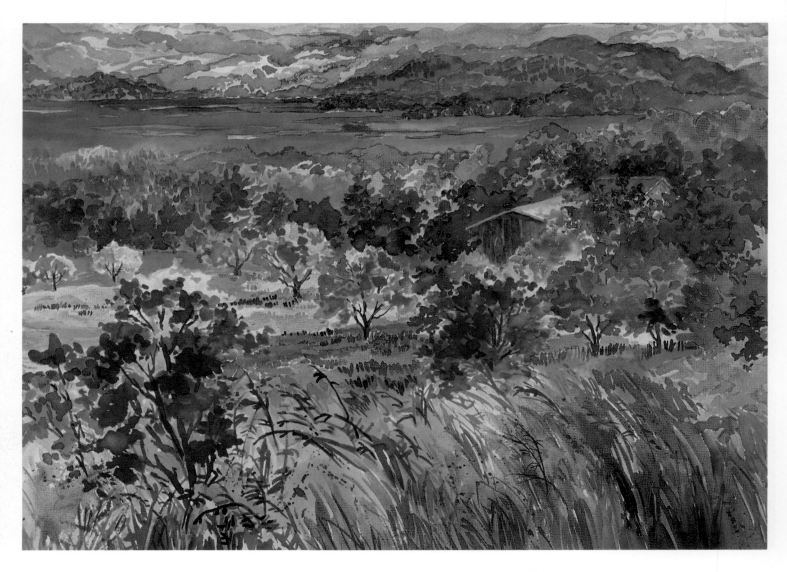

LAKE LEELANAU
GWEN TOMKOW
20" x 28"

FOR **LAKE LEELANAU** TOMKOW
USED A CHINESE BAMBOO BRUSH TO
STAY LOOSE. SHE BLOCKED IN THE
SHAPES, THEN SWITCHED TO A 3/4
ROUND BRUSH AND ESTABLISHED
LARGE AREAS OF TRANSPARENT,
BRIGHT, ENERGETIC COLORS. TO GIVE
A GLOW TO THE ORCHARD, SHE MIXED
A TOUCH OF FLUORESCENT PINK AND
CADMIUM YELLOW AND REPEATED IT
IN THE LAKE ABOVE. THE STACCATO
STROKES WEAVE IN A ZIG-ZAG
MOTION.

A SPECIAL PLACE IN NORTHERN MICHIGAN

I was transported into my own sunny, warm, happy and peaceful state of mind the first time I sat in the middle of a field of blowing grass, looking out at the panoramic Leelanau Peninsula in northern Michigan. The swaying, swirling shimmer of the gray-mauve grass flecked with Queen Anne's lace mesmerized me. I began to paint grasses with backlight, out of focus, as directional diagonals and horizontals, and as patterns to complement the curves of rolling orchards and sand dunes.

In *Blowin' Grass* the grasses and shadows create a rhythm of light weaving from the foreground, through the painting, to the background. I consider this kind of watercolor

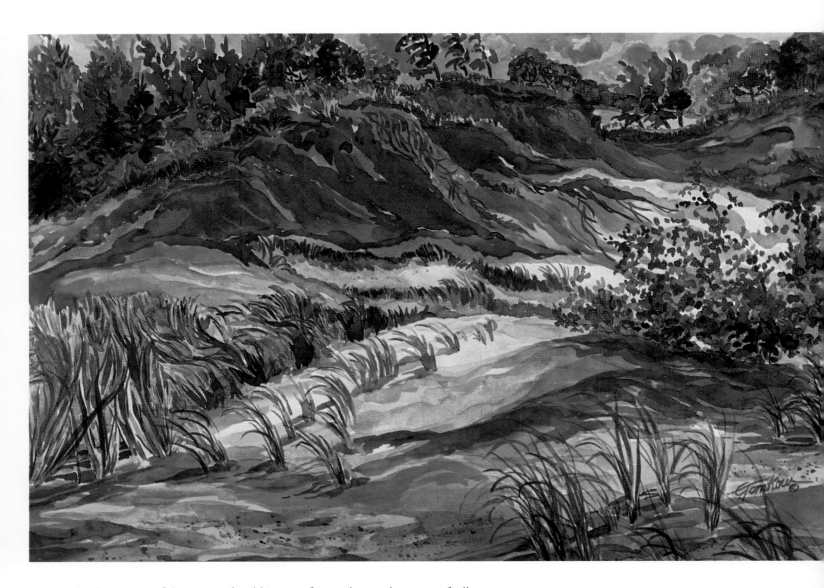

landscape one of the most enjoyable ways of capturing my innermost feelings on paper. It's like lyrical poetry set to music. The painting begins softly with light washes of color and crescendos to a symphony of glorious visual excitement. The romantic sand dunes become a concerto; the rows of cherry trees, a grand march; and the large vistas, a soothing melody that connects me and the viewer to the wonderful gift of nature.

Gwen Tomkow

BLOWIN' GRASS
GWEN TOMKOW
20" x 28"

FOR **BLOWIN' GRASS** TOMKOW STARTED WITH LIGHT GOLDEN SAND SHAPES ON DRY PAPER. SHE BUILT MANY LAYERS OF COLOR AND DEEP VALUES IN THE SHADOWS. THIS CREATES THE DESIRED TENSION NEXT TO THE PEACHY, MAUVE COLORS. THE GRASSES ARE LIKE FINGERS POINTING TOWARD THE DIFFERENT PLANES IN THE PAINTING. THE SKY WAS PAINTED LAST, DETERMINED BY THE COLORS AND MOVEMENT NEEDED BY THE PAINTING.

SHARING ENTHUSIASM FOR NATURE'S BEAUTY

Painting is my way of sharing my enthusiasm for nature's beauty. Its shapes, textures, colors and subtleties have long been a major source of my inspiration. My response to these qualities has resulted in a love affair with the splendor of the Rocky Mountains in Colorado. I have spent many years sketching and photographing the vast spaces there.

I am fascinated with the richness in all the earth's elements and the strong design features they forge. Yet I like to take liberties with this realistic matter and create new, yet related, images. My goal is to communicate with viewers in the hope that they respond with recognition, understanding and intimacy to these very personal interpretations.

Greta S. Greenfield

RED MOUNTAIN IS PAINTED ON CRESCENT ILLUSTRATION BOARD. GREENFIELD USED MASKING FLUID TO SAVE THE WHITE AREAS, THEN ADDED COLOR WITH A BROAD BRUSH. SHE PRESSED PLASTIC WRAP INTO SELECTED AREAS FOR TEXTURE. FINALLY, VALUES AND EDGES WERE ADJUSTED AND DETAILS ADDED WITH A SMALL BRUSH.

RED MOUNTAIN
GRETA S. GREENFIELD
20" x 30"

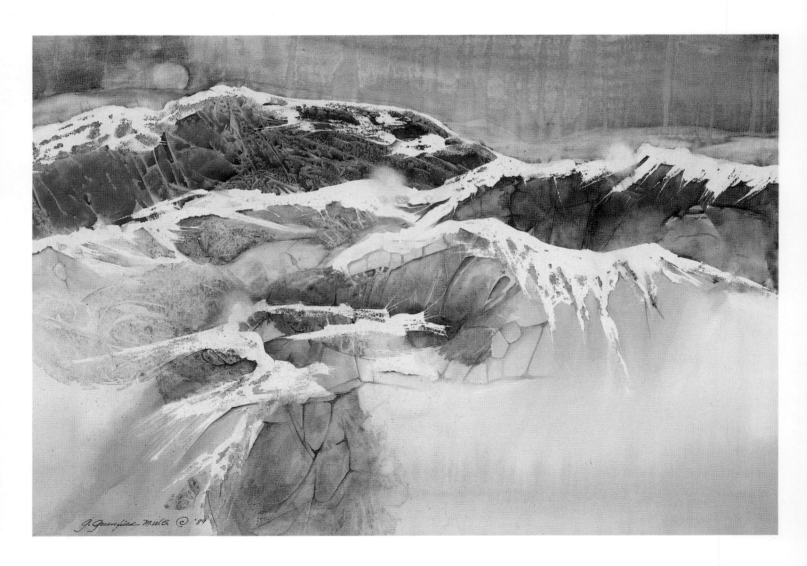

RECORD A PLACE AND TIME

This painting, called *Staten Island Ferry in Repair*, is part of a series of paintings created in one short period. The inspiration was one of recording a place and time. As a native and lifetime resident of Staten Island, I thought the building of the Verrazano Narrows Bridge connecting Staten Island with Brooklyn would drastically change the rural setting of the island. It did. However, in 1965, using a twin lens reflex camera, I tried to capture interesting points on Staten Island as it was at that time. Then, with accompanying notes and these photos, I was able, twenty-five years later, to paint a series of fifty-four paintings of Staten Island of the past.

All the paintings are the same size and were done in the "purest" transparent watercolor style, with no light opaque colors over dark, and no white paint. In 1991 the Museum of Staten Island presented a showing of thirty-four of the fifty-four paintings. All the paintings were completed in one year and the show was titled "Looking Back."

The enthusiasm of the Staten Islanders as they viewed them was very rewarding. The inspiration for the series—compelling when I first had the idea—became an obsession as I completed each painting. I was driven by what they did for me as I laid them side by side.

CAESAR NICOLAI

STATEN ISLAND FERRY IN REPAIR
CAESAR NICOLAI
13½" x 19½"

NICOLAI BEGAN THIS PAINTING WITH A DETAILED, ACCURATE PENCIL DRAWING RIGHT ON THE WATERCOLOR PAPER. ALL THE DARKS WERE THEN APPLIED TO GET A GOOD VISUAL PICTURE OF THE SUBJECT. NEXT THE SKY AND OTHER PROMINENT AREAS WERE PAINTED. FINALLY, THE DETAIL WORK COMPLETED THE PAINTING.

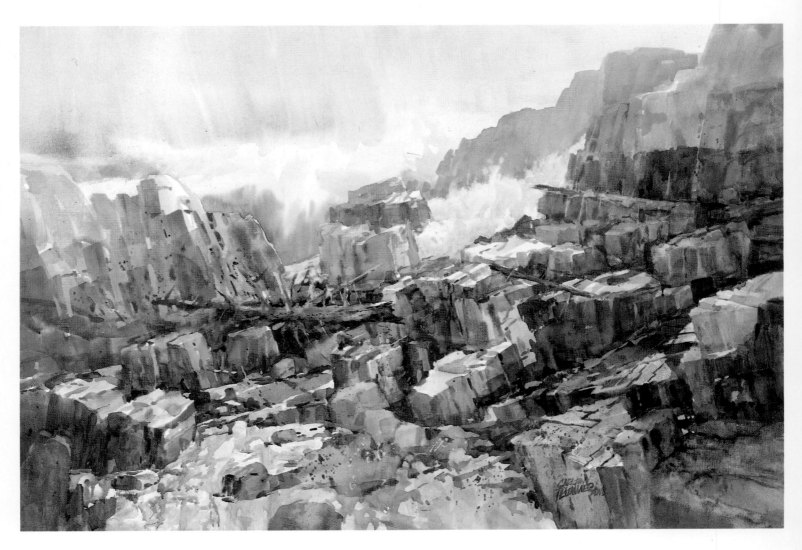

DIAGONAL LEDGES
CARLTON PLUMMER
20" x 28"

PLUMMER PAINTED **DIAGONAL LEDGES** AS A PERSONAL CHALLENGE TO SEE IF HE COULD SATISFY HIS CREATIVE NEED FOR COLOR BY USING BASICALLY THREE PURE COLORS: RED, YELLOW AND BLUE. HE WAS ABLE TO ACCOMPLISH THIS BUT FOUND HIMSELF ADDING RAW SIENNA AND GOUACHE FOR THE FINAL TOUCHES. DRAMA WAS EMPHASIZED BY THE DIAGONALS IN THE DESIGN.

LET YOUR SURROUNDINGS BECOME PART OF YOU

Coastal Maine and its environs have become a part of me and directly influence my painting. The sea and the varied landscape that complements it are a constant source of pleasure and inspiration.

Early in my career I worked directly from nature, striving to complete paintings based on what I could observe while on location. In recent years I have continued to paint on location, but I spend less time developing the painting and more time looking and gathering information. I feel the need to formulate inner ideas away from the source; consequently, I pull together and fine tune the painting back at my studio, where I draw on my memory and intuitive responses.

Although nature is my main source of inspiration and motivation, I am also moved by the nature of the medium when I approach it with no preconceived ideas: the accidental happenings of the rapid, free-flowing action of watercolor when used wet-into-wet. The initial application of paint provokes spontaneous responses that result in subsequent decisions. This method allows me to become quickly involved and to explore unlimited possibilities

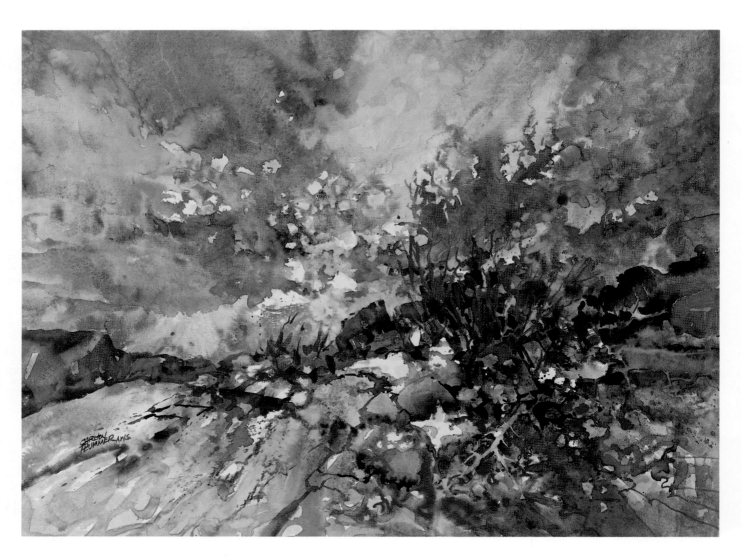

in technique and design. What at first seems accidental is really "controlled looseness." Unity is always a top priority and is important for the success of a painting.

Recently I have been excited by the diversity of color and its potential to create mood. Often it becomes the prime focus in my paintings. I continue to observe nature with its endless array of colors, but I find great pleasure in using color out of context to express emotion and to entertain the viewer.

CARLTON PLUMMER

SEA GARDEN
CARLTON PLUMMER
21" X 28"

SEA GARDEN IS AN EXPERIMEN-
TAL WORK ON STRATHMORE
AQUARIUS II PAPER, AND WAS PAINT-
ED WET-INTO-WET USING SOME COL-
ORED INKS AND GOUACHE. IT WAS
INTENDED TO BE AN ABSTRACT
INTERPRETATION OF SURF, BUT AS
THE PAINTING DEVELOPED PLUMMER
FELT THE NEED TO INTRODUCE
RELATED FORMS SUCH AS A LEDGE
AND SEAWEED. THE ABSTRACT FEEL-
ING IS STILL PRESENT, AND THE
COLOR IS USED AS AN EMOTIONAL
EXPRESSION.

CHAPTER 8

Exploring the Reaches of Imagination

PAINTING IS *an adventure to an unknown world. New ideas and concepts develop along the way.*

—*Ratindra Das*

THOUGH NATURE IS THE FOUNDATION of creativity for all of the artists in this chapter, what is seen by the eye is transformed and colored by the vision of the mind. A scene is not just a scene but a vision of possibilities inherent in the subject.

AFTERNOON, UTTAR
PRADESH, INDIA
ROBERT WADE
14" x 21"

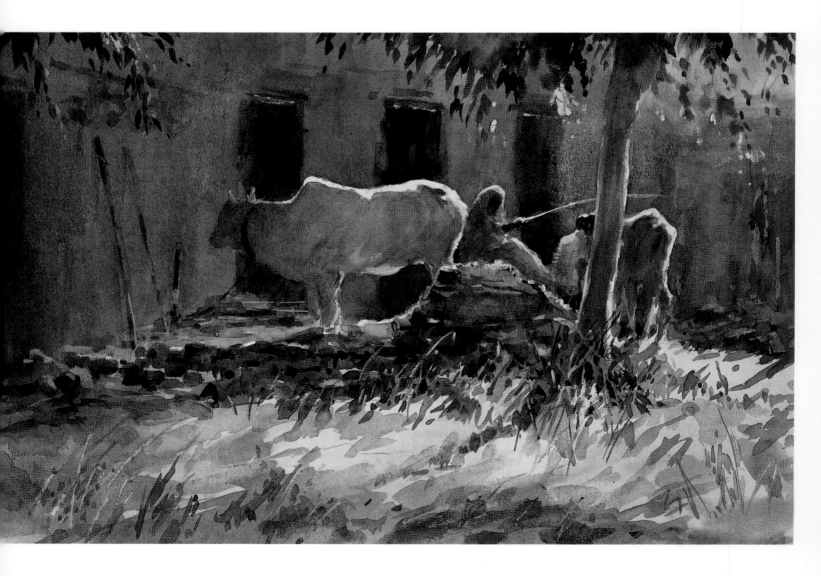

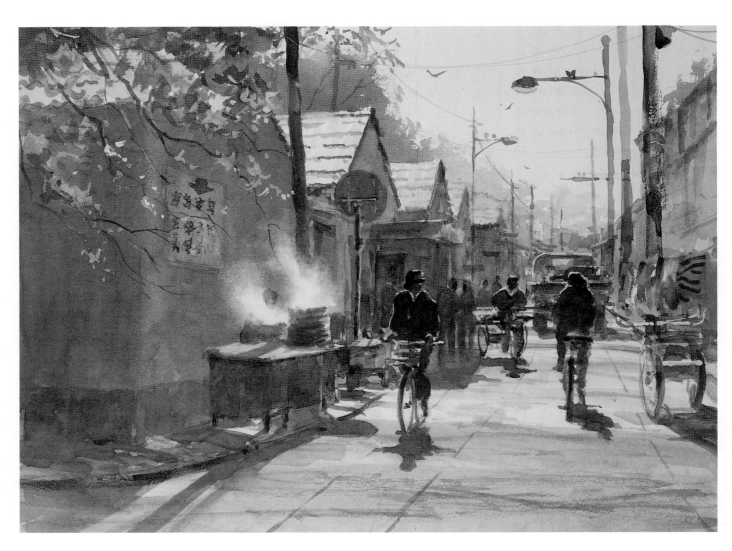

TAKE LIBERTIES WITH YOUR SUBJECT

A flash of light! A bolt of thunder! *Pow!* Inspiration strikes, and another masterpiece is born! Many people believe this is the way a painting is created. However, professional artists agree that most paintings evolve from application, dedication and much perspiration.

Of course, every once in a blue moon, we do encounter a subject that arouses instant excitement, creating an urgent need to capture that feeling, before it escapes forever. But, in my experience, a subject so powerfully emotive rarely yields a winner.

Let me make it clear that every good painting needs an idea, a vision, and my ideas come from the world around me. Then I can change the atmosphere, pull the subject this way and that as I take countless liberties with it, invent various lighting conditions and depart from how the subject looks in reality. My response to the subject grows and my reaction becomes more and more personal. I believe that this method allows me to paint with more spontaneity because my original small idea has grown beyond the limitations the subject had, at first, imposed on me.

BEIJING MORNING, CHINA
ROBERT WADE
18" x 25"

TO GET THE EFFECT OF THE HIGH, HAZY BACKLIGHTING IN **BEIJING MORNING, CHINA**, WADE MADE USE OF THE TRANSPARENT LEAVES, THE SHINE ON THE ROOFTOPS, AND THE STEAM FROM THE VENDOR'S POTS. AS HE PAINTED THE WASHES AROUND THE STEAM, HE BLOTTED CONSTANTLY WITH A WAD OF TISSUE TO KEEP THE EDGES SOFT. LAST, HE REINFORCED SOME OF THE HIGH-LIGHTS WITH A LITTLE GOUACHE.

IN **AFTERNOON, UTTAR PRADESH, INDIA** (LEFT) WADE COULDN'T RESIST THIS OPPORTUNITY TO PLAY AROUND WITH THE COLORS IN REFLECTED LIGHT. HE DIDN'T USE MASKING FLUID, RESERVING THE HIGHLIGHTS WITH SOME FAST BRUSH-WORK. BUT THE HIGHLIGHTS DID NEED A LITTLE RESTATING WITH GOUACHE.

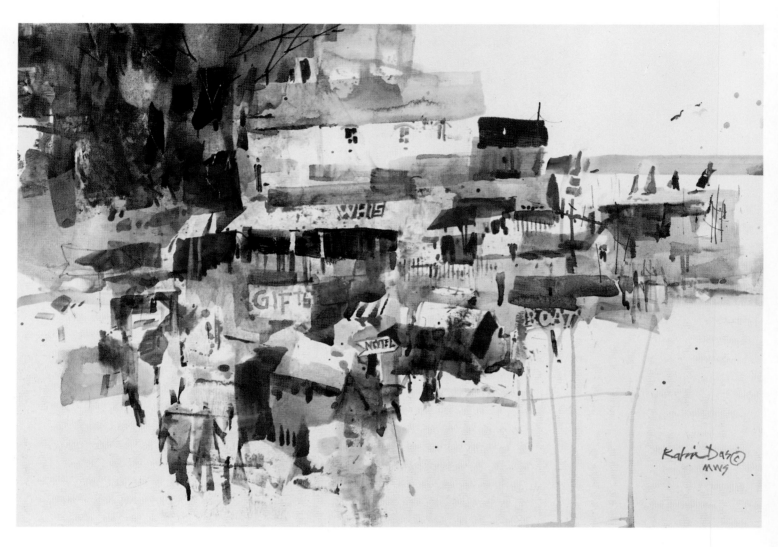

PAINT FROM YOUR MIND'S EYE

BY THE BAY
RATINDRA DAS
15" x 21"

Thoreau once said, "The eye may see for the hand, but not for the mind." An idea is born when mind and eye see together. My paintings usually evolve out of the assimilation of stored information gathered through all my senses over a period of time. I constantly look for forms, shapes and their interrelationships in my immediate surroundings.

I don't start a painting with the idea of creating a masterpiece. Instead, I approach it as an adventure to an unknown world. New ideas and concepts develop along the way. Due to my background as an architect, I am quite naturally drawn to geometric shapes and forms, solids and voids, lights and darks.

Many times I have been asked where the scene is in *By the Bay*. It is one of those instances where mind and eye worked together. It was created from stored information and perception—a place that "ought to be."

INSTEAD OF STARTING BY THE BAY WITH HIS FAVORITE BRUSH, DAS USED A BRAYER AND SOME CARD-BOARD MATS AND APPLIED COLOR AND STAMPINGS ON A PIECE OF HOT-PRESS PAPER. HE WAS EXCITED WHEN HE SAW THE UNPREDICTABLE MOTTLING EFFECTS AND TRIED TO CAPITALIZE ON THEM. CALLIGRAPHIC BRUSH LINES AND COMMERCIAL SIGNS ADDED LIFE AND CONVICTION TO THE MOTIF.

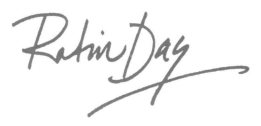

DRAW FROM THE IMAGINATION

CHICAGO & RUSH II
DAVID R. BECKER
22" x 28"

As an instructor of art and illustration, I make it a point to stress the power and freedom of drawing from the imagination. However, I believe all creativity stems from knowledge and experience. How it manifests itself, either as a song, a novel or a painting, is up to one's own individual wiring and God-given talents, but the fodder is a rich imagination nurtured by anything it can soak up—memories, travels, dreams or encounters. These become fused and erupt into an idea. That, I believe, is what they call inspiration. The idea generated from that inspiration takes shape as it is honed by the skill of the artist.

BECKER FIRST DOES A VALUE SKETCH; HE BELIEVES THIS IS THE MOST IMPORTANT TOOL FOR PAINT-ING. **CHICAGO & RUSH II** WAS DONE IN TWO BASIC WASHES. THE DARK BACKGROUND AND THE LIGHT AND MEDIUM FOREGROUND WERE DONE IN ONE WASH USING WET-INTO-WET TECHNIQUE. THE SECOND WASH WAS FOR DEFINING OBJECTS WITH HARD EDGES AND FOR CREATING MID-DLE GROUND AND FOREGROUND DETAIL. IT WAS COMPLETED IN ABOUT AN HOUR.

The subject of this painting was a building site directly across from where I used to live, near Chicago and Rush streets. On my way to work I noticed how the morning sunlight struck the building perfectly, so I snapped a few pictures and took some mental notes. The imagination is a powerful tool. An artist can use it to show others the world as he sees it and to bring others into his dream of what the world could be.

David R. Becker

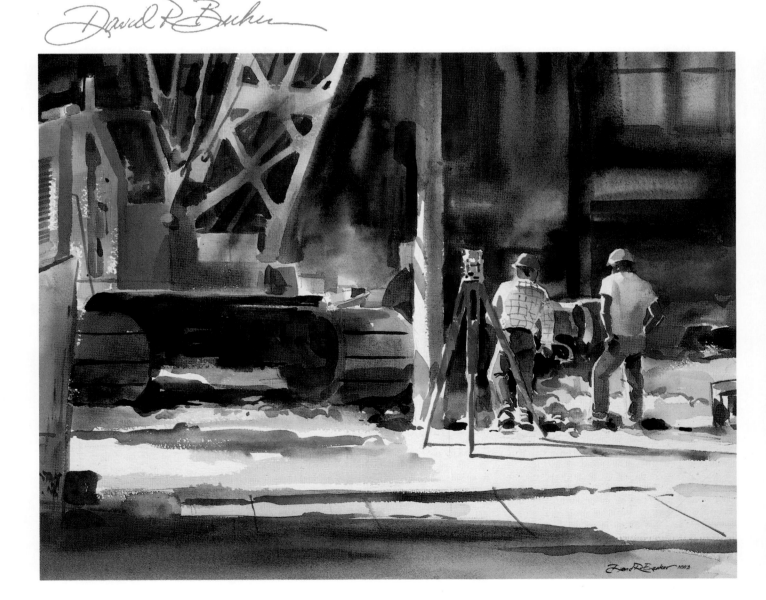

EXPLORE, ASK QUESTIONS AND EXPERIMENT

Within each of us is something only we can share. To discover what it is and to stimulate ideas I *explore, ask questions* and *experiment.*

To explore, I go for walks to the zoo, to the library. I pay close attention to everything around me, looking for patterns of light, intriguing shapes, out-of-focus areas, unique color combinations. I keep a journal of everything I like.

I ask myself a series of questions, such as, What do I want to develop: an abstract design, an impressionistic work, a realistic interpretation? What method should I use: direct painting, two-dimensional sculpting? How can I achieve my goal?

I experiment by taking time to try different techniques so I can incorporate them into my work. Every time your brush strokes across the paper, or paint splashes onto the surface, you set up a problem-solving situation. It is through this problem-solving process that we actually learn to paint. We are forced to make decisions. Decisions give us experience. Experience develops us. We grow. There's no time like the present: Just do it!

Joan Hansen

PAINT THE MYSTERY OF SPACE

My interest and fascination with flying and with the mystery of space inspired me to begin my series called Galaxies. Wondering what astronauts see in space, I try to capture the visual harmony of the beautiful patterns, forms, explosive colors and drama, as well as the intensity of the dynamic forces of the planets and celestial bodies. I use swirling colors to represent fire, air, water—nature in all her spectacular glory.

Lori Fronczak

FRONCZAK'S PAINTINGS ARE CREATED WITH LAYERS OF FLUID COLORS BY A WET-ON-WET METHOD. SHE ALMOST RANDOMLY DEVELOPS STRONG COLOR, TEXTURE, SHAPES AND LINES, THEN STRENGTHENS THE NEGATIVE AREAS WITH LAYERS OF TRANSPARENT, GLAZING COLORS AND OPAQUES, CREATING A SENSE OF DEPTH AND VOLUME. WHEN SHE WANTS TO ADD NEW AND DIFFERENT DIMENSIONS, SHE USES A VARIETY OF MATERIALS— PLASTIC, STENCILS, WAX, SALT, SAND, GESSO, CALLIGRAPHY, OR MASKING—TO FURTHER DEVELOP CONTRAST, VALUE, TEXTURE, LINE AND COLOR.

GALAXY PATTERN VII
LORI FRONCZAK
30" x 40"

CREATE ANOTHER WORLD

For the past three years, I have worked on a series of watercolors based on birds and their environment. I have always loved birds, but I became truly inspired when I acquired seven of my own and was able to observe their individual personalities and characteristics. I became increasingly fascinated by them.

When I work on an idea for a painting, whether its subject is a bird or anything else, the first thing I think of is the atmosphere I am trying to achieve. I want to create another world for the viewer to walk into.

Then I usually do lots of drawings and take 35mm slides to help supplement information. For this series, I study the bird's anatomy as well as the interplay of color, value and shadows on the bird and its surroundings. I also carefully watch to see how it moves, bends, scratches, ruffles feathers and "speaks." This helps me make the bird more lifelike.

Carol Cottone-Kolthoff

AVIARY TRIPTYCH
CAROL COTTONE-KOLTHOFF
30" x 66"

COTTONE-KOLTHOFF WANTED VIEW-
ERS TO FEEL AS IF THEY HAD WALKED
INTO AN AVIARY. SHE TOOK NUMER-
OUS PHOTOS OF BIRDS AND FOLIAGE
AT THE SAN DIEGO ZOO, AS WELL AS
DOING ON-SITE SKETCHES AND COLOR
STUDIES. NEXT SHE DID A FULL-
SCALE PRELIMINARY DRAWING, THEN
REDREW ON THREE SHEETS OF
ARCHES 300-LB. ROUGH WATERCOL-
OR PAPER.

BEFORE SHE BEGAN THE
PAINTING PHASE, COTTONE-KOLTHOFF
SHIELDED THE MAIN SUBJECTS SO
SHE COULD APPLY WASHES TO THE
LARGE CONTINUOUS BACKGROUND
AREA, WHERE SPEED WAS ESSENTIAL.
TO DO THIS, SHE TRACED THE SUB-
JECT ONTO A CLEAR PLASTIC ADHE-
SIVE SHEETING CALLED FORM-X-FILM
AND CUT OUT THE IMAGE 1/4-INCH
SMALLER ALL THE WAY AROUND.
AFTER ADHERING THE FILM, SHE
USED WINSOR & NEWTON MASKING
FLUID TO SEAL THE EDGES.

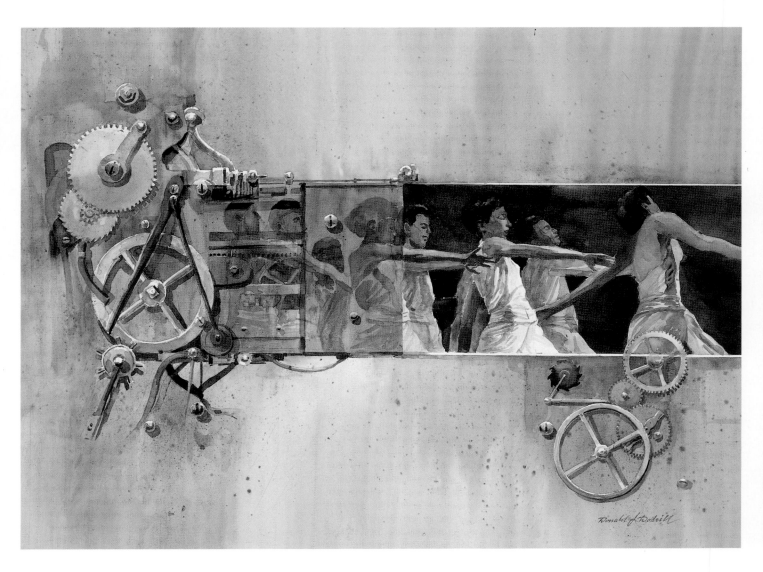

FIND TIME-LY INSPIRATION

For many years, I have been fascinated by the element of time as an idea and inspiration for my paintings. Time affects everything we see, everything that we do, our appearance, and the environment around us. I find the subject of time an infinite inspiration.

In *Time Mechanisms II* I have integrated parts of clock mechanisms with a group of dancers. The clock parts in this painting are those of an antique clock made in Europe more than two hundred years ago. I arranged the figures of the dancers to appear to emerge from the clock mechanism, and I gave the metal portions of the clock mechanism a semitransparent appearance so the dancers would be visible before they emerged. I have always been fascinated by the timing and coordination of professional dancers and decided to relate them in this way to the clock mechanism. The dancers represent several ethnic cultures to enforce the theory that time is universal, relevant to all.

Donald J. Dodrill

TIME MECHANISMS II
DONALD L. DODRILL
19" x 29"

DODRILL MASKED SOME OF THE CLOCK PARTS BEFORE BEGINNING THE PAINTING TO RETAIN LIGHTER SURFACES AGAINST THE DARKER BACKGROUND. THE BACKGROUND WASH WAS THE FIRST AREA PAINTED, WET-ON-WET, WITH SOME OF THE WET SURFACE SPATTERED WITH DARK BLUE-GRAY PAINT FROM A STIFF TOOTHBRUSH. DODRILL TRIED TO GROUP THE DANCERS AS THEY WOULD APPEAR IN A DANCE ARRANGEMENT, WITH SOME OF THE FIGURES OVERLAPPING.

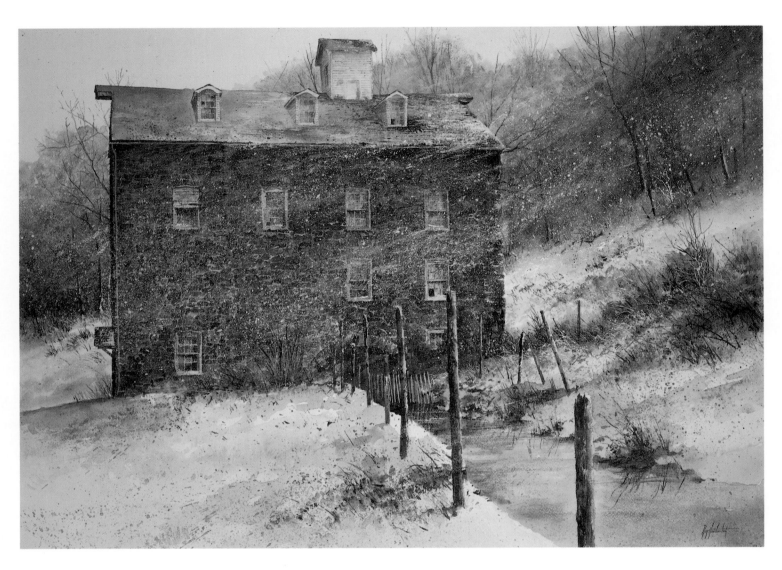

CAPTURING A MOOD, NO MATTER THE SUBJECT

I do not search for inspiration. There are no journeys through the countryside looking for ideas for paintings. It happens spontaneously. A strong emotional response to a place or thing that almost cries out to be painted. Sometimes it may involve subjects I have seen and passed over many times before; but on a particular occasion, something was different . . . something was right . . . there was a mood that aroused my senses and gave me a story to tell.

My subject matter varies greatly, from landscapes and seascapes to still lifes, florals, and even an occasional portrait. But, regardless of subject, one common thread remains: mood. I want the atmosphere of the painting to create an emotional response in the viewer. Watercolor, with all its subtle color and value gradations and its many welcome surprises, is the perfect medium for capturing mood.

Ray Hendershot

BLIZZARD
RAY HENDERSHOT
20" x 29½"

TO CAPTURE THE MOOD OF THE HEAVY, WINDBLOWN SNOWSTORM, HENDERSHOT SPATTERED AND STREAKED A GREAT DEAL OF OPAQUE WHITE GOUACHE AFTER COMPLETING THE PAINTING OF THE SUBJECT. HE GAVE CAREFUL ATTENTION TO THE DIAGONAL DIRECTION OF THE STREAKS TO EMPHASIZE THE EFFECT OF THE WIND. IT WAS A RISKY PROCESS, BUT WELL WORTH THE EFFORT.

REIGNITE YOUR MEMORIES

Always the question: What to paint? Often, I recall my favorite locations, then daydream about the one that interests me most that day. Such was the basic inspiration for *Green County Line*. Having lived in Michigan and New England and summered in southern Indiana and Tennessee, I was fascinated with snow and snow fences. But what would a broken-down snow fence look like without the snow? As I pondered the design, the locale became the hills of Indiana, where I cannot ever recall actually seeing a snow fence—just rail fences or barbed wire on posts.

The name of this painting relates to an area in Indiana that inspired the idea. The fence divides the area both on land and on paper. It's not exactly a snow fence—but then, the joy of daydreaming is to make your vision a reality.

J. Rudman

RUDMAN PAINTED THE GRAY FENCE QUICKLY BUT FOUND SHE HAD A SPLIT COLOR SCHEME AND NO UNITY. THE SKY AREA WAS COOL, THE LAND, WARM. SHE ALSO HAD DIFFICULTY MAKING THE MIDDLE GROUND WORK AND SCRUBBED IT OUT (THANKS TO GOOD PAPER) THREE TIMES. EDITING THE PAINTING TOOK A YEAR. FINALLY, SHE DECIDED TO GLAZE THE SKY WITH A YELLOW OCHRE WASH FOR THE FINAL TOUCH.

GREEN COUNTY LINE
JOAN RUDMAN
22" x 28"

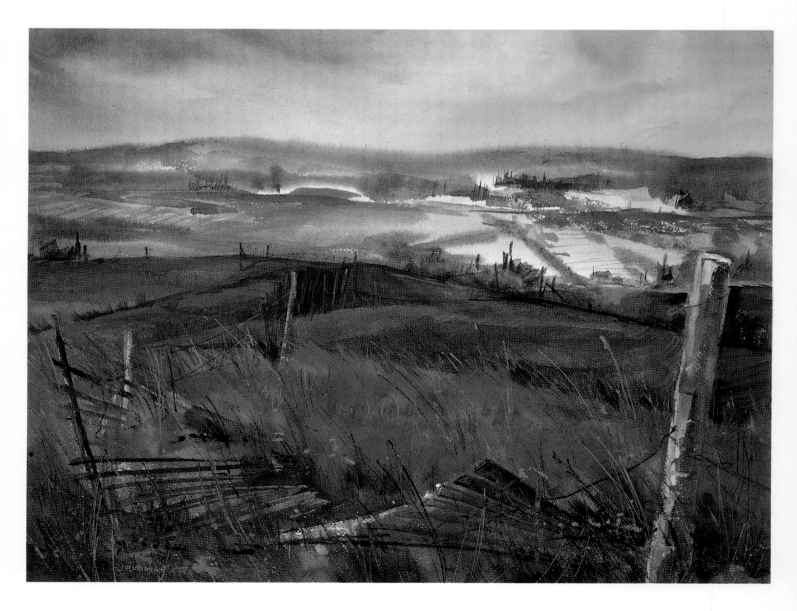

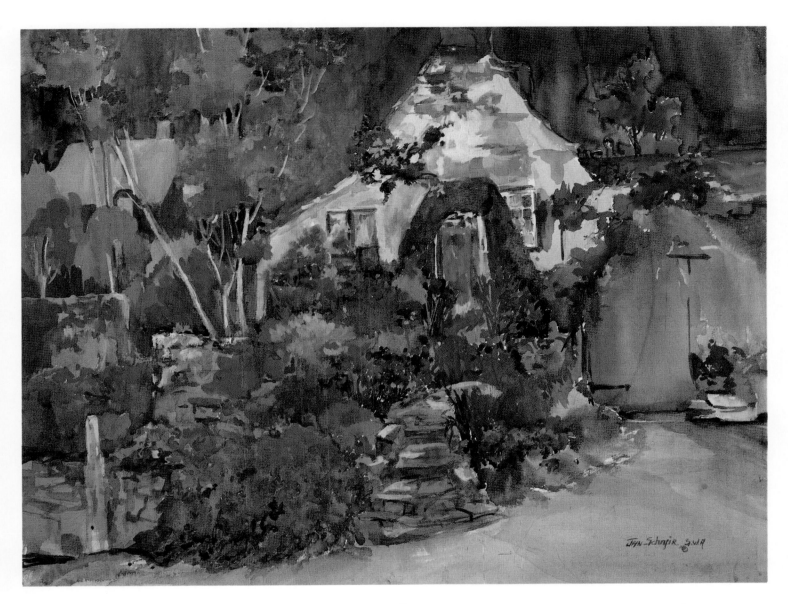

FIND OUT WHAT ATTRACTS YOU TO A SUBJECT

It seems only natural to me to express my love of life through painting, but it has taken many years of studying and learning the basics to be able to put down on paper exactly what I want to say about a subject.

Whenever I approach a subject, whether it's a landscape, still life or portrait, I spend time walking around, staring, squinting my eyes and sometimes touching the object to find what attracts me and makes me want to capture the image. Then 90 percent of my creative process takes place right on the paper, making the original subject only a starting place for the finished painting.

The model for *Chiff Chaffs* was an English cottage and nursery, which I set out to capture in paint from a nearby hillside.

Jan Schafir

CHIFF CHAFFS
JANICE K. SCHAFIR
18" x 24"

SCHAFIR USUALLY MAKES A VALUE SKETCH BEFORE DRAWING ON WATER-COLOR PAPER, BUT HER EXCITEMENT ABOUT THIS SCENE FORCED HER TO DRAW DIRECTLY ON THE PAPER. SHE STARTED WASHES OF LIGHT EARTH TONES WHERE SHE WANTED A GLOW TO SHINE THROUGH SUBSEQUENT LAYERS, THEN PROCEEDED TO BUILD UP THE COLORS. PAINTING OUTDOOR STUDIES ALLOWS HER TO CAPTURE THE ESSENCE OF THE SCENE, BUT SHE USUALLY DOES THE FINAL ONE-THIRD OF THE PAINTING IN HER STUDIO.

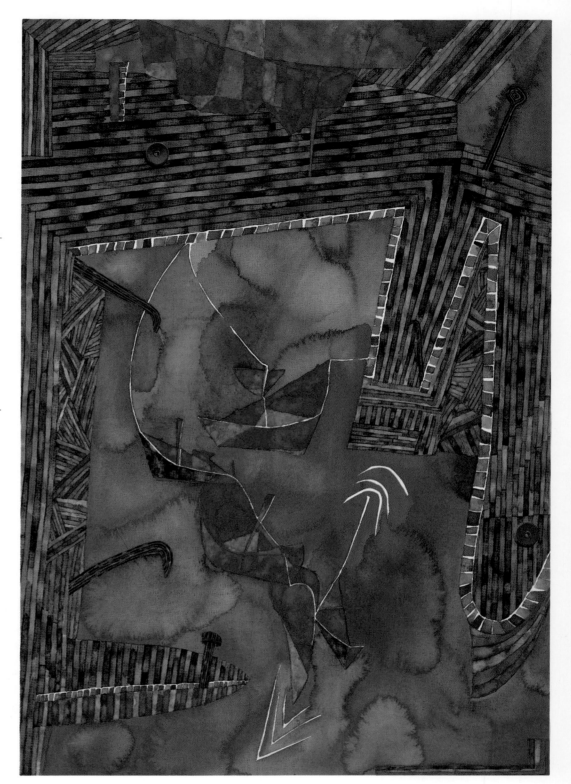

VIVID VESSELS
MILES G. BATT
29" x 21"

VIVID VESSELS UTILIZES MULTI-
PLE EYE LEVELS AS A COMPOSITIONAL
DEVICE TO ADD VARIETY AND MOVE-
MENT TO WHAT COULD BE A PRE-
DICTABLE PAINTING. AN IMAGINED
FLIGHT OVER THE SUBJECT LOCATION
DESIGNED THE LARGE CENTRAL
SHAPE. BATT ANIMATED VARIED
GREENS BY INTRODUCING FRESH
WATER INTO NEARLY DRY WASHES.
RED-ORANGE BOAT SHAPES BALANCE
THE GREEN, AND RELATIVELY COLOR-
LESS GRAY SHAPES SERVE TO BAL-
ANCE THE VIVIDLY COLORED AREAS.
BUILDINGS AT THE TOP ARE PURPOSE-
LY UPSIDE DOWN, PRESENTING
ANOTHER UNEXPECTED VIEW.

LOVE OF THE WORLD AND THE CREATIVE PROCESS

Watercolor ideas. If only we could buy them in handy six-packs to go! Creativity is a lifestyle, and ideas are the product and lifeblood of that lifestyle. Faith in those ideas and the persistence to build on them are indispensable. Here are three ways to help keep you receptive to ideas:

First, look for *similarities*. Perceive the similarity between the unfamiliar and what is familiar. Careful scrutiny of anything coupled with a systematic invention of symbols may result in wonderfully imaginative paintings.

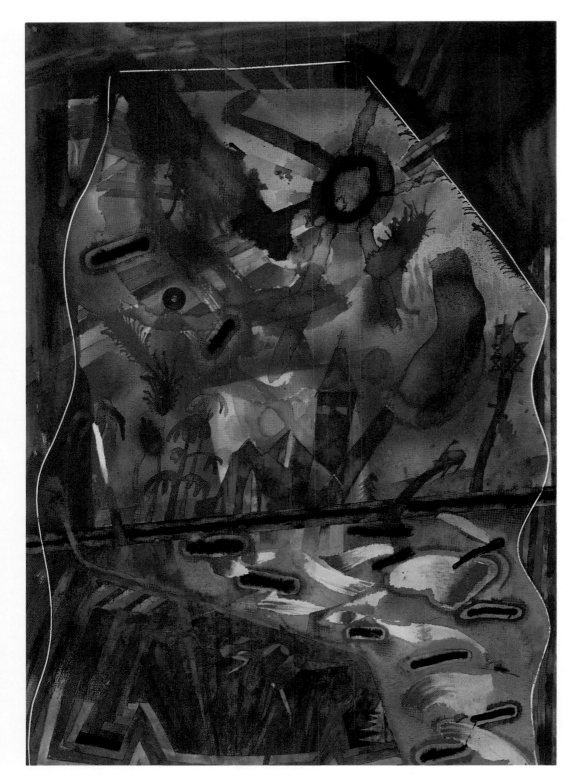

Second, look for *opposites*. Opposites teach us as much as similarities—the differences between the information we get from internal and external sources are vital.

And third, *change your frame of reference*. The power to perceive various meanings from a single stimulus serves free association and reinforces flexibility.

Love of the external world and the creative process itself combined with the internal need to express and contribute by painting something will always motivate my spirit.

Miles G. Batt

CHAPTER 9

Communicating a Significant Message

THE VISUAL ARTS *must communicate to the human spirit, forcing individuals to reflect on themselves and their existence beyond their own self-interest.*

—*Dean Mitchell*

A PAINTING IS A POWERFUL VEHICLE of communication. Pictures can tell a story, convey a mood, or be a visual autobiography of the artist. Sometimes a painting is a plea to the viewer to care—to care as deeply as the artist about the earth and its inhabitants.

UNCHAMBERED NAUTILUS
KASS MORIN FREEMAN
20½" x 31"

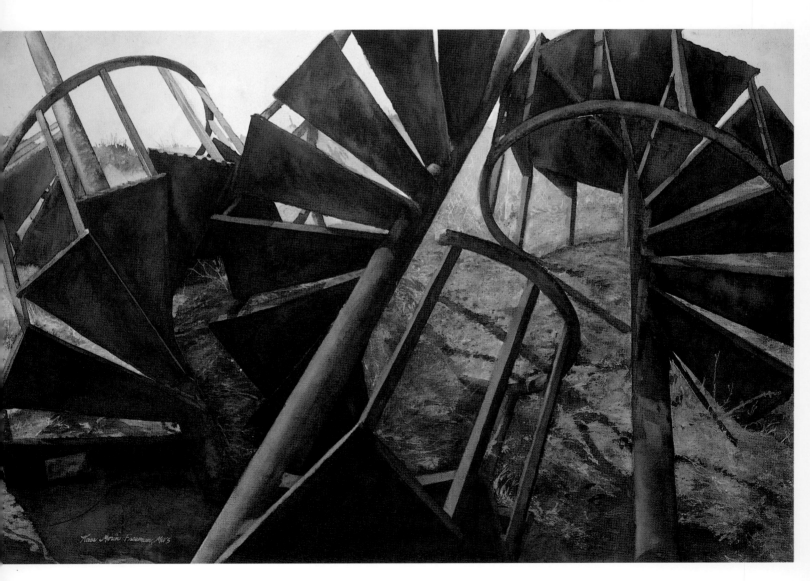

START WITH A STORY

In the late seventies I suddenly found myself teaching some watercolor courses. At the time, my major love was metal sculpture, and this affection for hard-edged shapes in space often finds itself revealed in the subjects I choose for my watercolors.

The story-telling quality of a picture is what gets me started. The story evolves in my mind, the characters (whether people or objects) become symbolic, expressing the feelings of the tale. Oftentimes, the title is a clue to the story.

Kass Morin Freeman

END OF DAY
KASS MORIN FREEMAN
20" x 30"

FREEMAN DREW THE COMPOSITION FOR **UNCHAMBERED NAUTILUS** (LEFT) FROM A NUMBER OF SLIDES OF AN OLD WORLD WAR II SUBMARINE STAIRCASE DISCOVERED IN A MARINA JUNKYARD. BY FLIP-FLOPPING THE SLIDES SHE MADE THREE DRAWINGS; THEN, WITH SCISSORS AND TAPE, SHE CUT AND PASTED THE SHAPES, MOVING THEM AROUND AND SOMETIMES OPENING THEM UP TO GET BETTER NEGATIVE SPACES BETWEEN THE FORMS. FOR A LIGHT SOURCE, SHE MARKED A WESTERLY SETTING SUN ON THE LEFT SIDE OF HER PAPER.

END OF DAY CONVEYS THE IDEA THAT THE FARMER HAS BEEN PAINTED OUT OF THE PICTURE. AFTER THE PAINTING WAS DONE, FREEMAN POURED CADMIUM AND AUREOLIN YELLOW OVER THE RIGHT SIDE TO ACCENTUATE THE WARM LATE-AFTERNOON GLOW.

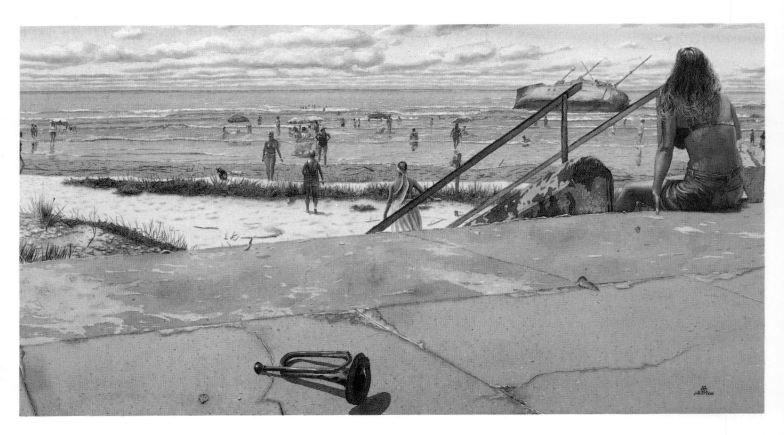

EXPLORE THE VAST FIELD OF SYMBOLISM

Ideas for my paintings have evolved gradually. One early piece, *Child of Vision*, is a nontraditional self-portrait in which only a face is reflected on the dark, worn surface of a record album. This led to further exploration of nontraditional and symbolic subject matter.

The series that I'm working on now is called Waiting for the Storm. Among the factors that inspired this series are the wind that travels through beaches and deserts carrying dust, paper fragments and leaves; cities and countrysides obscured by clouds; and people who travel these places like eyewitnesses of the colors of loneliness.

The Top was inspired by the islands off eastern Texas. This area is almost at sea level. With the exception of a few buildings, the highest level to be found on these islands is probably the sidewalks of the freeways that run through these coasts—hence *The Top*.

THE TOP
FRANCISCO VALVERDE
14½" x 27"

AFTER WORKING FOR SEVERAL DAYS ON THE SKETCH FOR **THE TOP**, VALVERDE TRANSFERRED THE DRAWING TO ARCHES 300-LB. HOT-PRESS PAPER. THE CHARACTERS, UMBRELLAS, SHIP AND TRUMPET WERE COVERED WITH MASKING FLUID. THE ARTIST APPLIED A SERIES OF THIN WASHES, LETTING THEM DRY BEFORE PAINTING OVER THEM WITH ADDITIONAL TRANSPARENT GLAZES. SOME OF THE SHADOWS, AS IN THE CASE OF THE TRUMPET, WERE PAINTED FROM THE BEGINNING TO ESTABLISH THE DARKEST VALUES. THERE WERE NO OPAQUE COLORS USED.

TELL A MEMORY-STIRRING STORY

To me, still life offers the greatest opportunity to tell a personal story, to create an autobiography. I began painting realistic still lifes in an attempt to create order out of the chaos of parenting and to join the memory of my youth with the childhood of my children. My past career as a textile designer is reflected in the use of patterned fabrics and surfaces; my present is represented by a scattering of toys.

Working from these basic inspirations, I create a technical assignment for myself—to represent heavy versus light, wet versus dry, solid versus translucent, shiny versus dull, etc. In *Music & Mirrors* I my challenge was reflections of reflections. These contrasts create a mood that draws the viewer into my story and memories—a sun-drenched day guzzling cold drinks or a shadowy trip through an attic.

J. LEWIS-TAKAHASHI

RATHER THAN LAYING OUT SUBSEQUENT WASHES AS IN CLASSICAL WATERCOLOR PAINTING, LEWIS-TAKAHASHI PICKS ONE FOCAL SPOT— IN THIS CASE, THE JINGLE BELLS— AND COMPLETELY FINISHES THAT ONE OBJECT. WHEN SHE SEES THAT ONE OBJECT POPPING OUT OF THE WHITE SHEET OF PAPER, SHE CAN FEEL THE PAINTING COME ALIVE. SHE USES NO FRISKET TO MAINTAIN THE WHITE AREAS. THE BRIGHT WHITE OF LANAQUARELLE PAPER PROVIDES A BRILLIANT SPARKLE ALL ITS OWN.

MUSIC & MIRRORS I
JENNIFER LEWIS-TAKAHASHI
28" x 36"

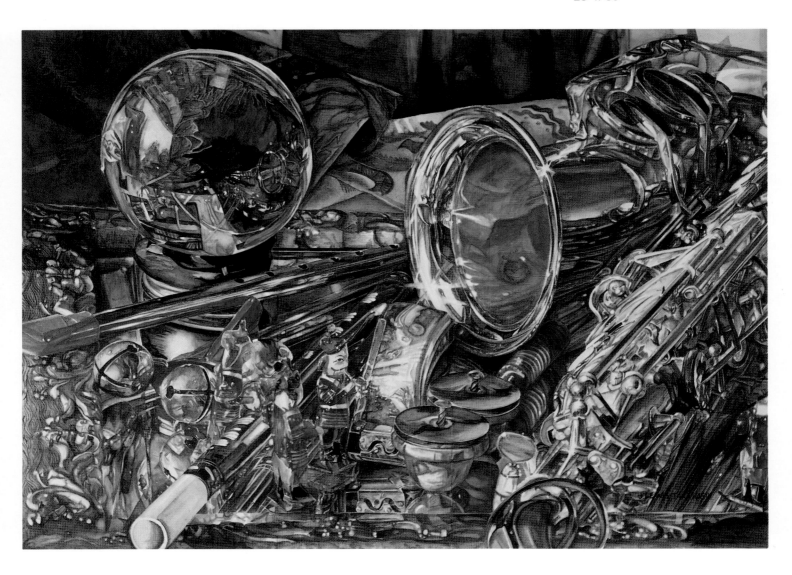

EXPRESS YOUR LOVE FOR WILD PLACES

From boyhood I possessed a great love for the outdoors. I was particularly fascinated by birds, wildlife, and the unspoiled places they inhabit. The desire to express that love and fascination has been the motivation for my paintings.

A painting may be inspired by a location that is emotionally appealing and that attracts a certain type of animal or bird. I then envision that animal or bird in action or at rest. It is from that initial excitement that my paintings evolve. Other times, inspiration comes from observing the movements or gestures of the particular bird or animal. My best work comes from being there and having my heart stirred by what I see and feel.

It is my desire as I create each painting to communicate my love and enthusiasm for wildlife and wild places. I hope to evoke a similar response from my viewers.

D. ENRIGHT

ENRIGHT BEGINS A PAINTING BY DOING A PENCIL THUMBNAIL SKETCH TO WORK OUT THE COMPOSITION AND THE DARK AND LIGHT PATTERN. FOR A WILDLIFE PAINTING, HE DOES A CAREFUL DRAWING OF THE ANIMAL OR BIRD ON A PIECE OF LAYOUT PAPER, THEN PROJECTS THE DRAWING TO THE WATERCOLOR PAPER WITH AN ART-O-GRAPH TO PROTECT THE PAPER'S SURFACE. HE JUST BLOCKS IN THE BACKGROUND MATERIAL.

ENRIGHT USES NO WHITE. HE BEGINS PAINTING THE SKY, MOVES TO THE BACKGROUND AND WORKS FORWARD, COMPLETING THE WILDLIFE SUBJECT LAST.

READY TO SOAR
DON ENRIGHT
20" x 28"

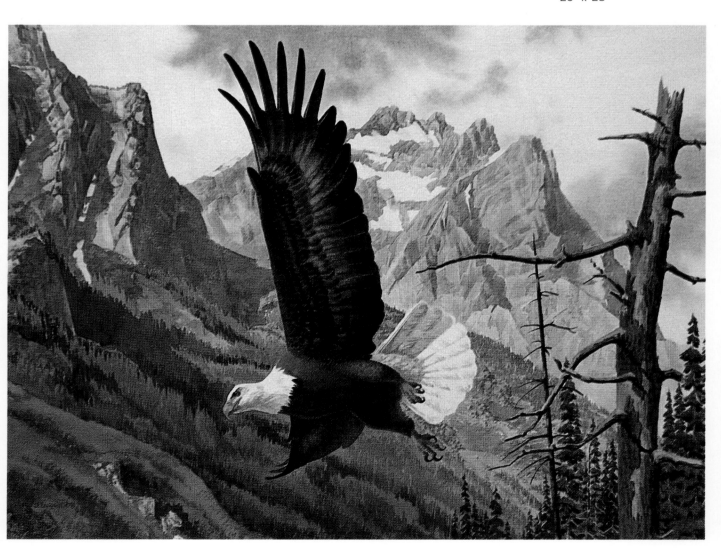

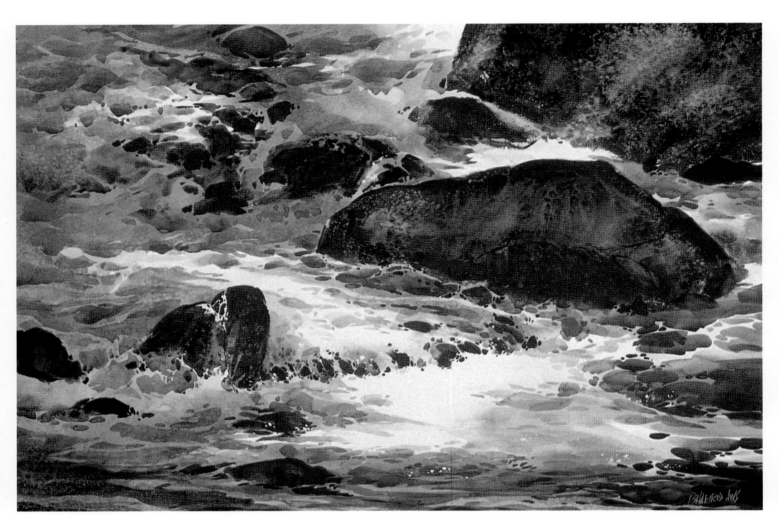

INSPIRE AND COMMUNICATE WITH THE VIEWER

Inspiration in painting is not only what the viewer should experience in response to an image. It is also the seeds that exist within artists that enable them to rise above the relatively simple matter of making a picture. I certainly find myself consciously and unconsciously stirred when painting, providing me with a range of responses, emotions and other indefinables that help elevate the painting experience. If an attunement or sensory response can be evoked from the viewer, a most exquisite form of communication has been established, and the artist's role has been truly fulfilled.

In *Relentless*, it was the dash and vigor of the running stream that caught my attention. Painting its energies was the next natural step.

RELENTLESS
IRVING SHAPIRO
24" x 32"

THE ARTIST CAPTURES THE POWER AND TEXTURES OF THE COLORADO LANDSCAPE, GIVING ATTENTION TO BOTH THE LARGE PATTERNS AND THE SUBTLE SURFACES. HE USES HOT-PRESS WATERCOLOR BOARD MOST OFTEN, BECAUSE IT LENDS ITSELF TO THE CLARITY OF POTENT DARKS AND THE MEANDERING WASHES THAT SO EFFECTIVELY CAPTURE THE DESIGNS OF THE ORGANIC CONTENT. IN MANY AREAS, HE SPRAYS WATER ON THE SURFACE OF COLOR WASHES TO ECHO THE RANDOM DESIGNS NATURE GIVES US TO TRANSLATE.

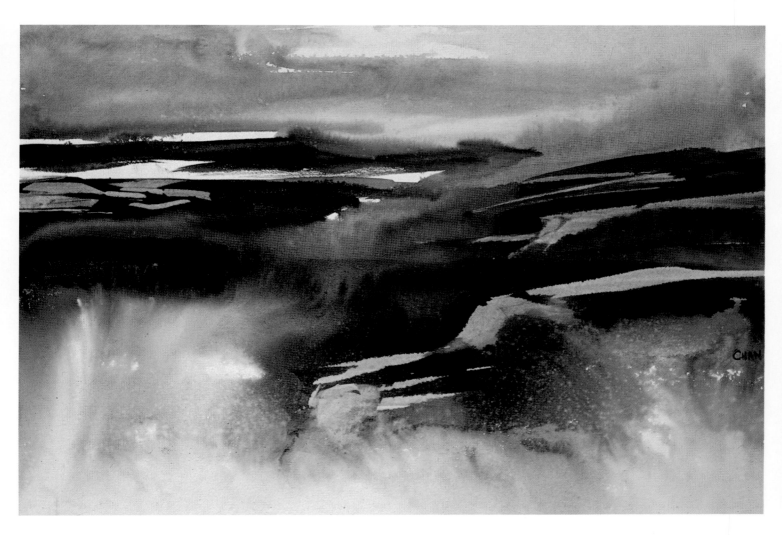

TELL ONE STORY AT A TIME

My goal is to paint directly, freshly, simply, but with strength, striving to tell one story at a time. I am a product of my Asian upbringing, instilled as a child with the belief in lifelong learning. Floral classes with Mario Cooper at the Art Students League and wet-into-wet landscape classes with the late Edgar Whitney laid the foundation for my watercolor technique. The most important element in the artwork is the mood of the painting—that unexplained quality that evokes feelings.

Mary C Chan

NIAGARA REMEMBERED
MARY C. CHAN
14" x 18"

THE CHINESE WORD FOR LANDSCAPE PAINTING IS *SHAN-SHUI*— MOUNTAIN/ROCK-WATER. **NIAGARA REMEMBERED** IS A CONTEMPORARY INTERPRETATION OF THIS ANCIENT TECHNIQUE. CHAN USES COLORS AT FULL STRENGTH ON DRY PAPER, THEN SPLASHES ON WATER WITH A SPRAY BOTTLE. IF THE PAPER IS NOT WET ENOUGH, SHE DIPS THE BRUSH AND DRAGS ON LOTS OF WATER. SHE ENJOYS USING AN EXCESSIVE AMOUNT OF WATER, SPLASHING AROUND AND SPRAYING UNTIL SHE GETS THE DESIRED EFFECT. SHE USES THE BACK END OF AN AQUARELLE BRUSH TO SCRAPE OUT THE TOPS OF THE LARGE SLABS OF ROCKS.

EVENING REFLECTIONS
JACQUELINE PEPPARD
40" x 30"

PEPPARD ELIMINATES BLACK, WHITE
AND ALL OPAQUES FROM HER
PALETTE, USING ONLY TRANSPARENT
PIGMENT. WITHOUT OPAQUES, THE
LIGHT PASSES THROUGH THE PIG-
MENT, HITS THE PAPER AND BOUNCES
BACK, ILLUMINATING THE PIGMENT
FROM WITHIN. THE LAYERING OF
TRANSPARENT WASHES PRODUCED
THE WONDERFUL BLUE-VIOLET IN THE
WATER AND THE PURE, RICH COLOR
IN THE FOREGROUND GRASSES.

WAKE PEOPLE UP TO THE GRANDEUR OF NATURE

It is my intent to reflect the grandeur, power and movement in nature. I want to inspire viewers out of complacency so they may establish a connection with the earth. It seems to be the extremes that wake people and get them to respond, so I work to create drama and emotion in my paintings.

I look for special lighting situations and try to determine which elements make a particular scene intriguing. I focus on and heighten or exaggerate those elements or effects. Late afternoon to dusk is the light I like best. The colors are intensely saturated and warm. The lighting during storms also grabs my attention no matter what time of day it is.

Because I like dealing with fleeting light situations and the way I work with watercolor makes it impossible to work outdoors fast enough, I use a camera as a sketch tool. During a shooting session I free my mind from any preconceptions and photograph all the different approaches and perspectives I can.

In this painting, I was not so much intrigued by the mountains as I was with the foreground. The purples in the quiet, meandering stream, along with the blues and greens in the grasses, are soothing.

COMMUNICATE TO THE HUMAN SPIRIT

I must be concerned with what I leave behind when I'm gone. The visual arts must communicate to the human spirit, forcing individuals to reflect on themselves and their existence beyond their own self-interest.

I was raised by my maternal grandmother. Her deep commitment to giving unconditional, reinforcing love above all else has had a deep moral and spiritual impact on me. I have always tried to maintain a sense of humanity in my work, to create something that will take on its own personality but also reflect something about our world. Above all, it is important to love what you create. I love what I paint. I wouldn't paint anything I wouldn't hang on my own walls.

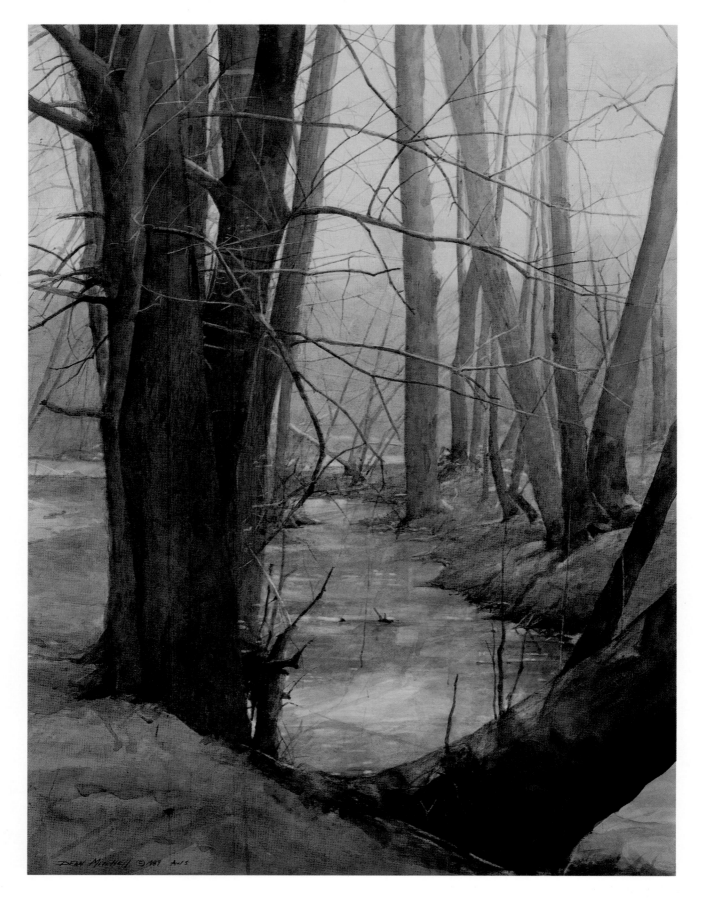

PRICELESS TREASURES
DEAN MITCHELL
24" x 18"

PRICELESS TREASURES IS
TRANSPARENT WATERCOLOR ON A
COLD-PRESS SURFACE. MITCHELL
CREATED THE SOFT, AIRY ATMOS-
PHERE BY WORKING LIGHT TO DARK
IN A SERIES OF DELICATE WASHES,
AS WELL AS SOME LIFTING WITH
WATER.

CHAPTER 10

For the Love of Beautiful Design

FOR THE PAINTERS IN THIS CHAPTER, the two-dimensional image takes on a life of its own. Combined with a love for the particular subject matter is a love for taking the complex, disorganized shapes found in reality and simplifying them into a strong design that communicates more powerfully than a mere copy.

THE HEART *and soul of a painting is not the object nor subject, but the composition and design, its values of light and dark, and its color harmony.*

—*Ken Schulz*

FOOTLOCKER STILL LIFE
WITH BOOTS
ROBERT C. DEVOE
28" x 42"

GLASS AND LIGHT
ROBERT C. DeVOE
35" x 23½"

AS HIS DRAWING SOURCE AND PAINT-
ING REFERENCE, DeVOE USES 35MM
PHOTOGRAPHIC SLIDES, WHICH HE
MAKES FROM HIS OWN STILL-LIFE
SETUPS. HE APPLIES PAINT MOSTLY
WITH AIRBRUSHES, USING BOTH
FREEHAND AND MASKING TECH-
NIQUES. AS A FINAL STEP, HE
REFINES EDGES WITH A WET BRUSH
TIP OR WITH COLORED PENCILS.

CREATE YOUR IMAGE, CONCEPT TO FINISH

I took up still life because it seemed an "easy" and unambiguous form in which to practice aesthetic choices and develop technical skills. But as I worked with it, I became fascinated by the unlimited challenges and rewards it offered me.

It, more than any other art form, enables me to take charge of every aspect of the image: to choose the shapes, textures and colors; to orchestrate their relationships; to determine the quality and direction of light; even, at an extreme, to design and make the objects. Such an attitude may seem obsessive to some, but for me, creating a still life has all the excitement of putting on a play in which I get to be the playwright, set designer, director, star, supporting cast and even audience.

Such a challenge is inspiration enough to keep me working, but when I want inspiration to help shape a particular project, I usually find an abundance in the work of my illustrious predecessors. The critic-philosopher E.H. Gombrich has demonstrated that the major source of art is not nature but art, and I quite agree. I deeply love the natural world, but I'm never so inspired to paint by looking at a live peony as I am by looking at a painting by Fantin Latour, or one by Cezanne, or William Merritt Chase, or John Stuart Ingle, or . . . the list is endless, and so are the possibilities.

Robert C DeVoe

BRING INSPIRING PATTERNS TO LIFE

I am inspired by dark shapes, light shapes, repetitive patterns; a dark band cut by a slash of light. Because I love nature and birds, my dark shapes may become shadows cast by a cactus and my slash of color or light may become a bird.

An idea may come from another artist's work. Then I look for something in nature I can use to translate that idea. An abstract painting of strong, vertical dark lines and a single spot of bright color inspired *Hooded Oriole-Palms*.

Earnshaw [signature]

HOODED ORIOLE—PALMS
ADELE EARNSHAW
17" x 39"

EARNSHAW MADE AN EFFORT IN
HOODED ORIOLE—PALMS TO
KEEP THE SHAPES INTERESTING BY
VARYING THE SIZE OF EACH NEGATIVE
SPACE. SHE PAINTED LIGHT TO DARK,
SAVING THE WHITE PAPER FOR THE
LIGHTEST VALUE. A FAN BRUSH PRO-
VIDED TEXTURE ON THE PALMS.

SONORAN COSTA'S
ADELE EARNSHAW
10½" x 28½"

SONORAN COSTA'S WAS PAINT-
ED IN SECTIONS, ONE CACTUS PAD AT
A TIME UNTIL THE COLOR AND VALUE
OF EACH PAD WAS ESTABLISHED.
THEN EARNSHAW GLAZED LARGER
AREAS OF THE PAINTING IN A TRANS-
PARENT WASH TO UNIFY THEM. SHE
PAINTED THE DARK NEGATIVE SHAPES
LAST.

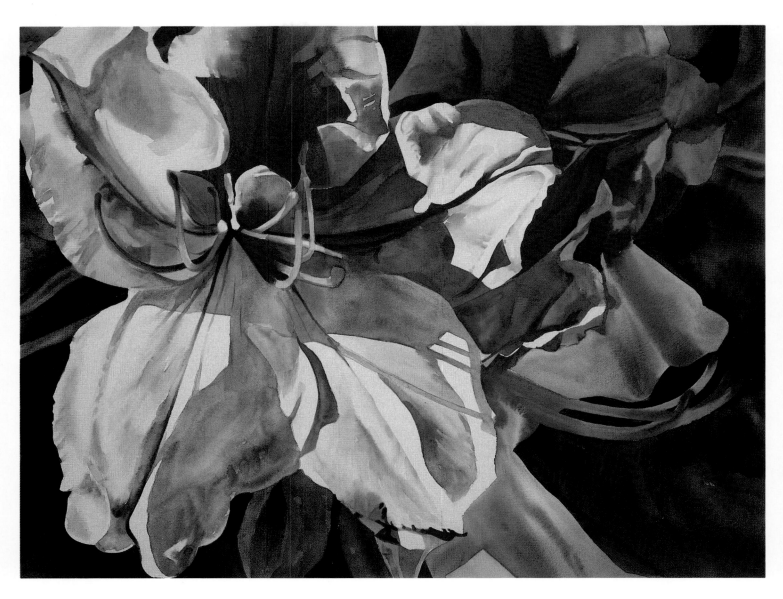

APPRECIATE THE ABSTRACT PATTERNS OF LIGHT

Living on the shore of Lake Champlain, and a love of gardening, have contributed to my lifelong appreciation of nature. The expression of my feelings gives meaning to my work, and I prefer to be selective in what I portray rather than copying exactly what I see.

I often use a close-up point of view; simplifying shapes helps me create a stronger design and composition. By getting past seeing things as objects, I can appreciate their abstract qualities and see the relationships of shapes, rhythm, movement, composition, color, values and texture.

The abstract patterns created by light have always fascinated me and play an important role in my paintings. They help me to simplify design and strengthen composition. I feel that by simplifying the subject matter I give viewers a chance to involve their own imagination and perhaps see things in a new way.

Ann Pember

AZALEA
ANN PEMBER
21 ½" x 29"

PEMBER SIMPLIFIED THE SUBJECT WITH A CAREFUL DRAWING AND USED WARM, INTENSE COLORS. SHE TRIED TO GET THE COLOR DOWN RICHLY ENOUGH WITH THE FIRST WASH TO PRESERVE ITS BRILLIANCE. MOST AREAS WERE PREWET BEFORE SHE FLOATED COLOR IN, ALLOWING IT TO MIX ON THE PAPER. SHADOW AREAS RECEIVED SOME CAREFUL GLAZING TO BALANCE VALUES.

RITES OF SPRING
LARRY K. STEPHENSON
60" x 40"

THE FLORAL CENTER OF **RITES OF SPRING** WAS EXECUTED USING TRANSPARENT WATERCOLOR TECHNIQUES. STEPHENSON APPLIED LAYER AFTER LAYER OF CONTROLLED WASHES WHILE GRADUALLY DEFINING THE HARD EDGES. HE USED NO MASKING AGENTS. THE BORDERS WERE PAINTED USING OPAQUE GOUACHE.

ATTRACT THE VIEWER FROM A DISTANCE

Nowhere in nature can you find purer color than sunlight passing through the petal of a flower. I paint large, "in-your-face" paintings for maximum impact. Most of my work is executed on 40″ x 60″ Arches watercolor paper. I want my work to attract the viewer from a distance and continue to entertain as the viewer moves closer to the painting.

Realism is very much a part of my Oklahoma upbringing. This part of the country still seems simpler and closer to the earth. I enjoy abstraction and own a variety of types of art in my own collection, yet my paintings constantly reflect my conservative nature, sometimes with a twist. This can be seen in the borders of several recent pieces, such as *Rites of Spring*.

HAVE FUN PROBLEM SOLVING

The best thing about being an artist is that it is not just my work but a state of being. I constantly view the world in terms of visual dynamics. I seek relationships between shapes, light, color and space. Then I paint what I see.

Though an emotional response is important, ultimately painting to me is about problem solving. This is not to say that painting is serious. It is great fun to develop the rhythm within a painting. I also love to play the game of looking at someone or something and breaking the colors down to their basic components.

Frey

STILL LIFE WITH BEN
KAREN FREY
22" x 30"

FREY USED A WET-INTO-WET TECH-
NIQUE IN **STILL LIFE WITH
BEN** ON A HIGHLY SIZED PAPER.
THIS MADE THE TIMING AND THE
WATER-TO-PIGMENT RATIO EVEN
MORE CRUCIAL. SHE CHOSE TO KEEP
THE FOREGROUND AND THE BACK-
GROUND SOFT AND OUT OF FOCUS,
YET USED HIGH VALUE CONTRASTS
AND INTENSE COLOR. AS A BALANCE,
AND TO DRAW ATTENTION TO THE
FIGURE, SHE PAINTED THE CAT WITH
CRISP EDGES, SOFT COLOR, AND LOW
VALUE CONTRAST.

IMPOSING ORDER ON VISUAL IMAGES

My painting reflects my interests and passion for imposing order and structure on visual images. I take comfort and satisfaction in creating controlled watercolors that display artistry, but to me the most important aspect in a work of art is the design or composition. The motivation for design comes from an unfailing sense of wonder about light and its effects on the form of everyday images.

A love of antiques and the pattern of Asian rugs led me in creating this painting. The strawberry plate was used by my grandmother for Sunday suppers. But the infatuation with sunlight streaming through the window is the true reason for capturing form and color.

After painting watercolor landscapes for ten years, this is my first major still life. Trying to capture the texture of the rug led me to discover a Pointillistic technique.

BUCHANAN'S AESTHETIC FOCUS WAS ON CONTRASTS: CONTRASTS BETWEEN THE FLAT PATTERN OF THE RUG AND THE THREE-DIMENSIONAL FORMS OF THE OBJECTS, CONTRASTS OF VALUES, AND CONTRASTS OF TEXTURES AND COLORS. HE BUILT THE IMAGE BY GLAZING LAYER UPON LAYER OF TRANSPARENT COLORS, RESERVING LIGHT SHAPES. FOR THE ASIAN RUG HE USED A POINTILLISTIC APPROACH, WHICH ALLOWED HIM TO BUILD THE VALUE AND COLOR AT A CONTROLLED RATE. THIS WAS A BREAKTHROUGH TECHNIQUE AND THIS CONTROLLED METHOD HELPED HIM SHOW THE TEXTURE OF THE RUG AND CREATE A SOFT EDGE FOR THE CAST SHADOWS.

FLO-BLUE
ROBERT E. BUCHANAN
22½" x 33½"

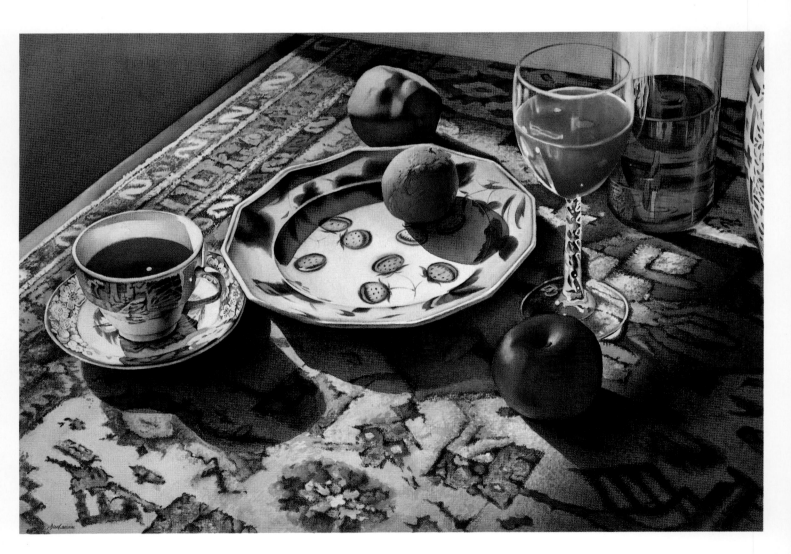

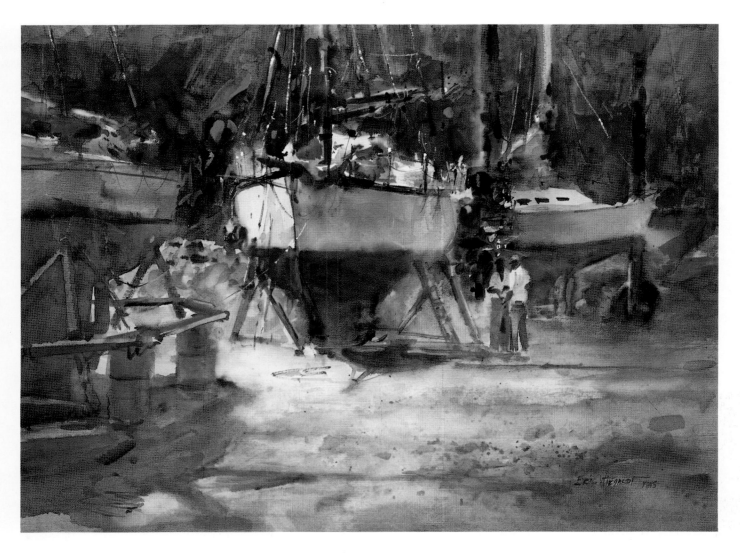

SIMPLIFY REALITY INTO A STRONG DESIGN

I am very much attracted to the Pacific Northwest, where I live. For me, marinescapes offer an avenue for the creative design experience. I love taking the complex, disorganized shape and value relationships found in reality and simplifying them into a strong design pattern. I try to be sensitive to the value, shape and color relationships as I see them, but I will not hesitate to use my own sense of these to improve the design.

Everything I paint is from a personal visual experience. I gather information through the use of a sketchbook, camera, or on-location color study. I spend a good portion of my time absorbing through all my senses, as I feel this stimulus is essential to the creative energy. It is important for me to relax and allow reality to unfold into its abstract patterns.

If I can get the big shapes manipulated into a strong pattern, there is tremendous flexibility in interpreting the details. This flexibility allows me to paint intuitively and emotionally, a very satisfying process.

Eric Wiegardt

DRY DOCK
ERIC WIEGARDT
22" x 30"

WIEGARDT PREFERS TO WORK AS THE PAPER IS IN TRANSITION FROM WET TO DRY. HE DOES NOT WET THE WHOLE PAPER FIRST BUT CAPITALIZES ON HIS INITIAL DAMP WASHES WITH SUCCESSIVE PIGMENT APPLICATIONS. THIS ALLOWS FOR A SPONTANEOUS EDGE QUALITY UNIQUE TO WATERCOLOR. SINCE TIMING IS CRITICAL, THE ARTIST MUST JUDGE QUICKLY AND RELY ON HIS INTUITIVE IMPULSES. HE USES WINSOR & NEWTON PAPER, WHICH ALLOWS FOR MUCH LIFTING AND SCRUBBING, AS IN THE FORE-GROUND WHERE A SOFTER TEXTURE WAS DEVELOPED.

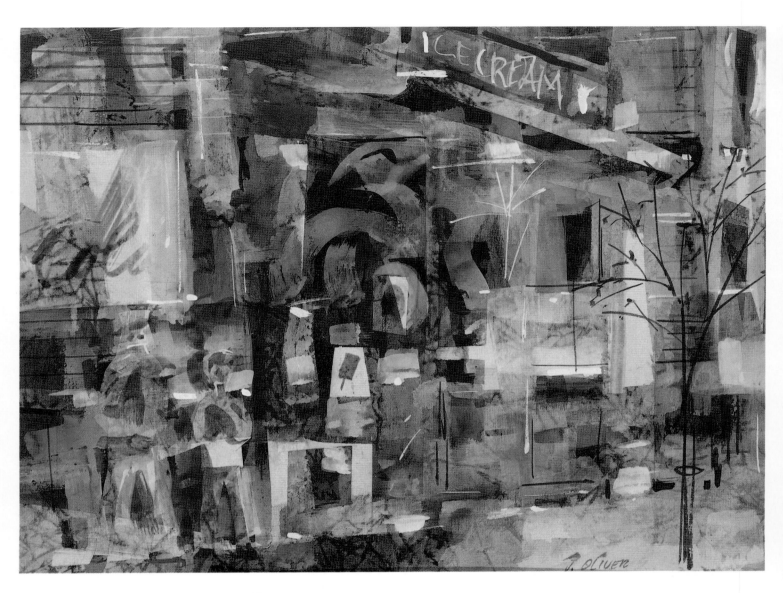

PAINTING PIECES OF POETRY

I take a lot of photos or slides of things that "grab" me because of their colors or the lighting on them. It could be a puddle at my feet, it could be a distant view. To me, they are pieces of poetry. Usually I combine parts or all of several different photos to make a composition.

I've been influenced by the Cubists and the Impressionists, and I like to play with planes: pushing one back, bringing another forward. I like to give figures a feeling of movement and elusiveness, so that they melt into the landscape. The viewer is aware first of the more permanent things like sky, water, rocks, hills and trees, then buildings, and finally, the figures, the most ephemeral. In this painting, the two kids eating ice cream cones are not the first things a viewer sees, yet their subtle presence adds life to this cold, gray winter day.

ICE CREAM STORE
JANE OLIVER
11" x 15"

OLIVER WORKS IN TRANSPARENT WATERCOLOR ON HOT-PRESS PAPER, OVERLAYING COLORS TO CREATE DEPTH AND VIBRATIONS AND TO GIVE A SENSE OF MOVEMENT AND LIFE TO THE SCENE, ESPECIALLY TO THE FIGURES. SHE USES FRISKETED SHAPES DONE IN ACRYLICS OR INKS, ALONG WITH WET WASHES AND OVERLAPPING COLORS AND SHAPES.

JANE OLIVER

TAKE PICTURES EVERYWHERE

My constant companion is an auto-focus camera. I take photos everywhere there are people. I average two rolls of 36 exposure film per week. Out of these frames, I usually have three to four pictures that have possibilities. It may be a person's stance, a certain facial expression, something about the immediacy of the moment. Once I have selected a photo to work with, it may be months before the actual painting begins. I think about where this person should be: in a field, a garden, a park, near the ocean, on some stairs, in the water, etc. Then I think about the lighting conditions. Most often, I paint strong light with bold value changes. I work my value studies on a computer using the Ansel ScanMan program. After I have solved my contrast and design problems on the computer, it's time to begin the painting.

I try to convey an impression of the model's personality, to capture a moment of life. I feel each person has a color that is right for him or her. As I stare at my sketches and photo, the correct color and temperature seem to come to me intuitively. Often I can imagine the entire painting on the blank white paper sitting before me. When this type of inspiration hits me, I paint until the feeling no longer exists.

D. Margeson

THREE WADERS WAS DEVELOPED FROM SEVERAL PHOTOGRAPHS OF PEOPLE WADING IN THIS COUNTRY RIVER. ORIGINALLY THERE WERE ONLY TWO FIGURES, BUT THE DESIGN WAS NOT BALANCED. THE ADDITION OF THE THIRD FIGURE, LEANING OVER, CONNECTED THE OTHER TWO. MARGESON SLOWLY BUILT UP TRANSPARENT WASHES IN BOTH THE FLESH TONES AND CLOTHING BEFORE THE DARKER VALUES IN THE BACKGROUND VEGETATION. BY DETAILING THE WATER IN THE LEFT FOREGROUND, ENCIRCLING THE WADERS, THE EMPHASIS IS PLACED ON THE THREE YOUNG GIRLS. THE PAINTING WAS DONE SOLELY WITH TRANSPARENT WATERCOLORS.

THREE WADERS
D.F. MARGESON
14" x 21"

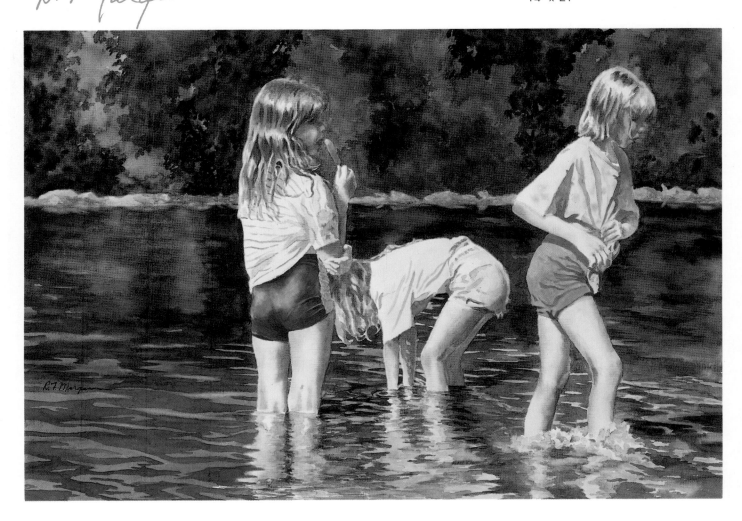

PAINT A SCENE IN YOUR MIND

I strive to have my paintings look spontaneous and inspired by the moment, but as a teacher of painting I need also to be methodical and thoughtful in my approach. I've learned that spontaneity needn't suffer from preplanning. Even when I paint for myself, I define what has inspired me to select a subject as if I were preparing to teach. This usually gives me a clear picture of what I want the final painting to convey to the potential viewer.

Often, when I see something that gives me an idea for a painting, I carry that idea in my head until I finally feel inspired to do the actual painting. This delay frequently results in a better painting than if I began immediately, while details and the specific visual image is too clear. While I carry the idea, I imagine the piece finished—in different moods, under different light sources, in various weather conditions, with variations to the composition, at different times of day. In my mind I paint the scene many ways before actually touching a brush to the paper. *A Quiet Moment* captures that moment at dusk as the last rays of sun drop below the horizon.

JAMES McFARLANE___.

A QUIET MOMENT IS BASED ON CONTRASTS—THE DRAMATIC CONTRAST BETWEEN LIGHT AND DARK AND THE LESS OBVIOUS CONTRAST BETWEEN THE COMPLEMENTARY COLORS. THE SUBTLE ORANGE GLOW IN THE SKY CONTRASTED WITH AN EQUALLY SOFT BLUE IN THE WATER SET THE MOOD. REDUCING HIS SUBJECT TO THE SIMPLEST SHAPES, ELIMINATING NONESSENTIAL DETAIL, AND CONSCIOUSLY CONSIDERING THE EFFECT OF THE COLORS ENABLED THE ARTIST TO CAPTURE THAT "QUIET MOMENT."

A QUIET MOMENT
JAMES McFARLANE
14½" X 21½"

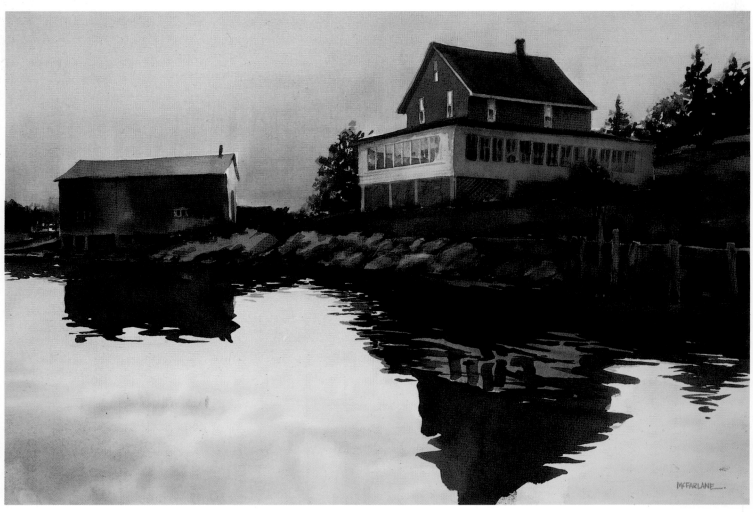

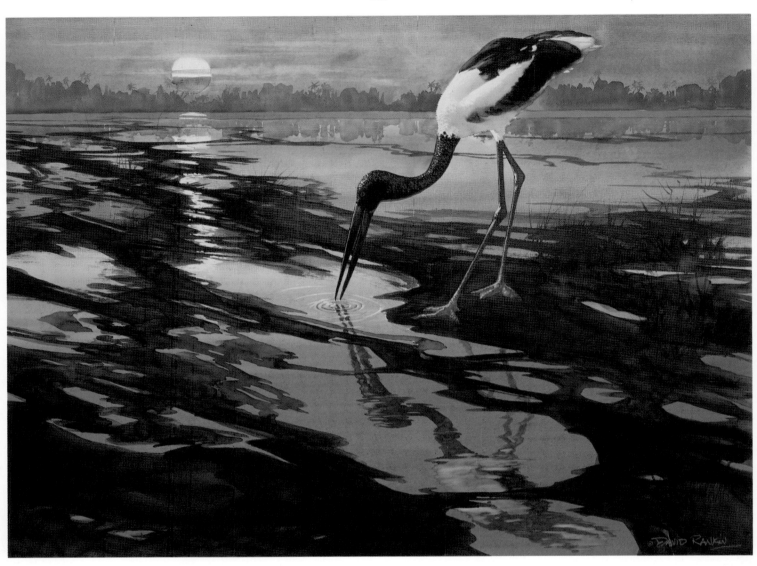

DESIGN A "NATURAL ABSTRACTION"

An intense interest in yoga led me to make the first of many trips to India, creating an ongoing fascination with the extraordinary beauty of India's wildlife and ancient cultural landscape. This, coupled with my meditative disciplines and spiritual life, inspires and powers my work today. Over the past decades of travel I have gradually developed what I call "natural abstraction" as the basis for most of my work. Natural abstraction is my attempt to create realistic paintings based on the abstract design relationships I discover in nature.

Last Light was the fourth painting in a sunset series inspired by field study of black-necked storks during my last trip to India. Although I used a stork here, it was the light and the design of the mud flats that powered this painting. To me, the ability to draw and paint are slaves to good design. A watercolor that is done well but has a weak design structure will have less visual appeal than one that may not be painted as well but has good, solid design as its basis.

LAST LIGHT
DAVID RANKIN
28" x 38"

RANKIN SOAKED THE SURFACE OF THE WATERCOLOR BOARD WITH WATER, THEN RAN LARGE, SWEEPING WASHES OF WINSOR & NEWTON ULTRAMARINE INTO COBALT BLUE, INDIAN YELLOW AND ROSE MADDER. HE GRADATED EACH ONE INTO THE OTHER BY TILTING THE BOARD AT EXTREME ANGLES IN BOTH DIRECTIONS. WHEN THE PAINT WAS BONE DRY, HE THEN OVERPAINTED ALL OF THE DARKER ELEMENTS, INCLUDING SOME GOUACHE IN THE WHITES OF THE STORK AND IN THE IRIDESCENCE OF ITS NECK.

DAVID RANKIN

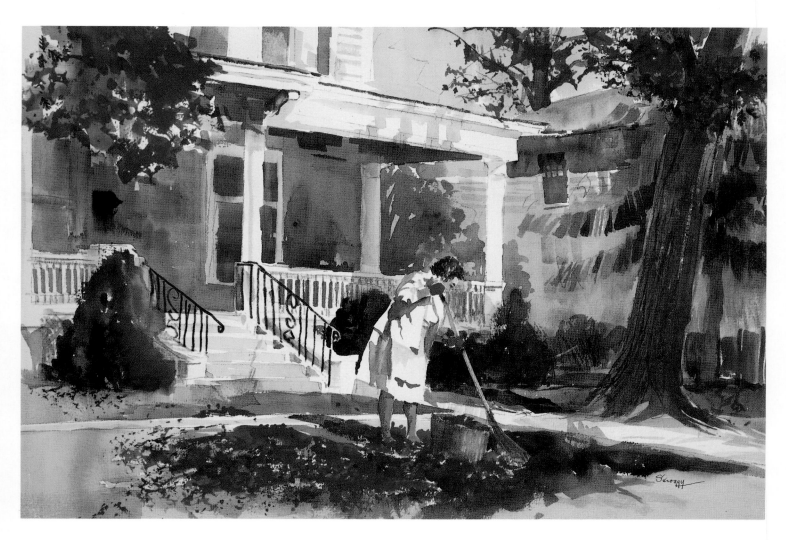

CREATE A DIALOGUE WITH THE VIEWER

When creating a painting for public viewing and sale, I realize that the piece will most often wind up in someone's home. If it will be staying for twenty or thirty years, I feel obliged to make sure it is a good guest. I do this by creating a dialogue with the viewer. By leaving some of the areas almost unfinished, there is a sense of mystery and involvement. I make choices that help create emotion by taking time to consider what visual information is important to the statement and what is distracting.

 I have heard it said that "it is better to paint adjectives than nouns," and this idea hits home with me. In *Fall's Fall*, the painting succeeds by concentrating on the feeling of the season, avoiding the trap of tempting detail in the Victorian architecture.

FALL'S FALL
HAL SCROGGY
15" x 22"

SCROGGY TOOK A QUICK PICTURE OF THIS SCENE WHEN HE WAS STOPPED IN TRAFFIC. BACK IN HIS STUDIO, HE WENT TO WORK WITH THE MATERIAL. THE HOUSE WAS A BUSY VICTORIAN DISTRACTION, SO HE SIMPLIFIED IT. HE CHOSE A GESTURE AND REPLACED THE WOMAN'S SLACKS WITH A HOUSE DRESS. HE THEN CHOSE THE COLORS TO GIVE A SEASONAL FEELING.

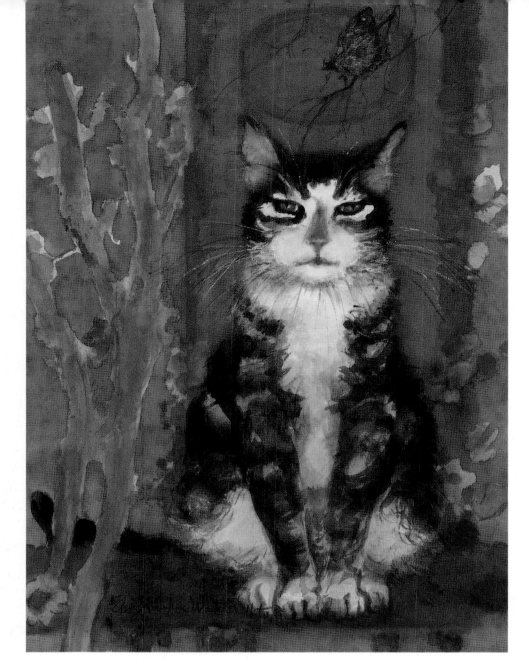

THE KING PRESIDES
EILEEN MONAGHAN
WHITAKER
30" x 22"

FROM QUICK SKETCHES, THEN A
THUMBNAIL DESIGN IN COLOR,
WHITAKER PENCILLED IN A DRAWING
OF THE CAT, WITH LOOSE BACK-
GROUND SHAPES. SHE PAINTED THE
CAT FIRST, GRADUALLY WORKING IN
THE BACKGROUND. HER PAINTINGS
DEVELOP SLOWLY. PRELIMINARY LAY-
OUTS ARE ONLY SUGGESTIONS TO
DEFINE BASIC SHAPES AND COLOR
PATTERN. AS THE WORK EVOLVED, IT
TOOK ON A LIFE OF ITS OWN.

FIRST MAKE SOME THUMBNAIL DESIGNS

Inspiration comes easily to me—I often get excited about something I see. I love to sketch and paint people, birds, animals, flowers, fruit, architecture. These and endless other subjects are material for my huge collection of sketchbooks. With sketches, I quickly capture the moment of inspiration. With paintings, I attempt to interpret my emotional reactions to these inspirations. Once I am engrossed in a painting, my hand, brush and emotions take over as I paint.

Before I reach this "euphoric" point, however, there is something I am very fussy about: *design*. I note design in everything. Once I have an idea for a painting, which may come from one or many sketches, I make a series of thumbnail designs for a composition in black and white, then in color. These are rough layouts, or "plans," for a painting.

Though not especially a feline fancier, I love to paint these handsome creatures. The pose in *The King Presides* suggests the imperious, the aloof and, yes, the regal attitude cats seem to exude.

Eileen Monaghan Whitaker

THE PLEASURE OF THE PROCESS

I enjoy spending time surrounded by beauty. I hike in the mountains, walk on the seashore and admire flowers. My inspiration comes from this beauty. I then play with the images of these things I enjoy, either on site or from photos.

My process of working includes a whole range of distilling and simplifying the image. I enjoy playing with the colors and shapes. Eventually the two-dimensional image takes on a life of its own. I have worked totally abstract from time to time, but for me, abstract paintings lack the emotional impact of realism. I enjoyed working with the red rock formations in *Wilson Arch*. I wanted to keep the colors as exciting as possible, even in the shadows.

So, the combination of visual image and manipulation of paint is my source of enjoyment. When my images instill similar pleasure in viewers, the process is complete for me.

R. HILKER

TO SHOW THE OVERALL WARMTH OF THE LIGHT, EVEN IN THE SHADOWS, HILKER COVERED ALL BUT THE SKY WITH A LIGHT WASH OF CADMIUM ORANGE AND NEW GAMBOGE. HORIZONTAL SURFACES ON THE ROCKS (LIGHTED BY THE BLUE SKY) WERE WASHED WITH CERULEAN BLUE AND LEFT A LITTLE LIGHTER THAN THE VERTICAL SURFACES.

WILSON ARCH
RICH HILKER
22" x 30"

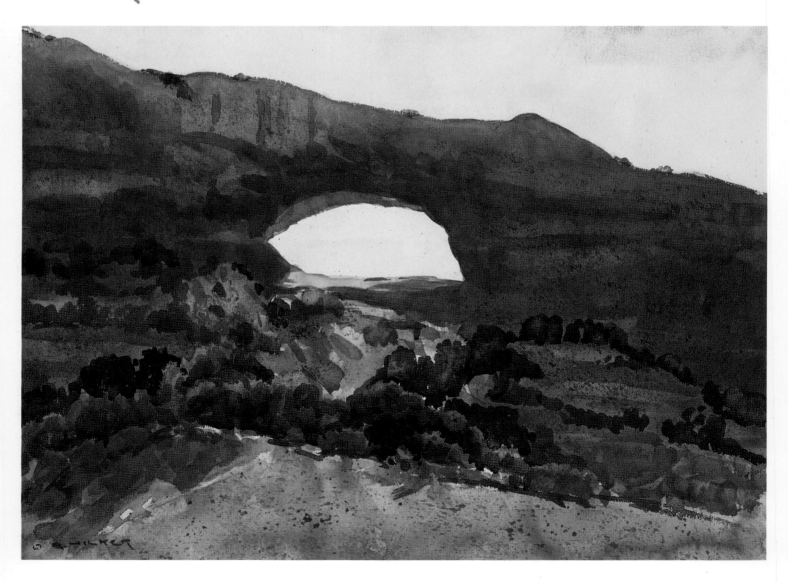

THE HEART AND SOUL OF A PAINTING IS DESIGN

In more than fifty years of painting, I don't recall waiting to be moved to paint. An object, a partial landscape or seascape, waterfowl, wildlife, a small pond, even a tiny flower or cloud formation will unexpectedly thrust itself on me and, tired or not, my interest is instantly reborn.

My approach to a painting is first an interest in the subject. But the heart and soul of a painting is not the object or subject but the composition and design, its values of light and dark, and color harmony. I plan with thumbnail sketches the composition, values and color harmony, bringing all three together in a simplicity of design. I strive to make each painting better than the last and hope that for the viewer it will rekindle a memory to be relived.

Ken Schulz

SCHULZ PAINTED THE SKY FIRST TO ESTABLISH THE OVERALL ATMOSPHERE AND A BACKDROP FOR THE GEESE. HE USED THREE VALUES OF LIGHT, MEDIUM AND DARK TO GIVE THE PAINTING IMMEDIATE IMPACT AND POWER. CLEAR WASHES OF COLOR AND DRYBRUSHING COMPLETED THE PAINTING.

TIME TO MOVE ON
KEN SCHULZ
15" X 21½"

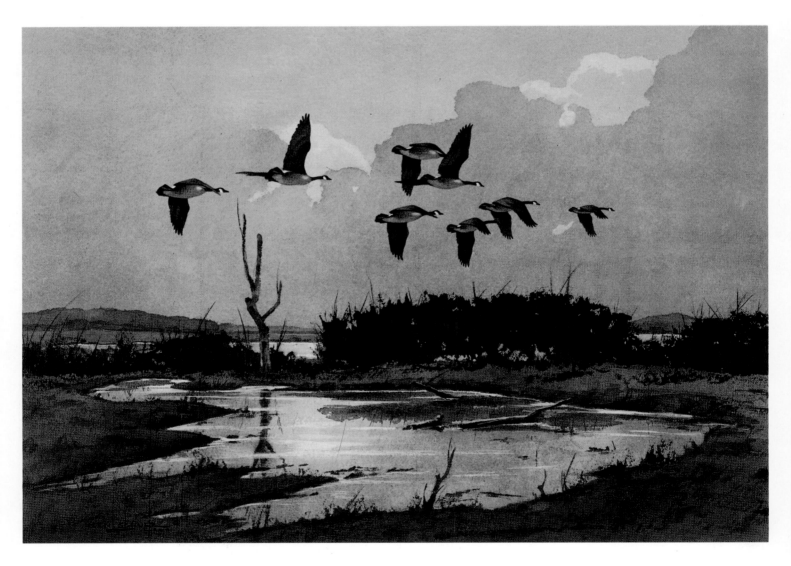

PERMISSIONS

Sue Archer, pp. 16-17
10138 Dahlia Avenue
Palm Beach Gardens, FL 33410
Lizard Run #8 © Sue Archer, collection of the artist
Seagrape #20 © Sue Archer

David M. Band, p. 9
1903 Eden Lane
Wichita Falls, TX 76306
Sunset, Stratton © David M. Band

Miles G. Batt, pp. 102-103
301 Riverland Road
Ft. Lauderdale, FL 33312
River Gathering © Miles G. Batt,
collection of the artist
Vivid Vessels © Miles G. Batt, courtesy of Tidwell/Slavens Galleries,
Charleston, SC, private collection

David R. Becker, p. 93
101 East Erie
Chicago, IL 60611
Chicago & Rush II © David R.
Becker

Richard Belanger, p. 14
5922 Molson
Montreal, Quebec, Canada, H1Y
3B9
Depanneur N.D.G. © Richard
Belanger, collection "Au Coin de
L'Encadrement"

Judith Blain, p. 25
2193 Deer Pass Trail
White Bear Lake, MN 55110
Heads, You Ask Her, Tails I Do ©
Judith Blain, exhibited at the Shaw
Gallery, Naples, FL

Gerald F. Brommer, p. 79
11252 Valley Spring Lane
North Hollywood, CA 91602
Coastal Path © Gerald F. Brommer

Jack R. Brouwer, p. 56
1821 Woodward Avenue
Grand Rapids, MI 49506
Camel Market © Jack R. Brouwer,
from the Egyptian Collection of
the artist

Robert E. Buchanan, p.120
874 E. Market Street
York, PA 17403
Flo-Blue © Robert E. Buchanan,
collection of Mr. & Mrs.Richard D.
Panza, OH

Barbara George Cain, p. 42
11617 Blue Creek Drive
Aledo, TX 76008
Slow Morning © Barbara George
Cain

Marc Castelli, p. 58
S./Apt., 526 S. Eagle Road
Havertown, PA 19083
You Can't Drive There © Marc
Castelli, Carla Massoni Gallery,
Chestertown, MD

Mary C. Chan, p.110
1555 Elm Street
Napa, CA 94559
Niagara Remembered © Mary C.
Chan, private collection

Cheng-Khee Chee, pp. 28-29
1508 Vermillion Road
Duluth, MN 55812
Lakeshore 93 No. 2 © Cheng-Khee
Chee, artist's collection
Koi 90 No. 4 © Cheng-Khee Chee,
artist's collection

William H. Condit, pp. 80-81
1256 S. Pearl Street
Denver, CO 80210
Civil War Hideout © William H.
Condit
Sounds of Nature's Music © William
H. Condit, collection of Mr. &
Mrs. William Stone, Denver, CO

Carol Cottone-Kolthoff, pp. 96-97
5085 Argonne Court
San Diego, CA 92117
Aviary Triptych © Carol Cottone-
Kolthoff

Sharon Crosbie, pp. 64-65
43W051 Smith Road
Elburn, IL 60119
A Place Where Dreams Are Made ©
Sharon Crosbie, collection of Steve
& Marcy Muldowney
Morning Light © Sharon Crosbie,
collection of the First Chicago
Bank in St. Charles, Illinois
Just the Two of Us © Sharon
Crosbie, collection of the artist

Ratindra Das, p. 92
1938 Berkshire Place
Wheaton, IL 60187
By the Bay © Ratindra Das, collection of the artist

James Dean, p. 32
4804 King Richard Drive
Annandale, VA 22003
Blue Forsythia © James Dean
Island Gulls © James Dean

Mary De Loyht-Arendt, p. 13
P.O. Box 1653
Scottsdale, AZ 85252
Sacred Mountain © Mary De
Loyht-Ardendt, Gallery A, Taos,
NM

Betty DeMaree, pp. 30-31
4725 W. Quincy Avenue #1403
Denver, CO 80236
Small Edition © Betty DeMaree
Leni, Small © Betty DeMaree

Robert C. DeVoe, pp. 114-115
380 Taylor Street
Ashland, OR 97520
Footlocker Still Life With Boots ©
Robert C. DeVoe
Glass & Light © Robert C. DeVoe

Linda Kooluris Dobbs, p. 63
330 Spadina Road, Apt. 1005
Toronto,Ontario, Canada, M5R
2V9
Piemonte Interior © Linda Kooluris
Dobbs, collection of Ann & Ed
Wood, Toronto, Canada

Donald L. Dodrill, p. 98
17 Alrich Road, Suite C
Columbus, OH 43214
Time Mechanisms II © Donald L.
Dodrill, collection of the artist

Elton Dorval, p. 49
8742 Bay Filly Lane
Racine, WI 53402
The Death of Raven Sherman ©
Elton Dorval

Adele Earnshaw, p. 116
P.O. Box 1666
Sedona, AZ 86339
Hooded Oriole—Palms © Adele
Earnshaw, collection of Mr. & Mrs.
Garrett
Sonoran Costa's © Adele Earnshaw,
collection of Mr. & Mrs. Joe Garcia

Theresa R. Einhorn, p. 6
3600 Lake Shore Drive #611
Chicago, IL 60613
Blue Canyon © Theresa R. Einhorn
Rock Falls © Theresa R. Einhorn

Benjamin Einsenstat, p.35
3639 Bryant Street
Palo Alto, CA 94306
Inner Harbor #1 © Benjamin
Einsenstat

Nita Engle, p. 51
177 Co. Rd. 550
Marquette, MI 49855
After the Rain, Whitby © Nita Engle,
collection of the artist

Don Enright, p. 108
1843 S. Cedarcrest Avenue
Coupeville, WA 98239
Ready to Soar © Don Enright

Tom Francesconi, pp. 2-3
2925 Birch Road
Homewood, IL 60430
Secluded Entry © Tom Francesconi,
collection of the artist
New England Summer © Tom
Francesconi, collection of Antonia
Rafalsky

Kass Morin Freeman, pp. 104-105
1183 Troxell Road
Lansdale, PA 19446
End of Day © Kass Morin
Freeman, collection of Ocean City
Arts and Cultural Center, Ocean
City, NJ
Gerber's Daisies © Kass Morin
Freeman
Unchambered Nautilus © Kass
Morin Freeman

Karen Frey, p. 119
1781 Brandon Street
Oakland, CA 94611
Still Life With Ben © Karen Frey

Gerald J. Fritzler, pp. 52-53
Box 253
Mesa, CO 81643
Rio Di Santa Maria Zobenigo ©
Gerald J. Fritzler, collection of Dr.
& Mrs. Larry Willis
Mevagissey Harbor-Cornwall ©
Gerald J. Fritzler, collection of
Bernice Cudd

Lori Fronczak, p.95
924 David Drive
Bensenville, IL 60106
Galaxy Pattern VII © Lori
Fronczak, collection of the artist

Henry Fukuhara, p.59
1214 Marine Street
Santa Monica, CA 90405
Chichicostenango © Henry
Fukuhara, courtesy of the Stary
Sheets Fine Art Galleries,
Irvine, CA

Tom Gallovich, p. 50
218 Bryant Street
Vandergrift, PA 15690
The Door Man © Tom Gallovich

Joe Garcia, p. 21
P.O. Box 2314
Julian, CA 92036
Coyote: Break Time © Joe Garcia,
collection of the artist

Donald James Getz, p. 68
2245 Major Road
Peninsula, OH 44264
*Silver Lady, No. 3 in Automotive
Images Series* © Donald James Getz

Nessa Grainger, p. 26
212 Old Turnpike Road
Califon, NJ 07830
Landlocked © Nessa Grainger

Jean Grastorf, p. 78
6049 4th Avenue N.
St. Petersburg, FL 33710
Beach © Jean Grastorf, collection of
Brian and Margaret Cornish

Greta S. Greenfield, p. 86
5545 Flagstaff Road
Boulder, CO 80302
Red Mountain © Greta S.
Greenfield

Joan Hansen, p. 94
599 Galveston Way
Bonita, CA 91902
Butterfly Ballet, Act II © Joan
Hansen

Bill Harvey, p. 8
5800 West Charlston #1017
Las Vegas, NV 89102
Clematis © Bill Harvey, courtesy of
Raku Gallery, Jerome, AZ

Ray Hendershot, p. 99
1007 Lakeview Terrace
Pennsburg, PA 18073
Blizzard © Ray Hendershot, col-
lection of the artist

Marilyn Henry, p. 70
P.O. Box 108
Highland, MD 20777
The Thunderbolt, Afternoon ©
Marilyn Henry, collection of
Kennywood Park Corporation

Rich Hilker, p. 128
402 Broken Fence Road
Boulder, CO 80302
Wilson Arch © Rich Hilker, Saxon
Mountain Gallery, Georgetown,
CO

Sharon Hinckley, p. 47
5666 La Jolla Boulevard #200
La Jolla, CA 92037
Dancing Tulips © Sharon Hinckley

Karen Honaker, p. 37
3373 Branden Court
San Jose, CA 95148
Pigeon Point Promontory © Karen
Honaker, collection of Mr.& Mrs.
Stan Kulp, Santa Cruz, CA

Steven Jordan, p. 74
463 W. Coleman Boulevard
Mt. Pleasant, SC 29464
Tale of Colonial Lake © Steven
Jordan

R.K. Kaiser, p. 69
7 Ellis Court
Monmouth Jct., NJ 08852
Derelict No. 2—Monhegan Island ©
R.K. Kaiser, collection of the artist

Earl Grenville Killeen, p. 72-73
3 South Parkway
Clinton, CT 06413
Seedeater © Earl Grenville Killeen
Chrysalis © Earl Grenville Killeen

Glen Knowles, p. 34
1315 West Ave. O
Palmdale, CA 93551
Looking for Work © Glen Knowles

Judy Koenig, p. 66
1152 Rambling Road
Simi Valley, CA 93065
Animal Crackers © Judy Koenig,
S.R. Brennan Gallery, Palm
Desert, CA

Mary Kay Krell, pp. 71
4001 Ashley Court
Colleyville, TX 76034
Prairie Gold © Mary Kay Krell, col-
lection of Mr. & Mrs. T. Salvatore,
New York

Andrew Kusmin, p. 36
72 Main Street
Westford, CT 01886
Clean Sheets © Andrew Kusmin

Dale Laitinen, p. 55
1108 Mannor Drive
Modesto, CA 95351
Big Sur Bridge © Dale Laitinen,
collection of Phylis Penland

Jack Lestrade, p. 54
P.O. Box 4804
Carmel, CA 93921
Sospel © Jack Lestrade, corporate
collection of Lerch Bates and
Associates, Littuston, CO

Jennifer Lewis-Takahashi, p. 107
126 Prospect Place
S. Orange, NJ 07079
Music & Mirrors I © Jennifer
Lewis-Takahashi

D.F. Margeson, p. 123
16002 S.E. 42nd Place
Bellevue, WA 98006
Three Waders © D.F. Margeson

Anne Adams Robertson Massie,
p. 38, *Bedford County Point to Point
II* © Anne Adams Robertson
Massie, collection of the artist

William McAllister, p. 61
20914 Pilar Road
Woodland Hills, CA 91364
Sky Under Venetian Red © William
McAllister

James McFarlane, p. 124
37 Adair Drive
Norristown, PA 19403
A Quiet Moment © James
McFarlane, collection of Mr. &
Mrs. Craig Curcio

Susan Morris McGee, p. 5
P.O. Box 31041
Sarasota, FL 34232
Quiet Riot © Susan Morris McGee,
collection of the artist

Frances H. McIlvain, p. 57
40 Whitman Drive
Red Bank, NJ 07701
Passage to the Sea © Frances
McIlvain

Joseph Melancon, p. 67
9263 Biscayne Boulevard
Dallas, TX 75218
Kindred Spirits I © Joseph
Melancon, collection of the artist

Dean Mitchell, pp. 112-113
11918 England
Overland Park, KS 66213
Quincy Plant Worker © Dean
Mitchell, collection of the artist
Priceless Treasures © Dean Mitchell,
Phil Schneider collection,
Beaconsfield, Quebec, Canada

Leonard Mizerek, p. 62
35 Edgewater Hillside
Westport, CT 06880
Corfu © Leonard Mizerek, collec-
tion of Leonard Mizerek

Caesar Nicolai, p. 87
17 Roman Avenue S.I.
New York, NY 10314
Staten Island Ferry in Repair
© Caesar Nicolai

Jane Oliver, p. 122
20 Park Avenue
Maplewood, NJ 07040
Ice Cream Store © Jane Oliver

Annette Lotuso Paquet, p. 12
5131 Shawridge Road
San Diego, CA 92130
"Cut Ups" or Not Much Longer
© Annette Lotuso Paquet, collec-
tion of the artist

Ann Pember, p. 117
14 Water Edge Road
Keeseville, NY 12944
Azalea © Ann Pember, collection
of the artist

Jacqueline Peppard, p. 111
P.O. Box 1134
Telluride, CO 81435
Evening Reflections © Jacqueline
Peppard, collection of Mountain
Village Metro District, Telluride,
CO

Jim Petty, p.15
P.O. Box 1569
Espanola, NM 87532
Taos Gorge © Jim Petty, Post-
Western Gallery, Santa Fe, NM

Carlton Plummer, pp. 88-89
10 Monument Hill Road
Chelmsford, MA 01824
Diagonal Ledges © Carlton
Plummer
Sea Garden © Carlton Plummer,
collection of Momentum
Marketing

Susan Prahl, p. 19
4861 Huntington Drive
Redding, CA 96002
Dardanelle Blasted © Susan Prahl

David Rankin, p. 125
2320 Allison Road
Cleveland, OH 44118
Last Light © David Rankin

Robert Reynolds, pp. 75-76
958 Skyline Drive
San Luis Obispo, CA 93405
Winter Light © Robert Reynolds
Autumn Light © Robert Reynolds

Joan Rudman, p. 100
274 Quarry Road
Stamford, CT 06903
Green County Line © Joan Rudman,
collection of the artist

Janice K. Schafir, p. 101
38350 Parkside Court
Fremont, CA 94536
Chiff Chaffs © Janice K. Schafir

Carl Schmalz, p. 43
40 Arnold Road
Amherst, MA 01002
Mailboxes & Cosmos © Carl Schmalz

Carol Ann Schrader, p. 40
64 Stateline Road
Oak Grove, KY 42262
Margaret's July © Carol Ann
Schrader

Garren Schrom, p. 33
981 E. Conifer Court
Highlands Ranch, CO 80126
Riding Still © Garren Schrom

Ken Schulz, p. 129
P.O. Box 396
Gatlinburg, TN 37738
Time to Move On © Ken Schulz

Hal Scroggy, p. 126
171 Court Drive #302
Fairlawn, OH 44333
Fall's Fall © Hal Scroggy

Irving Shapiro, p. 109
650 Onwentsia Avenue
Highland Park, IL 60035
Relentless © Irving Shapiro, private
collection

Barbara L. Siegal, p. 18
3783 First Avenue #3
San Diego, CA 92103
Canyon Fantasy © Barbara L.
Siegal, private collection,
Philadelphia, PA

Nancy Tipton Steensen, p. 39
313 Niem Road
Woodland, WA 98674
Cartoon Coma © Nancy Tipton
Steensen, collection of Mrs. M.
Sams

Larry K. Stephenson, p. 118
918 E. Grand Avenue
Ponca City, OK 74601
Rites of Spring © Larry K.
Stephenson

Shirley Sterling, p. 48
4011 Manorfield Drive
Seabrook, TX 77586
Fish Fantasy Diptych © Shirley
Sterling, collection of the Marriott
Rivercenter Hotel, San Antonio,
TX

Colleen Newport Stevens, p. 46
8386 Meadow Run Cove
Germantown, TN 38138
Just Wear a Hat, No One Will Know
© Colleen Newport Stevens

Penny Stewart, p. 22
6860 Cedar Ridge Court
Colorado Springs, CO 80919
New Mexico Puzzle Pieces: Dixon #1
© Penny Stewart, collection of Mr.
& Mrs. Dan League

Carol P. Surface, p. 24
2617 Mathews Avenue #1B
Redondo Beach, CA 90278
Afternoon Delight © Carol P.
Surface, collection of Ms.Diana
DiDomenico, Redondo Beach, CA

Ray Swanson, p. 60
P.O. Box 937
Carefree, AZ 85377
In Aberdeen Harbor © Ray Swanson

Gwen Tomkow, pp. 84-85
P.O. Box 2263
Farmington Hills, MI 48333
Lake Leelanau © Gwen Tomkow,
collection of Charles Harmon
Blowin' Grass © Gwen Tomkow,
Joppich's Bay Street Gallery,
Northport, MI

Lois Salmon Toole, pp. 82-83
561 North Street
Chagrin Falls, OH 44022
Bottoms Up II © Lois Salmon
Toole, collection of the artist
C.A. Harrington © Lois Salmon
Toole

Thomas Trausch, p. 7
2403 Mustang Trail
Woodstock, IL 60098
Shagbark © Thomas Trausch, in
the private collection of Ms.
Georgia Maskalunas

Judy D. Treman, p. 41
11627 104th Avenue N.E
Kirkland, WA 98034
Grandmother's Treasures © Judy D.
Treman, private collection

Francisco Valverde, p. 106
2317 Quenby Street
Houston, TX 77005
The Top © 1992 Francisco
Valverde, collection of William and
Chelsea Estes

Robert Wade, pp. 90-91,
2 McLeod Place
Mt. Waverly, Victoria, Australia
3149
Beijing Morning, China © Robert
Wade
Afternoon, Uttar Pradesh, India ©
Robert Wade

Lenox H. Wallace, p. 23
2829 W. 183rd Street
Homewood, IL 60430
Underbrush © Lenox H. Wallace,
collection of the artist

Dona LeCrone Walston, p. 4
318 Twisted Wood Drive
San Antonio, TX 78216
Waterlilies IV © Dona LeCrone
Walston, Harris Gallery, Houston,
TX

Joyce Ward, p. 11
5652 Lockhill Road
San Antonio, TX 78240
Sunlight on My Tallow Tree © Joyce
Ward

Jeffrey J. Watkins, p. 20
7195 Ridge Road
Lockport, NY 14094
Ever Green © Jeffrey J. Watkins,
collection of the artist

Ben Watson III, p. 10
3506 Brook Glen
Dallas, TX 75044
October © Ben Watson III, collec-
tion of Leon R. Russell

Eileen Monaghan Whitaker, p.127
1579 Alta La Jolla Drive
La Jolla, CA 92037
The King Presides © Eileen
Monaghan Whitaker, collection of
the artist

Patrick R. White pp. 44-45
P.O. Box 965
Tatum, NM 88267
One Nation Under God © Patrick R.
White, collection of the artist
Paper and Rose © Patrick R. White,
collection of Nathan and Buffye
White

Eric Wiegardt, p. 121
Box 1114
Ocean Park, WA 98640
Dry Dock © Eric Wiegardt, collec-
tion of Denise Fuentes

William C. Wright, p. 75
Box 21
Stevenson, MD 21153
Haddock With Shell

Ruth Wynn, p. 27
30 Oakledge Road
Waltham, MA 02154
Summer Home © Ruth Wynn

More Great Books for Beautiful Watercolors!

Mrs. Pearl Robbins
3479 51st Avenue Cir W
Bradenton, FL 34210